Shadows of Reality

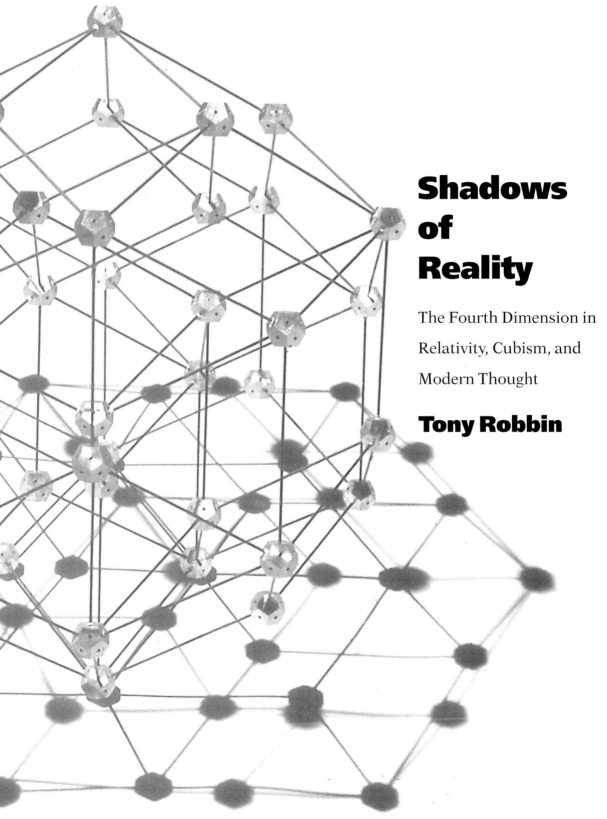

Shadows of Reality

The Fourth Dimension in Relativity, Cubism, and Modern Thought

Tony Robbin

YALE UNIVERSITY PRESS NEW HAVEN & LONDON

Designed by James J. Johnson and set in
Aster Roman types by Keystone Typesetting, Inc.
Printed in the United States of America.

Library of Congress Cataloging-in-Publication Data

Robbin, Tony.
 Shadows of reality : the fourth dimension in
relativity, cubism, and modern thought / Tony Robbin.
 p. cm.
 Includes bibliographical references and index.
 ISBN-13: 978-0-300-11039-5 (alk. paper)
 ISBN-10: 0-300-11039-1 (alk. paper)

 1. Geometric quantization. 2. Fourth dimension.
3. Art—Mathematics. 4. Geometry in art. 5. Hyperspace.
I. Title.
QC174.17.G46R63 2006
530.11—dc22
2005022806

A catalogue record for this book is available from the
British Library.

The paper in this book meets the guidelines for
permanence and durability of the Committee on
Production Guidelines for Book Longevity of the
Council on Library Resources.

10 9 8 7 6 5 4 3 2 1

**To Linda Henderson and Tom
Banchoff, who climbed up first
and set the rope**

I have felt and given evidence of the practical
utility of handling space of four dimensions, as if
it were conceivable apace. Moreover, it should be
borne in mind that every perspective represen-
tation of figured space of four dimensions is a
figure in real space, and that the properties of
figures admit of being studied to a great extent,
if not completely, in their perspective
representations.

—James Joseph Sylvester, 30 December 1869

Contents

Illustrations follow page 58

Preface

We walk in the here and now, but is there a space beyond, a space that impinges on our own infinite space, or more dramatically, a space wholly applied to or inserted into our space? Perhaps we remember being in the space of the womb, and then we remember the cold infinity of space that suddenly existed after our birth, and those memories foster our belief that such a space beyond space is possible. Mathematics can define and conquer the extra space and make four-dimensional geometry into a sensible world, perhaps even as sensible as the three-dimensional world. During the nineteenth century, mathematicians and philosophers explored and comprehended such difficult thoughts by the use of two mathematical models: the Flatland, or slicing, model and the shadow, or projection, model.

We can understand these two metaphors for four-dimensional space by considering the different two-dimensional manifestations of a chair. The Flatland model assumes viewers to be pond scum, floating on the surface of the water. As the chair slips into their surface world, successive slices of the chair are wetted. First the four legs appear as four circles; then, the seat appears as a square; then, two circles again as the back approaches the water; and finally, the thin rectangle of the back of the chair is present in the two-dimensional world. But in the shadow model, if the sun were to cast a shadow of the chair on the surface of a smooth beach, then the whole chair would be present to any two-dimensional creatures living on that beach. True, with shadows, the lengths or angles between the parts could be distorted by the projection, but the continuity of the chair is preserved, and with it is preserved the relationship between its parts.

The strength of the slicing model is its grounding in calculus, which reinforces the notion that slices represent reality by capturing infinitely thin sections of space and then stacking them together to define motion. Further, the stacking together of all of space at each instant is a definition of time; one often hears that time is the fourth dimension. The slicing model is mathematically self-consistent and thus true, and it is often taken to be an accurate, complete, and exclusive representation of four-dimensional reality. This may seem to be the end of the story, yet the Flatland metaphor constrains thought as much as it liberates it.

The projection model is an equally clear and powerful structural intuition that was developed at the same time as the slicing model. Contrary to popular exposition, it is the projection model that revolutionized thought at the beginning of the twentieth century. The ideas developed as part of this projection metaphor continue to be the basis for the most advanced contemporary thought in mathematics and physics. Like the slicing model based on calculus, the shadow model is also self-

consistent and mathematically true; it is supported by projective geometry, an elegant and powerful mathematics that, like calculus, flowered in the nineteenth century. In projective geometry a point at infinity lies on a projective line, is a part of that line, and this simple adjustment of making infinity a part of space vastly changes and enriches geometry to make it more like the way space really is. Projected figures are whole, sliced figures are not, and more and more the disconnected quality of the Flatland spatial model presents problems. Even time cannot be so simply described as a series of slices.

Pablo Picasso not only looked at the projections of four-dimensional cubes in a mathematics book when he invented cubism, he also read the text, embracing not just the images but also the ideas. Hermann Minkowski had the projection model in the back of his mind when he used four-dimensional geometry to codify special relativity; a close reading of his texts shows this to be true. Nicolaas de Bruijn's projection algorithms for generating quasicrystals revolutionized the way mathematicians think about patterns and lattices, including the lattices of atoms that make matter solid. Roger Penrose showed that a light ray is more like a projected line than a regular line in space, and the resulting twistor program is the most provocative and profound restructuring of physics since the discoveries of Albert Einstein. Projective geometry is now being applied to the paradoxes of Quantum Information Theory, and projections of regular four-dimensional geometric figures are being observed in quantum physics in a most surprising way. We use projection methods to climb the dimension ladder in order to study quantum foam, the exciting and most current attempt to understand the space of the quantum world. Such new projection models present us with an understanding that cannot be reduced to a Flatland model without inducing hopeless paradox. These new applications of the projection model happen at a time when computer graphics gives us powerful new moving images of higher-

dimensional objects. The computer revolution in visualization of higher-dimensional figures is presented in chapter 10.

Projective geometry began as artists' attempts to create the illusion of space and three-dimensional form on a two-dimensional surface. Mathematicians generalized these *perspective* techniques to study objects in any orientation and eventually in any number of dimensions, thus establishing a generalized *projection*. Simultaneously, *perspective* evolved to *projectivity*, whereby objects and spaces were studied with an eye to what remained constant, as structures were passed from pillar to post by chains of projection operations, including those that projected objects back onto themselves. Finally *projective* came to mean systems defined by homogeneous coordinates where concepts like metric dimension and direction lose all traditional meaning, but gain a richness relevant to modern understanding. *Perspective, projection, projectivity, projective*—these subtle concepts promoted one another, building higher levels of abstraction, until they defined self-referential, internally cohesive structures housed in a higher-dimensional framework. Such higher-dimensional frameworks now begin to have more and more reality as they become more familiar and as culture stabilizes their appearance.

I have been on this journey for more than thirty years. For this book, I looked back with pleasure to the time when the projection model of four-dimensional geometry first appeared. I got to know Washington Irving Stringham better, the nineteenth-century mathematician whose drawings of four-dimensional figures caused a sensation in Europe and America. I discovered the amazing T. P. Hall, who anticipated by seventy-five years the behavior of computer-generated four-dimensional figures. I saw the moment when Picasso invented true cubism, and without this backward look I never would have met the wonderful Alice Derain, Picasso's muse in his four-dimensional quest. I always wanted to know Minkowski's mindset better. It was fun rooting

around in the dusty stacks of the Columbia University Science and Mathematics Library and the Clark University Archives, and I am grateful for new e-mail pals, archivists in the United States and Europe.

Even more thrilling was talking with living mathematicians and physicists, deepening old friendships and making new ones. Many of the people in the later chapters of this book made time for me out of a respect for my artwork, my pioneering computer programming of the fourth dimension, and my commitment to visualizing four-dimensional geometry. Their acceptance of me, and the access they consequently provided, make this long writing project worthwhile. I got and also gave.

Acknowledgments

Mathematicians Scott Carter, in Mobile, Alabama, and Charles Straus, in Oneonta, New York, deserve a special acknowledgment. They spent many hours in meetings with me, teaching, discussing, and debating. They read and commented on tentative early drafts and, later, more detailed ones. They e-mailed explanations and drawings, and even researched questions that I had. I cannot thank them enough for their patience, their knowledge, and their generosity. There would not have been a book without their help.

Other readers of the manuscript were P. K. Aravind, Florence Fasanelli, George Francis, Linda Henderson, Jan Schall, and Marjorie Senechal. Each took the time to read carefully, and each brought their expert judgment to the text and made useful suggestions, for which I will always be grateful. Any errors that remain in the text are my responsibility alone.

Archivists Mott Lynn at Clark University and James Stimpert at Johns Hopkins University provided copies of obscure primary sources, as did mathematicians Calvin Moore in Berkeley and Edeltraude Buchsteiner-Kiessling in Halle, Germany. Painter Gary Tenenbaum found and purchased for me a rare copy of the 1903 Jouffret text in Paris.

I used several libraries at Columbia University: Mathematics and Science, Engineering, Rare Book and Manuscript, and Avery Architectural and Fine Art. The Milne Library of the State University of New York, Oneonta, was also a great help, as was the Stevens-German Library of Hartwick College, Oneonta. The New York State Library in Albany was also a source for texts. New York City's libraries, especially the Science, Industry, and Business Library, have great collections and were very useful to me. All of these libraries deserve our continued support.

I was invited to conferences at the University of California at Irvine, the Institute for Mathematical Behavioral Sciences; the University of Illinois at Urbana-Champaign, the Beckman Institute; and the University of Minnesota at Minneapolis, the Institute for Mathematics and Its Applications. These meetings and site visits were most helpful. For this book, I interviewed P. K. Aravind, John Baez, Ronnie Brown, Scott Carter, David Corefield, George Francis, Englebert Schucking, and Marjorie Senechal, and I am grateful for their help. Schucking also invited me to join a dinner with Penrose, during which I had the opportunity to question Penrose directly; this was a treat and was also very informative. I am also grateful that Dick de Bruijn took the time for lengthy e-mail correspondence and that William Wootters and Jeff Weeks spent time with me on the phone. And I was happy to meet Peggy Kidwell, who cleared up some historical details.

When my French or German failed me, I

turned to Kurt Baumann, Douglas Chayka, Tom Clack, François Gabriel, Marcelle Kosersky, and Marianne Neuber. A special thanks to Gerry Stoner and Ellen Fuchs Thorn of Generic Compositors for help in preparing the manuscript. Davide Cervone and George Francis made special illustrations for me that are worth a great many of my words.

At Yale University Press, Senior Science Editor Jean Thomson Black dove into this project with great energy and insight, and I am grateful for her help. Also at Yale University Press, I thank Laura Davulis for her help. And a very special acknowledgment is due to Jessie Hunnicutt for her most thorough editing.

As always, nothing happens without the advocacy of my wonderful agent, Robin Straus.

Finally, my wife, Rena Kosersky, and my son, Max Robbin, were an unfailing source of support (and forgiveness) for this absorbing project.

PART ONE

Past Uses
of the
Projective Model

The Origins of Four-Dimensional Geometry

In mathematician Felix Klein's posthumously published memoir *Developments of Mathematics in the Nineteenth Century* (1926), Klein says of Hermann Grassmann that unlike "we academics [who] grow in strong competition with each other, like a tree in the midst of a forest which must stay slender and rise above the others simply to exist and to conquer its portion of light and air, he who stands alone can grow on all sides" (161). Grassmann never had a university position, taught only in German gymnasiums, and was consequently allowed to be a generalist: a philosopher, physicist, naturalist, and philologist who specialized in the Rig Veda, a Hindu classic. Grassmann's mathematics was outside the mainstream of thought; read by few, his great work *Die lineale Ausdehnungslehre* (The Theory of Linear Extension, 1844) was described even by Klein as "almost unreadable." Yet this book, more philosophy than mathematics, for the first time proposed a system whereby space and its geometric components and descriptions could be extrapolated to other dimensions.

Grassmann was not completely alone in his philosophical musings. August Möbius speculated that a left-handed crystal, structured like a left-turning circular staircase, could be turned into a right-handed crystal by passing it through a fourth dimension. Arthur Cayley published a paper on four-dimensional analytic geometry in

1844, at age twenty-two, and a few others worked on the idea of a general four-dimensional geometry. But these disparate musings lacked both a critical mass and a specific geometric interpretation.

In the second half of the nineteenth century, however, four-dimensional geometry advanced rapidly with the discovery and description of the four-dimensional analogs of the platonic solids, the geometric building blocks of space. In three dimensions there are five platonic solids: tetrahedron, cube, octahedron, icosahedron, and dodecahedron (fig. 1.1). They are "platonic" because they are regular: not only is every two-dimensional bounding face the same, but also each vertex is identical. In four dimensions, however, there are *six* platonic solids, also called polytopes (fig. 1.2).

According to the great Canadian geometer Harold Scott MacDonald Coxeter, the credit for the discovery of the platonic solids in four-dimensional space should go to Ludwig Schläfli (1814–1895). His book *Theorie der vielfachen Kontinuität* (Theory of Continuous Manifolds, 1852), with a title and a spirit so much like Grassmann's but with an intensely analytic approach, went far beyond what had been done before. In calculus, an *integral* computes the area under a curve. By taking integrals of integrals of integrals, Schläfli computed the four-dimensional volumes of "polyspheres." Schläfli next extended Euler's theory to

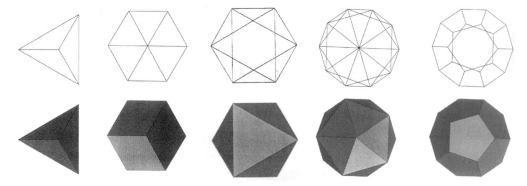

Fig. 1.1. The five platonic solids of three-dimensional space. Computer drawing by Koji Miyazaki and Motonaga Ishii, used by permission.

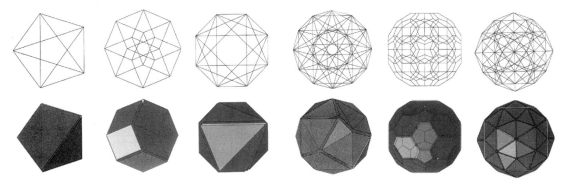

Fig. 1.2. The six platonic solids of four-dimensional space. Computer drawing by Koji Miyazaki and Motonaga Ishii, used by permission.

four dimensions. This remarkably useful formula, devised in the eighteenth century by Swiss mathematician Leonhard Euler, is often stated as follows: in a three-dimensional figure, the number of vertices minus the number of edges plus the number of faces minus the number of whole figures is equal to one ($v - e + f - c = 1$). That is to say, in a cube the 8 vertices minus the 12 edges plus the 6 faces minus the 1 whole cube is equal to 1. Schläfli stated that the minus-plus, minus-plus pattern continues indefinitely beginning with vertices until the whole figure is reached. For a four-dimensional cube, or hypercube, Schläfli ultimately determined that the 16 vertices minus the 32 edges

plus the 24 faces minus the 8 cubes, or cells, plus the 1 whole hypercube is equal to 1 ($v - e + f - c + u = 1$). Knowing the Euler rule for regular figures, and being able to compute the volumes of higher-dimensional regular figures, Schläfli discovered which polytopes can fit inside which polyspheres, and also how to "dissect" the polytopes to reveal their lower-dimensional cells. Although Schläfli's book was difficult, his results were clear and conclusive, and having solid objects to work with moved the effort from abstract and analytic to geometric and ultimately visual (box 1.1).

Thirty years later, in 1880, Washington Irving Stringham (1847–1909; box 1.2), a fellow of Johns

Box 1.1 Polytopes and Schläfli Symbols

Schläfli's results are elegantly summarized by what came to be called Schläfli symbols. The three-dimensional platonic solids are noted as {3, 3}, {4, 3}, {3, 4}, {3, 5}, and {5, 3} meaning, respectively, that three-sided faces fit three around each vertex to make a tetrahedron, four-sided squares are assembled three around each corner to make a cube, triangles fit four around each vertex to make an octahedron, triangles meet five at a time to make an icosahedron, and pentagonal faces meet three at a time to make a dodecahedron. The six regular, convex polytopes in four dimensions are then {3, 3, 3}, the four-dimensional tetrahedron, where three tetrahedra fit around each edge; {4, 3, 3}, the four-dimensional cube, or hypercube or tesseract, where three cubes fit around each edge making a total of 8 cells; {3, 3, 4} the four-dimensional octahedron, the 16-cell, where four tetrahedra fit around each edge; {3, 4, 3}, the four-dimensional cube-octahedron, which is regular in four dimensions although it is only semiregular in three, with 24 octahedral cells that fit three around each edge; {5, 3, 3}, the four-dimensional dodecahedron, or 120-cell, where three dodecahedra fit around each edge; and {3, 3, 5}, the four-dimensional icosahedron, the 600-cell, where five tetrahedra fit around each edge. Schläfli's work also describes stellated versions of four of the ten polytopes discussed by Coxeter (pl. 1).

Hopkins University, published his sixteen-page paper "Regular Figures in n-Dimensional Space" in the university's *American Journal of Mathematics*. Although it largely duplicated Schläfli's discoveries, Stringham's paper, for the first time, included illustrations of four-dimensional figures. Long forgotten until its rediscovery by art historian Linda Henderson, this paper swept through Europe when it was written and was cited in every important mathematical text on four-dimensional geometry for the next two decades.

Stringham's approach, both in his drawings and in his mathematics, was to define the three-dimensional cells, or *coverings*, of four-dimensional figures, and then, in keeping with the mechanical drawing techniques of his time, to imagine the cells folded up to make a four-dimensional figure. For example, in the three-dimensional case imagine a triangle with a triangle attached to each of its three sides. The tetrahedron, the three-dimensional analog of the triangle, can be constructed and visualized by folding up the three outside triangles so that their three far corners meet in three-dimensional space. As he wrote: "In particular, the 4-fold pentahedroid [the four-dimensional tetrahedron, or the 5-cell] has 5 summits, 10 edges, 10 triangular [faces] and 5 tetrahedral boundaries [or cells]. To construct this figure select any one summit of each of four tetrahedra and unite them. Bring the faces, which lie adjacent to each other, into coincidence. There will remain four faces still free; take a fifth tetrahedron, and join each one of its faces to one of these remaining ones. The resulting figure will be the complete 4-fold pentahedroid" (1880, 3). In an imaginative leap, Stringham arranged these covering parts as exploded technical drawings, where the parts are shown slightly separated (fig. 1.3; box 1.3).

The 16-cell is constructed in a way similar to the method used for the 5-cell, and Stringham is comfortable describing and drawing it. In three dimensions, the octahedron is the dual of the cube; it is made by joining the centers of the 8

Box 1.2 Washington Irving Stringham

Lost to history until art historian Linda Henderson rediscovered his influential drawings of four-dimensional figures, Stringham remains a mostly unknown figure. Stringham was born 10 December 1847 in Yorkshire Centre (now Delavan) in western New York. Even then, when western New York was more populated, it was a bleak place: 100 miles from Buffalo, 100 miles from Erie, 100 miles from everywhere. As Calvin Moore recounts in his history of the mathematics department of the University of California at Berkeley, after the Civil War Stringham's family moved to the relative sophistication of Topeka, Kansas. There, Stringham "established a house and sign painting business, and worked in a drugstore while attending Washburn College parttime. He also served as Librarian and teacher of penmanship at Washburn. With this unusual background, Stringham applied to and was admitted to Harvard College" (Moore, e-mail to the author, 4 February 2004).

Stringham received his bachelor's degree from Harvard College in 1877 with highest honors. In 1878, he was granted admission to the graduate program at Johns Hopkins University. While reading his handwritten application to the mathematics department, I was pleased to note that he intended not only to study mathematics but also "as far as possible, to pursue the study of Fine Arts." In his 20 May 1880 letter to the trustees of Johns Hopkins University in support of his request for a degree, Stringham listed ten courses of study during the previous year, including mainly calculus but also symbolic logic, quaternions, number theory, and physics. Last, he mentions, "I have been engaged privately in Investigations in the Geometry of N. Dimensional Space." In between January and May 1880, Stringham gave four talks on the subject to the Scientific Association and the Mathematical Seminary, the math club at Johns Hopkins started by William E. Story. These talks eventually became Stringham's first paper in the *American Journal of Mathematics.* His study, seemingly unconnected to the degree program, may have been a continuation of work done the previous year listed as "other desultory work which I do not think worthy of mention" in a similar account to

university president Daniel Coit Gilman (Gilman Papers, Milton S. Eisenhower Library, Johns Hopkins University).

After graduation from Johns Hopkins, Stringham went to Europe to see the sights and to study mathematics in Leipzig with the great German geometer Felix Klein (1849–1925). Stringham wrote Gilman with boyish excitement of his weekly seminars "with Prof. Klein's wonderful critical faculty continually at play." In the seminar, in addition to German students, there was "one Englishman, one Frenchman, one Italian, and one American (myself)." He hoped to negotiate a teaching position at Johns Hopkins or Harvard that would permit him to stay in Europe another year, but in the end Stringham reluctantly accepted the position of chair of the mathematics department at the University of California at Berkeley, starting in the fall of 1882. Stringham's worst fears came true: though he soon entered the office of the dean and was the acting president of the college at the time of his sudden death in 1909, Stringham rarely had a chance to study modern mathematics or do any original work. In 1884, Stringham wrote to Gilman, who had previously been at Berkeley and who had gotten Stringham the job, about being bogged down in administrative affairs. He complained that the Board of Regents constantly intruded with an "arbitrary exercise of power in matters concerning which the judgement of the Faculty in Berkeley would certainly be more competent" and stated, "I have not been able to apply myself to my favorite studies." Stringham published a few papers after this period, but mainly on the problems of teaching mathematics to undergraduate students. This wonderful mathematician with so many lively interests was swallowed by the morass that is university politics.

Yet Stringham likely took satisfaction in what he *did* accomplish during his years at Berkeley. When Stringham arrived the college had four hundred students and was a battleground between populist farmers and workers who saw the public university as a route to economic advancement, and patrician railroad barons who wanted it as a playground. Perhaps remembering his own modest beginnings, Stringham was committed to bringing a professional math curriculum to this public institution, and it remains a leading mathematical institution to this day.

Fig. 1.3. Stringham's exploded drawings of four-dimensional figures. *Left to right:* the four-dimensional tetrahedron, the hypercube, and the four-dimensional octahedron.

faces of the cube, which cuts off the cube's corners to result in a figure with 8 triangular faces, that is, two square-based pyramids joined on their bases. The four-dimensional 16-cell is generated by an analogous procedure that involves taking the centers of the 8 cells of the hypercube and joining these points with lines of equal length, making a compact figure of 24 edges, 32 faces, and 16 tetrahedral cells, 4 of which are wrapped around each edge. Again, Stringham asks us to imagine a folding up of pointed cells: "the edges of the figure are found by joining each summit with each of the other summits except its antipole, i.e. with six adjacent ones" (6).

Stringham constructed the hypercube in a different way, by extruding a cube into a fourth spatial dimension: "It may be generated by giving the 3-fold cube a motion of translation in the fourth dimension in a direction perpendicular to the three dimensional space in which it is situated. Each summit generated an edge, each edge a square, each square a cube" (5). Such a motion results in twice the number of vertices, edges, and faces of the original cube, as the "cube must be counted once for its initial and once for its final position."

Like Schläfli, Stringham examined Euler's formula extended to four dimensions. Stringham used the formula to discover the successive lower-dimensional cells of four-dimensional figures. Counting up the interior angles of the lower-dimensional cells, he could exclude four-dimensional figures whose lower-dimensional cells were too wide and too many to fit together without intersecting, even in four-dimensional space. By this method of counting their parts, Stringham rediscovered the possible arrangements of three-dimensional platonic solids as cells for four-dimensional figures. In the last section of his paper, Stringham extended this method to the fifth dimension, and he concluded, correctly, that only the tetrahedron, the cube, and the octahedron have analogs in five-dimensional space.

Stringham's work was so influential (and seemingly unprecedented) at the time that it is a fair question to ask about his sources. Schläfli wrote his major work in 1852, but it was not published until 1901, six years after his death. As was common in the *Journal* at that time, Stringham gave no references, so it is unknown whether Stringham was familiar with Schläfli's pioneering work or what other sources he may have had. There could, however, have been two distinct threads to Schläfli. Arthur Cayley translated large portions of *Theorie der vielfachen Kontinuität* and published them in 1858 and 1860 in Cambridge University's *Quarterly Journal of Pure and Applied Mathematics.* Cayley changed the title to "On the Multiple Integral . . ." and treated this great work on the geometric *n*-dimensional polytopes as a treatise on problems in calculus, emphasizing the method rather than the results. Cayley's translation would have been of interest to James Joseph Sylvester, who returned to America in 1876 to head the mathematics department at Johns Hopkins and became Stringham's mentor there. Cayley and Sylvester were great friends; both were lawyers at the courts of Lincoln's Inn in London, their day jobs for a time. Sylvester's interest in a spatial fourth dimension was evident in an 1869 volume of *Nature*, in which he argued for "the

Box 1.3 Mechanical Drawing

The development of technical or mechanical drawing is inextricably bound to the development of projective geometry, because both spring from Renaissance perspective. For their time, the techniques and texts of Filippo Brunelleschi (1377–1446), Leon Battista Alberti (1404–1472), and Piero della Francesca (ca. 1420–1492) represented both the most advanced geometry as well as the most advanced drawing techniques. The synergy provided by Renaissance technical drawing powered the scientific and technological progress of Europe.

Gaspard Monge (1746–1818), considered the inventor of modern technical drawing, continued the tradition of applying projective geometry to the description of useful objects. Monge's work as an instructor in the military academy of Mézières and later as director of the École Polytechnique used projective geometry to design fortifications. This application was so important to Napoleon that it was kept secret until the publication of Monge's *Geometría Descriptiva* in 1803. Monge's basic technique was to project an object in space to a plane, then rotate that plane (with the image embedded) to lay flat on a page (fig. 1.4). Multiple projections further define the object of study. Monge's most complicated drawing shows a cutaway drawing of the intersection of two cylinders (fig. 1.5). In Monge's text, there are sections through objects but no exploded drawings that show how parts would fit when brought together. Victor Poncelet (1788–1867), Monge's most original student, pondered his teacher's work while a prisoner of war in Russia in 1813 and developed the purely mathematical side of projective geometry. Claude Crozet (1790–1864) brought the drawing techniques to the U.S. Military Academy at West Point, continuing the connection between the military and mechanical drawing.

William Minifie (1805–1888), an architect and teacher of drawing in Baltimore's high schools, gave the discipline a tremendous boost with the publication of his *Text Book of Geometrical Drawing* in 1849. The book was used as a text throughout the United States and Great Britain. Even the first edition had a rather complete catalog of the techniques of mechanical drawing: geometric objects are shown with their "coverings" or as unfolded figures (fig. 1.6); with transparent faces or with parts removed; and as sections, elevations, and plans. Side and bottom views are shown rotated so that both lie adjacent on the page. Isometric and perspective views of objects are shown together. These are not just drawing techniques but tools and practices to develop visualization and conceptual understanding of the third dimension. By 1881, when Stringham had just published the first drawings

Fig. 1.4. A drawing from Monge's 1803 text on descriptive geometry showing the basic procedure of projecting a figure on a plane that is then rotated flat on a page.

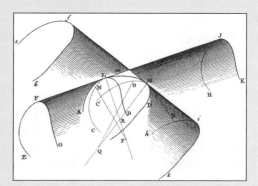

Fig. 1.5. Monge's most complicated example.

of four-dimensional figures in the *American Journal of Mathematics,* Minifie's book was in its eighth edition.

Stringham, as a teacher of penmanship and a professional sign painter, no doubt used Minifie's widely accepted text. For his four-dimensional drawings, Stringham borrowed Minifie's standard techniques. In particular, Stringham adapted the coverings of solids to depict his four-dimensional figures. However, there are no exploded drawings in Minifie's work, which made Stringham's use of them to show how three-dimensional cells fit together in a four-dimensional object all the more original. The exploded view did not come into

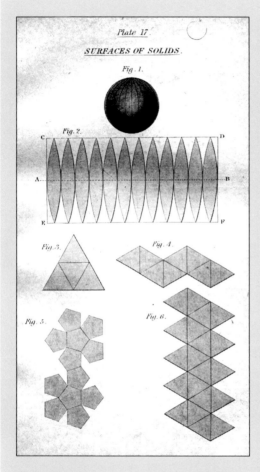

Fig. 1.6. Minifie's plate of surfaces, or "coverings," of solids. Such unfolded figures were a likely model for Stringham's four-dimensional unfolded drawings.

Coming from a family of industrialists, Schoute received the best education Holland could provide, graduating as a civil engineer from the Polytechnic in Delft (now called the Technical University of Delft) in 1867. But young Hendrick did not want to be an engineer and instead pursued mathematics, receiving his doctorate from Leiden University in the Netherlands in 1870. For ten years, Schoute was forced to teach high school math before finally receiving a university appointment in Groningen, a city in a rural province in the north of Holland without much of a mathematics department in its university. Nevertheless, the secluded appointment gave Schoute a chance to sit down and seriously develop his interest in four-dimensional geometry, using the mechanical drawing techniques he had learned as an engineering student.

As later formalized in his *Mehrdimensionale geometrie* (1902), Schoute's figures lay four mutually perpendicular axes of four-dimensional space—x_1, x_2, x_3, x_4—flat on the page (fig. 1.7). Line E is described as "half parallel" and "half normal [or perpendicular]" to both plane x_1, x_4 and also plane x_2, x_3, making those two planes absolutely perpendicular to each other, with only the point O in common, whereas plane x_1, x_4, having an edge in common with plane x_1, x_2, is therefore only partially perpendicular. There are actually six combinations of four axes, six planes of four-dimensional space that are mutually perpendicular at least to some degree. Because three views are sufficient in the mechanical drawing of civil engineering, however, Schoute apparently thought showing only four would suffice.

The Schoute formalism was adopted and extended by Esprit Jouffret. Given the history of mechanical drawing it is no surprise that he identified himself as an artillery lieutenant colonel and a former student of the École Polytechnique. Jouffret's *Traité élémentaire de géométrie à quatre dimensions* (1903) shows

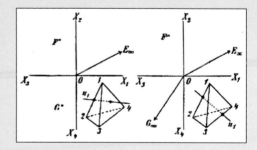

Fig. 1.7. Schoute applied the techniques of mechanical drawing to four dimensions.

common usage until far into the twentieth century. Thomas Ewing French (1871–1944) inherited Minifie's mantel as *the* professor of mechanical drawing, and neither his first edition of *A Manual of Engineering Drawing* (1911) nor the second edition of 1918 has an exploded drawing. They appear, in a most modest way, in the fifth edition of 1935 and are not fully exploited until much later.

Despite Stringham's pioneering efforts, the full application of classical mechanical drawing techniques to four-dimensional figures is the work of the Dutch mathematician Pieter Hendrick Schoute (1846–1923).

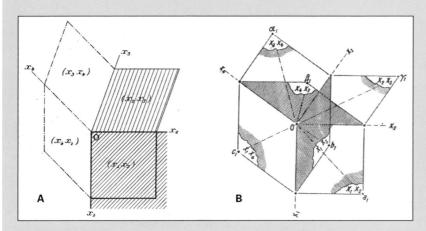

Fig. 1.8. Drawings from Jouffret's 1903 and 1906 texts, respectively. Jouffret extended the Schoute technique of four-dimensional mechanical drawing.

A Solid, surrounded by planes of projection.

Vertical planes of projection revolved to coincide with the horizontal plane.

Fig. 1.9. A drawing from Thorne's 1888 text on mechanical drawing. It is the earliest example found of the glass-box technique of mechanical drawing.

the four planes in the process of being unfolded and laid flat on the page (fig. 1.8A). A drawing from *Mélange de géométrie à quatre dimensions* (1906) shows all six planes of four-dimensional space passing through the origin (fig. 1.8B). This "glass box" approach is the fundamental gambit of mechanical drawing; possibly the first example of it appears in William Thorne's *Junior Course: Mechanical Drawing* (1888; fig. 1.9).

By 1911 French's work clearly articulated the glass-box metaphor. One imagined the object to be drawn inside a glass box with hinged faces. The image of the object was imprinted on the sides and top of the glass box. The box then opened flat with the views shown side by side. In the United States the convention is that the viewer is outside the box looking down on it, so that when the box is opened, the left view is to the left and the top view is on top, the so-called third-angle view. Most of the rest of the world uses the earlier first-angle view, where the viewer is inside the box with the object, showing the top view projected on the floor of the box beneath the viewer's feet. Technical drawing is now primarily in the domain of computer graphics, and professors of architecture debate whether something is lost by replacing a pen with a mouse. Contemporary computer technical drawing of mathematical objects is the subject of chapter 10.

practical utility of handling space of four dimensions, as if it were conceivable space" (238).

However, Stringham's visualizations and combinatorics are so different in style from Schläfli's (and Sylvester's) intense analysis that a different source is likely. In conversation, mathematician Dan Silver suggested to me a more likely thread connecting Schläfli and Stringham, one that runs via Johann Benedict Listing and William E. Story. When describing the omniattentive outsider mathematician Grassmann, Felix Klein could have been describing Listing as well. Known as the father of topology and knot theory, Listing was most famous in his lifetime for his work on optics, and he was gifted in art and architecture. (Indeed, much of four-dimensional geometry was done by generalist mathematicians on the fringes of establishment thought.) In 1862, Listing published his *Der Census räumlicher Complexe oder Verallgemeinerung des Eurler'schen Satzes von den Polyedern* (The Census of Spatial Complexes or the Generalization of Euler's Formula for Polyhedra). In *Census*, Listing followed Schläfli's example and boosted Euler's formula to four dimensions. It is likely that Listing's visual approach, and his drawings in the back of the book, would have been appreciated by Stringham.

William Story (1850–1930) was a junior faculty member at Johns Hopkins during the 1880s and associate editor of the *Journal*. In the 1870s he had studied for his doctorate at the University of Leipzig, where Listing's work would have been known. Story is the unsung hero of American four-dimensional geometry studies. Though he published little himself on the subject, his name turns up, behind the scenes, on many of the important nineteenth-century American papers. Indeed, in the only footnote to his paper, Stringham thanked Story for his help. Furthermore, in a letter defending himself against charges from a furious Sylvester of lateness and incompetence in editing the *Journal*, Story stated, "I worked this paper out very carefully with Stringham, giving him constantly suggestions and criticisms [because] Stringham

had not [the paper] then in any kind of form" (Cooke and Rickey, 39).

Stringham's method of visualizing the folding up of three-dimensional sections, or slices, to make four-dimensional figures extends the mechanical drawing techniques of his time. The folding visualization is easier to manage with figures made up of acute angles: the sharp-pointed "summits" of tetrahedra and octahedra, and the stellated versions that Stringham also drew for his illustration plates. It is harder to imagine cubic cells folding together at a point without distortion. Perhaps for this reason, Stringham seemed less at ease with the hypercube, which in some ways is the most logical of the four-dimensional solids because it is the easiest to imagine stacked into a Cartesian grid. He did draw the hypercube in projection, but he de-emphasized this figure in favor of the other figures. With his main efforts devoted to the exploded drawings of the three-dimensional covering cells, Stringham's paper stops short of the projection model. The notion that in projection several spaces would be in the same place at the same time was alien to his thinking. In fact, such a phenomenon would be seen as evidence of error. As dazzling as it was at the time, Stringham's taste for the solid assembly of parts was quite distinct from the modern taste for superimposition, multiplicity, and paradox.

On 7 July 1882, the German mathematician Victor Schlegel (1843–1905) presented a paper, "Quelque théorèmes de géométrie à n dimensions" (Some Theorems in n-Dimensional Geometry) to the Société Mathématique de France, which was published later that year in the society's *Bulletin*. (Dutch mathematician Pieter Hendrick Schoute also presented a paper at this meeting.) The only reference cited by Schlegel was the Stringham work of 1880, but Schlegel presented a systematic discussion of the four-dimensional polytopes as projections, a topic barely mentioned by Stringham. Schlegel's 1872 text *System der Räumlehre* (System of Spatial Theory) had demonstrated a

thorough understanding of projective geometry, and he was prepared to apply this discipline to four dimensions when the idea was introduced to him by Stringham's paper. Schlegel, yet another outsider, did far more than any other mathematician to establish the projection model. Although Schlegel received his doctorate from Leipzig—the prestigious crossroads for so many involved with this story—in 1881, when he was thirty-eight, he spent much of his career, both before and after earning his doctorate, as a teacher in vocational schools and gymnasiums, teaching mathematics and mechanical drawing.

Schlegel's choice of projection for a better representation of the four-dimensional figures is the origin of the more familiar Schlegel diagrams of three-dimensional forms that show all the faces of a polyhedron contained in a single face (for example, the look of a glass box to one pressing one's nose against a side). For the hypercube, "the most convenient is the following: one constructs a cube inside another, such that the faces of one are parallel (situées vis-à-vis) and one joins the vertices of one to the corresponding vertices of the other" (Schlegel 1882, 194). This is the hypercube drawn in four-dimensional perspective; there are four vanishing points (fig. 1.10). Schlegel does not say if such a perspective projection was original, nor does he indicate that the image was used elsewhere. Indeed, Schlegel chose an unusual viewpoint; he drew the hypercube from the point of view of one looking down from a corner. The purpose of such a drawing was to show that four lines of sight exist, one along each edge of the hypercube. Schlegel noticed that these lines of sight enclose a "pentaédroïde," or 5-cell, the four-dimensional simplex, thus demonstrating that the 5-cell has the same relation to the hypercube as the tetrahedron has to the cube. This insight led Schlegel to a general method for constructing the projection models of all the polytopes.

Only two years after Schlegel's perspective drawings of four-dimensional figures appeared in France, Schlegel built sculptural models of the

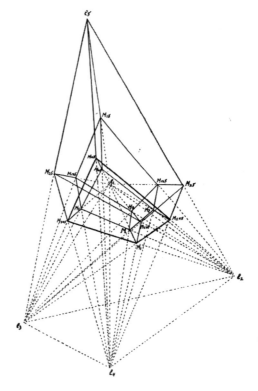

Fig. 1.10. Schlegel's 1882 drawing of a hypercube in perspective with four vanishing points.

polytopes and exhibited them in Halle, Germany. These models, made of thin metal rods and silk thread, were soon incorporated into the lively industry of mathematical model catalog sales from the late 1880s until at least the third decade of the twentieth century. Walter Dyck's catalog for an 1892 science museum exhibition in Munich lists metal wire and silk thread editions of the "projection models of the regular four-dimensional figures of Dr. V. Schlegel" as well as a projection model of the four-dimensional prism (fig. 1.11). Also listed were cardboard models of the interiors of the 120-cell and the 600-cell. Schlegel's models were sold through Brill, a mail-order house specializing in plaster casts of functions designed by mathematicians and manufactured to exacting standards. Included with any order of Schlegel's

143 **Projectionsmodell des vierdimensionalen vierseitigen Prisma's und seine Zerlegung in vier inhaltsgleiche Fünfzelle.** Von **V. Schlegel** in Hagen i. W. Verlag **L. Brill**, Darmstadt.
Specialkatalog 202 (pag. *33* u. *88*.)
Vergl. *Schlegel*: Sur un théorème de géométrie à quatre dimensions. C. r. de l'Association franç. pour l'avanc. des Sciences 1885, sowie die dem Modell beigegebene Note.

Fig. 1.11. A page from the Dyck 1892 exhibition catalog that listed Schlegel four-dimensional models in metal wire and thread, as well as cardboard. Some of the cardboard models are illustrated.

Fig. 1.12. The Altgeld collection of Brill models of four-dimensional figures in the mathematics department of the University of Illinois at Urbana-Champaign. These models were purchased in the 1920s.

models was a pamphlet by him explaining four-dimensional projection. For the equivalent of a few hundred dollars, anyone could purchase a large collection of mathematical models, including these four-dimensional projections, and many still exist in dusty cabinets of university mathematics departments in Europe and the United States (fig. 1.12). The Martin Shilling catalogs of 1903 and 1911 continued to offer these models, and by 1914, G. Bell and Sons also published a catalog selling the "Projections of the Six Regular Four-Dimensioned Solids," no doubt copies from the Schlegel prototypes. During the last decades of his life, Schlegel published papers on his four-dimensional projections in German, French, English, and Polish, and he further established the presence of the projection model in the mathematics community by giving presentations from Chicago to Palermo.

By 1885, a different study of four-dimensional figures was also under way, and again Stringham and Story were at the helm. This new study investigated the mysterious but informative properties of rotations of four-dimensional figures; it was not duplicated or fully appreciated until four-dimensional figures were examined with graphics computers seventy-five years later. For example, if a figure of an open three-dimensional cube is drawn on a page and that page is rotated, then not much information is given to the viewer: it cannot be determined with certainty whether the figure is really a cube or merely a complex concentric two-dimensional pattern, and rotating the paper adds no information (fig. 1.13). If the figure on the page is a shadow of the three-dimensional cube, however, and this cube is rotated in three-dimensional space, then the changing shadow reveals the figure on the page to be a rigid three-dimensional cube. Lines of constant length grow or shrink, fixed planes open or collapse even to the point of being hidden behind lines, and lines known to be mutually perpendicular may lie between two other lines on the page. Amid all this paradoxical informa-

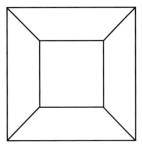

Fig. 1.13. Either a projection of a cube or a drawing of nested squares and trapezoids. Rotating the book does not resolve which description is the case.

tion, the fixed rigid cube is clearly present. Rotating the cube in its own space and then projecting it is thus vastly more informative than rotating the projection itself (by turning the piece of paper on which it was drawn).

At the American Association for the Advancement of Science meeting in Philadelphia in September 1884, Stringham presented a paper entitled "On the Rotation of a Rigid System in a Space of Four Dimensions." The paper used *quaternions*—a higher-dimensional algebraic system popular in England at the time—to define four-dimensional rotation where two of the four coordinates (of a vertex of a hypercube, for example) change and the two others remain the same. Moreover, Stringham proved that the quaternion operation can always be resolved into an easier and more familiar matrix multiplication of vectors, in analogy with three-dimensional rotation.

In 1889, William Story moved from Johns Hopkins to Clark University in Worcester, Massachusetts, to build there the best mathematics department in the United States at that time. One of Story's students, in an informal tutorial like the one including Stringham, was the polymath Thomas Proctor Hall, most notable here for his study of "rotation about a plane" (fig. 1.14).

T. P. Hall, as he was later known, was a glutton for learning.[1] Born in Ontario in 1858, Hall graduated from Woodstock College before earning a bachelor's degree in chemistry from the University

of Toronto, where he taught for two years. He returned to Woodstock College, got married, and completed a non-residence master's degree and doctorate in chemistry from the Illinois Wesleyan University, all by the time he was thirty. Hall then moved to Clark University to study physics with Albert A. Michelson, famous for his studies of the speed of light. He did finish a doctoral thesis in physics—on the boring topic of "New Methods of Measuring the Surface-Tension of Liquids"—but soon fell under the spell of Story and four-dimensional geometry. After leaving Clark, Hall taught for several years before attending medical school at the National Medical College in Chicago, where he received his M.D. in 1902. Hall became a leading proponent for the use of X-rays in medicine and was an editor of the *American X-Ray Magazine*. He finally settled in Vancouver in 1905, and there he taught at the University of British Columbia and practiced medicine until the end of his life in 1931. Hall was a founding member of the Vancouver Institute (1916) and was for a time president of the British Columbia Academy of Science.[2]

Hall's "The Projection of Fourfold Figures upon a Three-Flat" (1893) began with a review of Stringham's paper and the boilerplate combinatoric description of higher-dimensional figures (in this case, analogs of the tetrahedron, cube, and octahedron), and then took up the new problem of projecting these to an $n-1$ dimensional surface. Hall defined a coordinate system of the object to be projected, and another one of the surface onto which the projection is made. He then considered when various axes of these two systems are either parallel, inclined, or perpendicular to each other—how the object is oriented to the surface of projection. The results are three drawings of the tessaract (hypercube) very much like the computer projections of hypercubes of the present day: isometric projections where cells are hidden behind planes that are hidden behind lines (fig. 1.15A), cells are revealed but pressed flat into two dimensions (fig. 1.15B), and a hypercube is fully revealed but aligned to a long diagonal so that dis-

Fig. 1.14. Members of the mathematics and physics departments at Clark University in 1893. Hall is standing in the back, fourth from left. Story is standing next to the table on which several Brill plaster models are displayed. Used by permission of Clark University Archives.

tant vertices appear joined (fig. 1.15C). Hall could visualize such various manifestations of the hypercube because he had a technique to rotate the hypercube before it was projected. Hall addressed four-dimensional rotation in language very clear and very similar to that used today: "The only rotation possible in a plane is rotation about a point. In three-fold space rotation about a point is also rotation about a line. Rotation is essentially motion in a plane, and when another dimension is added to the rotating body, another dimension is added also to the axis of rotation. In four-fold space, accordingly, every rotation takes place about a fixed axial plane. Rotation implies the motion of only two rectangular axes. All other axes perpendicular to these are not affected by it. . . . The meaning of rotation about a plane becomes clearer when we consider its projection" (187).

Hall then described the three-dimensional models he has made to demonstrate the features of planar rotation: "I have constructed such a model to show the changes of [fig. 1.15C] into [fig. 1.15B], and conversely, as the tessaract is rotated." This model used "hinge-joints," and "one of the four diagonals in [fig. 1.15C] is made in two parts which telescope." As described, this is an astounding model, one that actualized some of the unanticipated properties of four-dimensional rotation. It is a great feat of higher-dimensional visualization that Hall did this without the aid of computers.

In his Third Annual Report of the President to the Board of Trustees, April 1893, Clark University president G. S. Hall (no relation) described the activities of "Dr. Hall, fellow in physics. . . . Dr. Hall also constructed a model to show the changes that take place in the projected cube-faces when an

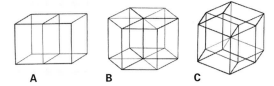

Fig. 1.15. Three drawings from Hall's 1893 publication describing how the hypercube transforms as it is rotated in four-dimensional space.

octa-tesseract is rotated, and a series of spun glass models of the projections of the penta-tesseract and octa-tesseract in various positions; the latter two series were presented to the University and are preserved in the collection of mathematical models." Later in the same document, President Hall listed all of the university's four-dimensional models: four Brill models—the 5-cell, 8-cell, 16-cell, and 24-cell—along with seven spun glass models by T. P. Hall that "illustrated rotations."

Sadly, Hall's models can no longer be found. After I alerted Clark University archivist Mott Linn to their importance, he searched the Clark collections and closets, to no avail. However, there is an interesting photograph that might include them (fig. 1.16). In the summer of 1891, Story bought many models from the Brill catalogs for the math department; his requisitions are in the Clark University Archives (total expenditures, $251.50). These were then placed in a case and photographed in 1893. On the bottom shelf of the case, one can clearly see several skeletal models: a cube in a cube and a tetrahedra in a tetrahedra, models of four-dimensional projections of the hypercube and 4-simplex, respectively. These look more like Schlegel's metal rod and string models sold by Brill than the work of Hall, whose preferred method for creating models was glass lampwork. Behind, there is another model, more complicated and hard to distinguish, probably a Brill model of the 24-cell, but possibly one of Hall's models "to show the changes."

In the same 1893 report, the university president reported on the activities of Story and de-

scribed in detail the great work that Story would soon complete entitled *Hyperspace and Non-Euclidean Geometry*. Story never did write the book; a brief essay of the same name appeared in 1897 as an article in the short-lived Clark journal *The Mathematical Review* (three issues only) and as a pamphlet reprint. Once again, it seems as though wherever in the United States there was an interest in four-dimensional geometry, William Story was there in the wings, prompting the actors, but he himself never took center stage.

Simon Newcomb (1835–1909) was a professor of mathematics at Johns Hopkins and editor of its *American Journal of Mathematics* in the mid-1880s, just after Stringham left for Berkeley but while Story was still at Hopkins. Newcomb was interested in many subjects. After taking his degree from Harvard, Newcomb began work for the navy as a "computer" (doing planetary computations) and continued a relationship with the U.S. Naval Observatory until his retirement in 1897. Most of his published papers and books are on the orbits of planets in our solar system. But he also wrote books on economics, fiction, at least two papers on four-dimensional geometry, and essays and articles for popular magazines, including an unfortunate article in a 22 October 1903 issue of the *Independent Magazine* called "The Outlook for the Flying Machine," which was very skeptical about the practicality and ultimate use of such heavier-than-air devices.[3] Though Newcomb was wrong about the airplane, his planetary astronomy was sound and universally adopted at the time, and his contributions to four-dimensional geometry are influential. Newcomb saw beyond the four-dimensional polytopes and worked with the idea of four-dimensional space.

It was Newcomb, at the height of his prestige, who was asked to assess the new geometries at the "Presidential Address Delivered before the American Mathematical Society at Its Fourth Annual Meeting," on 29 December 1897. The address, entitled "The Philosophy of Hyperspace,"

Surfaces of Constant Curvature. Twisted Curves.
Minimal Surfaces. Geometric Representation
of Functions. Regular Figures.

Fig. 1.16. The Clark University collection of Brill models, photographed in 1893. The four-dimensional models are shown in the enlarged detail. Used by permission of Clark University Archives.

was published in the society's *Bulletin* and reprinted in *Science* magazine. Newcomb believed both four-dimensional and non-Euclidean geometry to be part of "hyperspace," and he also considered the prospect that both are accurate descriptions of physical space. Newcomb first stated that four-dimensional geometry is mathematically true, meaning that the proposition of a fourth perpendicular can be added to geometry and lead to a self-consistent, logical mathematics. He then reviewed the powers of "a man capable of

such a motion" through the fourth dimension: to escape from a locked cell, and to turn left-handed pyramids into right-handed pyramids. He was pessimistic about the possibility of observing the fourth dimension directly but denied that a lack of observation precluded the "objective fact" of a parallel universe. Remarkably, given his skepticism about mechanical flight, Newcomb would not reject the notion that this alternative world is a "spirit" world. "The intrusion of spirits from without into our world is a favorite idea among primi-

tive men, but tends to die out with enlightenment and civilization. Yet there is nothing self-contradictory or illogical in the supposition." But, Newcomb continued, whether "spiritual" or not,"our conclusion is that space of four dimensions, with its resulting possibility of an infinite number of universes alongside our own, is a perfectly legitimate mathematical hypothesis. We cannot say whether this conception does or does not correspond to any objective reality" (1898, 190). Although there was no proof that any physics took place in four-dimensional space, Newcomb was intrigued by the possibility: "There are facts which seem to indicate at least the possibility of molecular motion or change of some sort not expressible in terms of time and three coordinates in space," that is, a vibration in the fourth dimension that may explain radiation or electricity (192). Newcomb also briefly considered the possibility that space is curved and reached a similar conclusion that, though it was beyond our powers of observation to see such curvature, we may not reject the possibility on logical grounds. In general, although Newcomb constantly warned his audience of the need to require rigor and proof before accepting such notions, the impression he gave in this establishment address was that four-dimensional geometry had moved from being a mathematical curiosity to a serious possibility as a description of reality.

Esprit Jouffret's *Mélange de géométrie à quatre dimensions* (Various Topics in the Geometry of Four Dimensions, 1906) and especially his *Traité*

élémentaire de géométrie à quatre dimensions (Elementary Treatise on the Geometry of Four Dimensions, 1903) are important developments in the history of the visualization of four-dimensional geometry. In the introduction to *Traité*, Jouffret listed the names of forty-seven mathematicians from eleven countries who had made contributions to four-dimensional geometry and said that by 15 March 1900, 439 articles were listed in *L'Enseignement mathématique*, testifying to the maturity of the discipline.[4] In particular he discussed Henri Poincaré, quoted Charles Howard Hinton at length, and cited Stringham and Newcomb. Each of Jouffret's texts is about 250 pages and discusses both "polyhedroids" and the nature of four-dimensional space. The *Traité* is especially rich in illustrations, and the arguments and methods of the book can be understood by regarding the illustrations alone. The *Mélange* has a more philosophical introduction and attempts to define points in four-dimensional space as atoms.

By the turn of the century, then, four-dimensional geometry was a fully developed, legitimate mathematical discipline, codified by texts in several languages. From this solid ground, four-dimensional geometry would soon advance to conquer the physics establishment and also the more unexpected realm of fine arts. At the beginning of the new century, authoritative voices presented the subject to a general public eager to know more, a public already tantalized by the fantasies of popularizers.

Fantasies of Four-Dimensional Space

By the end of the nineteenth century, many authors were touting the superiority of thought that was based on an understanding of four-dimensional geometry, and collectively they established in popular culture the once-esoteric mathematical idea of the fourth dimension. Some propagandists and spiritualists even envisioned a kind of Superhero 4-D Man, who could pass through walls and do similar amazing feats. Other texts by serious mathematicians and hyperspace philosophers helped shift the focus of four-dimensional research from investigating the four-dimensional polytopes to include explorations of the properties of four-dimensional space and the observations of viewers situated in that space. Nevertheless, exposition by both groups of authors rested almost exclusively on the slicing metaphor, and so established a misunderstanding of the fourth dimension that persists even today.

Turning the World Inside Out

The inaugural article of the *American Journal of Mathematics* (1878), by Simon Newcomb, was on a subject in four-dimensional geometry—specifically, the article discussed what has come to be known as sphere eversion. Newcomb stated, "If a fourth dimension were added to space, a closed material surface (or shell) could be turned inside out by simple flexure; without either stretching or tearing." To prove this, Newcomb first defined a series of "infinite plane spaces": the slicing model. Newcomb then described his four-dimensional sphere as having an inner surface and an outer surface, each in a different three-dimensional slice of four-dimensional space, even though the sphere is imagined to be infinitely thin. All the points in each "plane space" are equidistant to a series of points in four-dimensional space. (This is the key insight and one that is hard to imagine in four-dimensional space, but it is somewhat like the proposition that all the points in a line are equidistant to a plane lying flat below the line.) Consequently, it is possible to rotate the sphere, or shell, 180 degrees in this direction in such a way that the inside is now the outside, and since the radius of the sphere would not change, no tearing or stretching would occur.

The lower-dimensional analog, which Newcomb identified much later in his essay "The Fairyland of Geometry" (1906), makes this eversion all the more believable. Consider a circle on a page to be like a rubber band lying on a sheet of paper. The rubber band divides the pages into an area inside the circle and an area outside the circle. The rubber band, though thin, clearly has an inner surface—the one facing the center of the circle—and an outer surface—the one facing away from the center. Keeping the circle shape constant, the rubber band can be rolled so that its inside surface

becomes the outside surface. Now imagine that there are pictures drawn on both the inside and outside surfaces of the rubber band. An observer inside the rubber band, before the rotation, would see the pictures on the inside surface of the rubber band, while the pictures on the outside of the band would be hidden. Then after the rolling of the rubber band, the inside observer would see the pictures drawn on the outside of the rubber band. The opposite is true for the outside observer: he or she could no more see the pictures on the inside of the rubber band, before it was rolled, than one could see the internal organs of a human without the aid of an X-ray machine. This rolling that allows the inside to be seen outside and vice versa is possible because the rubber band (really a three-dimensional object itself) lies in a three-dimensional space and can be rotated through the third dimension. Such a rotation does not stretch or tear the rubber band because the radius of the rubber band circle has not been affected by the rolling. Of course, spinning the page on which the rubber band sits does not turn the rubber band inside out. It is only because the rubber band has another degree of freedom (another dimension in which to rotate) that the effect can take place.

We can also imagine that the observer in the center of the rubber band circle could fly off the page in a 180-degree arc and land on the page outside the rubber band circle. The change in perception would be the same as a rolling of the rubber band: what was hidden by the surface is now in plain view. These are exactly the type of phenomena that so captured the imagination of hyperspace philosophers at the end of the nineteenth century, when sphere eversion provided proof in the popular imagination of magical feats possible to those with access to the fourth dimension.

A God's-Eye View

Linda Henderson has traced the history of using a two-dimensional being observing three-dimensional space as an analog of our attempts to

visualize the fourth dimension. In *The Fourth Dimension and Non-Euclidean Geometry in Modern Art* (1983), she cites many authors who have used this device: Carl Friedrich Gauss by the 1820s, Gustav Theodor Fechner in 1846, Charles L. Dodgson in 1865, G. F. Rodwell in a May 1873 issue of *Nature,* and Hermann von Helmholtz's lectures and many publications beginning in 1876. Perhaps the best-known example, however, is the English clergyman, educator, and Shakespeare scholar Edwin Abbott Abbott and his immensely popular book *Flatland* (1884), a novel set in a society that was literally two-dimensional.

Abbott had many agendas for his short novel. His main goal was to satirize the social structure of the Victorian age. In Abbott's two-dimensional country, women have the lowest status, as they have little or no intelligence, imagination, or memory but possess a violent temperament. Since they are just lines, and therefore all point, by law each must "in any public place [sway] her back from right to left" to avoid the lethal poking of anyone: "The rhythmical and, if I may say so, well-modulated undulation of the back in our ladies of Circular rank is envied and imitated by the wife of a common Equilateral" (15). Indeed, rank, class, and class struggle fill most of the book. There is a rigid stratification of men depending on how many sides they have as polygons. It is a "Law of Nature" that sons gain a side on their father, but this law does not apply to "Tradesmen, still less often to Soldiers, and to the Workmen; who indeed can hardly be said to deserve the name of human Figures." Though it is possible for children to jump a whole rank in exceptional cases, the game is fixed so that only token advances can be made, "for all the higher classes are well aware that these rare phenomena, while they do little or nothing to vulgarize their own privileges, serve as a most useful barrier against revolution from below" (10). Language is important in *Flatland,* and errors of tact or manners can have disastrous effect on status, some lasting for five generations. Deviancy and irregularity, for example as to the

Fig. 2.1. Abbott's drawing of the sphere's visit to Flatland.

length of sides, can be punished by death. And during the Color Revolution, a renaissance when art flourished and the rigidity of society relaxed to allow for a more open culture, the resulting degradation of the "intellectual arts" and the confusion as to status so alarmed the populace that they were only too happy to have the Priests and the Aristocracy crush the Colorists and outlaw color altogether.

Though remembered now as an introduction to four-dimensional geometry, *Flatland* did not address the topic until the last quarter of the book. His narrator, A. Square, has an encounter with the Monarch of Lineland, and A. Square explains to his readers how impossible it is to communicate to this intelligent but limited monarch what it means to inhabit a plane. Next, A. Square encounters a sphere from Spaceland, who has just the same problem explaining his three-dimensional existence to the two-dimensional A. Square (fig. 2.1). The sphere offers four proofs to A. Square that he is from another dimension, and these proofs would be repeated throughout the whole of the nineteenth century's four-dimensional exposition. The visitor from the higher dimension can peer into closed houses, change in time yet remain integrally the same, get things from locked cupboards, and touch the insides of things without penetrating the skin. All these are possible because the visitor from the higher dimension has what the Flat-

lander can only imagine to be a God's-eye view of his world. "Behold," says A. Square. "I am become as a God. For wise men in our country say that to see all things, or as they express it, *omnividence*, is the attribute of God alone" (86).

Abbott described the experience of seeing a higher dimension as a *direct experience*, an experience of seeing what otherwise was only a logical inference: "There stood before me, visibly incorporated, all that I had before inferred, conjectured, dreamed." The "Arguments of Analogy" suggested a land of three dimensions, and now A. Square has a direct experience of it. But A. Square's experience need not stop at three: "Take me to that blessed Region where I in Thought shall see the insides of all solid things. There, before my ravished eye, a Cube moving in some altogether new direction, but strictly according to Analogy, so as to make every particle of his interior pass through a new kind of Space, with a wake of its own—shall create a still more perfect perfection than himself. . . . In that blessed region of Four Dimensions, shall we linger on the threshold of the Fifth, and not enter therein? Ah, no! Let us rather resolve that our ambition shall soar with our corporal assent. Then, yielding to our intellectual onset, the gates of the Sixth Dimension shall fly open; after that a Seventh, and then an Eighth" (96).

Square's yearnings for ever-higher dimen-

sions are too much for his spherical guide, however. A. Square is returned to Flatland, and Abbott returns to the theme of intolerance. We find out that A. Square's visitor is not the first of his kind—once a millennium, Flatland is visited by a creature from the third dimension, but this knowledge is suppressed by the authorities, and even the Flatland policemen who witness the visitation are put in prison. The narrator confesses that his vision of figures in a higher dimension has been fleeting and that he cannot recapture the image, yet he too is imprisoned for life, merely for professing such a deviant notion.

Flatland sold out its first printing and was quickly reprinted; it remains in print today. As only one example of how far and how fast the reputation of the book spread, consider the *Brooklyn Daily Eagle* of 27 January 1889 and its story under the headline "The Fourth Dimension, a Curious Theory Which Ends Where It Begins." The newspaper story recounts the observations of inhabitants of Flatland and reconstructs the arguments of analogy, referring the reader to the book by name at the end. Abbott's parable of A. Square was often repeated by other authors in the decades after *Flatland*'s publication. Even today, physicists use *Flatland* to explain spacetime to students and general readers. In large part, the prevalence of the slicing model is due to Abbott's elegant book.

Passing through Walls and Other Magic Tricks

Especially indicative of the cultural milieu for four-dimensional studies in Europe during the last quarter of the nineteenth century are the activities of Leipzig physicist and astronomer Johann Carl Friedrich Zöllner (1834–1882) in London. In Felix Klein's *Developments of Mathematics in the Nineteenth Century*, Klein writes of the origin of Zöllner's fascination with the fourth dimension. After a respectful paragraph enumerating Zöllner's credentials as scientific thinker ("not a few of his physical ideas . . . have been revived today") and

an experimentalist ("he was the first to use the radiometer for quantitative measurement, he observed the protuberances of the sun during an eclipse, etc."), Klein writes,

Shortly before, I had rather incidentally given Zöllner a purely scientific account of results that I had found on knotted closed space-curves and published in *Volume 9* of the *Math. Annalen*. . . . This result was that the presence of a knot can be considered an essential (i.e., invariant under deformations) property of a closed curve only if one is restricted to move in three-dimensional space; in four-dimensional space a closed curve can be unknotted by deformations. Hence knottedness is no longer a property of *analysis situs* once our considerations have gone beyond the usual space.

Zöllner took up this remark with an enthusiasm that was unintelligible to me. He thought he had a means of experimentally proving the "existence of the fourth dimension" and proposed to [the "well known American Spiritualist" Henry] Slade that the latter should try untying knots of closed cords. Slade took up this suggestion with his usual "we shall try it," and soon afterward carried out the experiment to his satisfaction. It may be mentioned in passing that this experiment made use of a sealed cord: Zöllner had to press on the sealed closing with both his thumbs while Slade put his hand over it. From this experiment Zöllner concluded that there were "mediums," who stand in a close relation to the fourth dimension and possess the power to move objects of our material world back and forth, so that—to our senses—they disappear and reappear!

Here began the great popular mystification, which, in combination with hypnotism, suggestion, religious sectarianism, popular philosophy of nature, etc., soon came to dominate many minds. This domination lasted a long time, and even today its traces are found

everywhere in vaudevilles, movies, and magic shows—and in colloquial speech.

Zöllner's excitement by these things and by the opposition they met may have accelerated his end. He was seized by a feverish activity. In 1882, not yet 50 years old, he was carried off from the midst of his work by an apoplexy. (Klein 1926, 157)

In addition to untying a knot in a cord whose ends were sealed together without touching the cord itself, Slade claimed to have joined solid wooden rings together, transported objects out of closed containers, and written on pages tightly pressed between two slates—all supposedly under scientific conditions. Slade was tried for fraud in London in 1876, but this scandal did little to dampen enthusiasm for the spiritualism of the fourth dimension. Prosecuting attorney George Lewis focused on the claim that Slade had written on a tablet that was facedown on a table. With the help of other conjurers, Lewis showed that this simple magician's trick could be performed with a pencil on the end of a finger, a gimmick table, or a wash that hid the prewritten tablet. A *New York Times* article entitled "Trial of a Trickster" (15 October 1876) quoted Lewis: "The defendants [Slade and his assistant] are guilty of acting in concert to produce the impression that this clumsy deception is the result of a supernatural agency." In other words, the complaint against Slade was more one of blasphemy than fraud; it seems that if Slade had only called himself a conjurer rather than a spiritualist he could have avoided the whole mess. But of course there was more money in spiritualism.

Zöllner came to Slade's defense, organizing a party of distinguished physicists, including William Crookes, J. J. Thompson, and Lord Rayleigh. Reasoning by analogy, as later examined in the work of Abbott, the physicists argued that such feats, impossible in three dimensions, would be commonplace to those with access to the fourth spatial dimension. After all, one can reach into a circle drawn on a page and remove a triangular sheet from the interior to read, write upon, or place into another circle. That Slade could not repeat his result under more controlled conditions by no means settled the matter. Indeed, the *New York Times* of 16 November 1880 gushed, "The world is under enormous obligation of Prof. ZOLLNER for having thus lucidly explained the wonderful power which Mr. SLADE has of making large and small objects of furniture totally disappear. The theory of the fourth dimension of space makes what is apparently inexplicable in Mr. SLADE's performances as clear as noonday. There is no Spiritualism, properly so called, about it. There is no foolishness in ZOLLNER and no trickery in SLADE. That eminent medium has access to the fourth dimension of space, and any man who is thus favored can, as a matter of course, do all sorts of things."

As it turned out, Slade beat the rap of conspiracy to commit fraud. There is some confusion about the resolution of the case in newspaper reports, but the *Brooklyn Daily Eagle* of 14 November 1876 reprinted and confirmed reports in the London *Times* that "the defendants have been acquitted of conspiracy to obtain money by false pretenses. . . . Slade, the principal defendant, has been convicted under the Vagrancy Act, and has been sentenced to three months imprisonment, with hard labor." It seems that convicting the fourth dimension was too much of a stretch, and soon after that even the vagrancy conviction was overturned on a technicality.

Nor did the unpleasantness in London do much to cramp Slade's style. As reported in the *New York Times* of 27 December 1880, when Slade returned to the United States, he showed no sign of humiliation; to the contrary, "those who imagined they would behold a gentleman of the patriarchal stamp were astonished when they gazed upon a figure such as is often seen after dinner on a fine afternoon in front of the Fifth-Avenue Hotel. Sporting men would recognize in him a striking resemblance to one of the proprietors of a garden

in Sixth-Avenue. Mr. Slade parts his dark glossy hair in the middle, and wears a heavy black mustache. His clothes are of the latest cut; he has a Piccadilly collar, a heavy gold watch-chain with a massive charm, and a red and blue silk handkerchief peeps from a breast pocket. He has a winning smile, and might be called handsome." Even the relatively sober physicist and hyperspace philosopher Charles Howard Hinton was caught up in the excitement of super feats. In 1884 he agreed that "a being, able to move in four dimensions, could get out of a closed box without going through the sides, for he could move off in the fourth dimension, and then move about, so that when he came back he would be outside the box" (Rucker 1980, 19).

It is no surprise, then, that *The Fourth Dimension Simply Explained* (1910), a selection of essays submitted to *Scientific American* in response to their 1909 contest of the same name, is filled with such magic tricks, especially the untying of knots by passing them through the fourth dimension. The 245 contest entries were judged, and the book compiled a year later, by Henry Parker Manning, a distinguished mathematician of four-dimensional geometry at Brown University. Unlike Zöllner, Manning did not say that such things happen, only that mathematically speaking such things could happen if one had access to a fourth spatial dimension. In his introduction to the book, he listed the capabilities: "A form being changeable into its symmetrical by mere rotation [for example, a left-handed spiral into a right-handed spiral]; the plane as an axis of rotation, and the possibility that two complete planes may have only a point in common; the possibility that a flexible sphere may be turned inside out without tearing, that an object may be passed out of a closed box or room without penetrating the walls, that a knot in a cord may be untied without moving the ends of the cord, and that the links of a chain may be separated unbroken" (15–16).

Manning suggested that, if such things are too difficult to imagine, we should fall back on either an algebraic notion of four dimensions (that they are merely four unknowns in an equation) or the notion that geometry makes sense even if point, line, and plane are purely abstract concepts in logical relation to one another, rather than representations of physical things. But he did not really mean it, as proved by his textbook *Geometry of Four Dimensions* (1914). Complete with diagrams, Manning's textbook treated the fourth dimension at the same level of concreteness as any text of three-dimensional, synthetic geometry. Still, for Manning, four-dimensional experience was a matter of slicing. In the introduction to *The Fourth Dimension Simply Explained,* he discussed the already familiar Flatland analogy and concluded that for us to "imagine such pictures" we would see a series of three-dimensional objects stacked in a series of spaces analogous to a series of planes in three-dimensional space.

Manning took pains to correct mathematical errors in the selected essays; as a math professor he wanted right answers only. As a result, perhaps, the selected essays are largely repetitions of the few mathematical facts Manning cites in the introduction. But what about those two-hundred-plus essays that were rejected? With the advantages of hindsight, more speculative essays could have merit, and at any rate a broader view might be had of what the fourth dimension meant to people around the world at that time.

One essay in particular deserves attention, not because it won or deserved to win but because it is by Claude Bragdon, who later became famous as an artist, designer, and theoretician of four-dimensional geometry. Bragdon generated a hypercube by extruding a cube into a fourth dimension (à la Stringham), detailed its attributes, and defined its cubic sections. He compared slices of a sphere to spherelike slices of a higher-dimensional figure. He quoted Immanuel Kant and Carl Friedrich Gauss, and was ambivalent about the "occult" evidence. He returned again and again to the Flatland analogy, all in a very reasonable, conventional, and surprisingly tame manner.

Capturing Time

Although Manning, in the introduction to *Geometry of Four Dimensions*, stated that the idea of time as the fourth dimension can be traced back to Joseph-Louis Lagrange in his *Theories des fonctions analytiques* (Theories of Analytic Function, 1797), the development of the idea that time could be considered a geometric dimension must be credited to Hinton. Beginning in *Scientific Romances* (1884) and continuing through *The Fourth Dimension* (1904), published just three years before his death at age fifty-seven, Hinton repeatedly turned to the notion that time could be defined as a fourth spatial dimension of geometry, not simply another number necessary to describe a place at a certain time. Furthermore, Hinton discussed the four-dimensional geometric objects made by objects and particles as they exist and move in time, and considered these proto-spacetime objects to be entities in themselves worthy of study.

For example, in *Scientific Romances*, Hinton asked that we consider a thread passing though a sheet of wax. If the thread were perpendicular to the wax, it would leave only a single hole as it passed through, but if it were at an angle and lifted straight up it would make a line in the wax. An observer confined to the wax would see a particle making a path in the wax. A number of such paths could describe a geometric shape, and threads not parallel to each other would make a shape that evolved as the threads passed through. Hinton asked us to imagine that the perceived particles are atoms and that the geometric figures and patterns are collections of atoms—matter. The value of such an understanding is twofold. First, "change and movement seem as if they were all that existed. But the appearance of them would be due merely to the momentary passing through our consciousness of ever existing realities." Second, in addition to the philosophical meaning is the aesthetic "beauty . . . of the ideal completeness of shapes in four dimensions" (Rucker 1980, 16).

Equally graphic and powerful was a drawing

Fig. 2.2. Hinton's 1904 drawing showing that what appears in two dimensions to be the circular path of a moving particle is in three dimensions a sequence of slices of a rigid spiral.

in the 1904 text of a spiral cutting through a plane (fig. 2.2). Often reconstructed without reference to Hinton, this drawing is still taken to be an accurate, complete, and exclusive representation of the idea of spacetime, as defined by physicists. To the Flatlander on the plane, a point or particle appears to be moving in a circle, but to the higher-dimensional viewer, a spiral is being pulled straight through a plane. According to Hinton, the spiral is the complete static model of events, it is the permanent (or invariant) object, it has a greater philosophical reality than the moving point, and thus it should be the object of our consideration. "We shall have in the film a point moving in a circle, [on the film we are only] conscious of its motion, knowing nothing of that real spiral. . . . The reality is of permanent structures stationary, and all the relative motions accounted for by one steady movement of the film as a whole" (Rucker 1980, 124). By training ourselves to see the four-dimensional geometric object, the complete static model, we capture time.

Physics Explained

Trained at Oxford as a physicist as well as a mathematician, Hinton was sure that physics could

prove the existence of the fourth dimension and that in turn the fourth dimension could explain problems in physics that were not well understood. Many of his insights and guesses were prescient, and others may yet turn out to be so. At the very least, they are less-sophisticated versions of current speculation.

In *Scientific Romances,* Hinton noted that liquids spreading out on paper become thinner and thinner until they merge with the flatness of the page. Reasoning by analogy, Hinton claimed that gases are dense in the fourth dimension and that as they expand and sublime, their "thickness" in the fourth dimension is diminished until it is zero and the gas is as fully dispersed as possible in three-dimensional space. Hinton explained, "The cause in this case would have to be sought for in an attractive force, acting with regard to our space as the force of gravity acts with regard to a horizontal plane" (Rucker 1980, 19). The details of a spreading fluid are more complicated than Hinton described, but the important point is that he considered there to be a force acting in the fourth dimension, and only in the fourth dimension, driving material out into the third dimension. As bizarre as this notion may seem, there is now serious speculation that there may be a fourth dimension to space and that gravity may act in the fourth dimension, affecting its presence in the third. In the August 2000 issue of *Scientific American,* physicists Nima Arkani-Hamed, Savas Dimopoulos, and Georgi Dvali report on their speculation that "our universe is confined to a three-dimensional 'membrane' that lies within a higher-dimensional realm," and that the "inexplicable weakness of gravity" relative to the other forces in nature can be explained by postulating that the character of its structure allows it to seep into this fourth spatial dimension and dissipate, whereas the other forces in nature are confined to the three-dimensional slice in which we find ourselves (62). Indeed, these authors even state that this fourth dimension is approximately one millimeter deep,

a thinness that agrees with Hinton's speculations. In general, current string theories explain particles and their interactions by describing the possibilities of vibrations of one-dimensional entities in many dimensions. Hinton was born too soon; this time would have been his glory.

Also in 1884, Hinton speculated on what we now call matter-antimatter annihilation. Hinton noted that the mirror image of a left-turning spiral is a right-turning spiral, and that if physical models (he suggests paper strips wound around pencils) of a left- and right-turning spiral are attached, the result is no turning at all. Hinton then claimed that the turning, not the paper, is the physical entity and that a mirror reflection is the three-dimensional spiral rotated through the fourth dimension (this is a true property of four-dimensional rotation). Thus, if two physical objects, made up essentially of spins in space, were mirror reflections of themselves, they would annihilate each other like "the Kilkenny cats [that] so clawed, scratched, bit, and finally devoured each other, that nothing was left of either of them save the tail" (Rucker 1980, 42).

Finally in *Scientific Romances,* Hinton tackled the all-important ether that resides in the fourth dimension. This "supporting body" is attached to every point in space, but it cannot be deep, otherwise physical effects would be subject to an inverse cube rule rather than the familiar inverse square law that describes the effects of gravity or the attenuation of the intensity of light as it spreads out from its source. Still, the ether is powerful: "The properties and powers of this solid sheet—this film quivering and trembling, yet infinite and solid—are too many to begin to enumerate. The aether is more solid than the vastest mountain chains, yet thinner than a leaf; undestroyed by the fiercest heat of any furnace, for the heat of the furnace is but its shaking and quivering; bearing all the heavenly bodies on it, and conveying their influence to all regions of what we call space." The ether is responsible for the propaga-

tion of light and also the conversion of electricity to magnetism, yet does not absorb or dissipate heat (Rucker 1980, 52).

In later writing, Hinton became increasingly interested in physiological and religious aspects of four-dimensional consciousness, yet he continued his search for the connection between four-dimensional space and problems in contemporary physics. In *A New Era of Thought* (1888), there is an eerie foreshadowing of general relativity: Hinton suggests that the ether has grooves in it that are the paths of particles. "If we make a similar supposition about our aether along which our earth slides," he argued, "we may conceive that the movements of particles of matter to be determined, not by the attraction or repulsion exerted on one another, but to be set in existence by the alterations in the directions of the grooves of the aether along which they are proceeding" (Rucker 1980, 112). General relativity equates gravitational force with a curvature of space to such a degree that it makes as much sense to say that the curvature of space creates matter as it does to say that matter creates curvature.

Finally, in *The Fourth Dimension*, Hinton anticipated aspects of special relativity. He noted that we are in a kind of liquid space where rigid rods can shrink as well as rotate and that those in such a world would not notice that the shrinking had taken place. Two observers in two relativistically different spaces could argue about which of their rigid rods is constant, Hinton explained, but "[there is no standard] to which we could ap-

peal, to say which of the two is right in this argument. . . . Hence distance independent of position is inconceivable" (Rucker 1980, 136). Here, Hinton took his clue from non-Euclidean geometry, but since he believed (contrary to current understanding) that space can be curved only if it is embedded in a fourth Euclidean dimension, discussion of the relativity of length of rigid rods is a function of their being a fourth dimension to space.

In short, the hyperspace philosophers of the nineteenth century reasoned by analogy. A four-dimensional world is to our space as a three-dimensional world is to a Flatlander, that is, viewed in slices: Abbott conceived of viewing four-dimensional objects only by their slices, Hinton's definition of time was based on slices, and conjurers claimed to accomplish magic feats by jumping through the fourth dimension from one slice of space to another. Although such analogies furthered the understanding of four-dimensional phenomena by endorsing the notion of time to be a sequence of spacelike slices and by probing for ways to integrate this new mathematics with physics, the analogies are only part of the toolbox of techniques mathematicians developed in the nineteenth century. Writers outside the mathematical community, even such sophisticated philosophers as Abbott and Hinton, largely ignored projection techniques to study four-dimensional figures or four-dimensional space.

The Fourth Dimension in Painting

At the turn of the twentieth century, European artists looked to the fourth dimension to structure new perceptions. These artists used the new four-dimensional geometry to make their emotional experience of the world whole. There have been valiant attempts to reconstruct, month by month, the intellectual state of play during the early years of cubism. Art historians Josep Palau i Fabre, Linda Henderson, and Pierre Daix have recaptured lost time to a remarkable degree. Their findings can be summarized with two statements about what happened in the first decade of the twentieth century: first, that artists developed a view of the figure as geometry; and second, that culture developed a philosophical and mystical approach to the fourth dimension, *n*-dimensional geometry, and non-Euclidean geometry, an approach so general that no real distinction between these very different geometries was made. What is not fully recognized, however, is that at one propitious moment a more serious and sophisticated engagement with the geometric fourth dimension pushed Pablo Picasso (1881–1973) and his collaborators into the discovery of cubism.

Many people consider Picasso's *Les Demoiselles d'Avignon* (1907; fig. 3.1) to be the first important painting of the twentieth century, but thematically, it should perhaps be considered one of the last important paintings of the nineteenth century, because the themes that it attempts to fuse are of the nineteenth century. First, there is the notion of the exotic other, a noble savage who is made free by living closer to the earth, which has a long tradition in French thought and art. Such a noble savage appeared throughout the nineteenth century, from the work of Eugène Delacroix in the first half of the century through that of Henri Rousseau in the latter half, and the fantasy of the noble savage as a cultural hero gathered further impetus from the examples of African art that French colonialism brought to Paris soon after the turn of the century. Picasso and painter André Derain (1880–1954) were fascinated by African art and visited exhibitions of it in 1907. A second theme in *Les Demoiselles* is Vincent van Gogh's idea of expressionism. In a letter to his brother (from Arles, 8 September 1888) discussing his painting *Night Café* (1888), van Gogh said that he exaggerated color, like Delacroix, and exaggerated line, like Katsushika Hokusai, so that even though the painting is not "true to life," it will be "true to an ardent temperament." Based on van Gogh's premise, expressionist emotion is a greater good than accurate representation. Finally, in *Les Demoiselles* Picasso drew on a dispassionate formalism, as in the work of Paul Cézanne, that looked to nature and the human figure to find a hidden, perfect geometry. There were Cézanne retrospectives in Paris in the years after the painter's death in 1906 that impressed the young Picasso. These

Fig. 3.1. Picasso's *Les Demoiselles d'Avignon* (1907) can be understood as an attempt to reconcile nineteenth-century themes. Oil on canvas, 96 × 92 in. Acquired through the Lille P. Bliss Bequest (333.1939). The Museum of Modern Art, New York. © 2005 Estate of Pablo Picasso/Artists Rights Society (ARS), New York. Digital Image © The Museum of Modern Art/ Licensed by Scala/Art Resources, New York.

Fig. 3.2. Picasso's *Portrait of Ambroise Vollard* (1910) is not fauvist, and there must have been a new inspiration for the work. Oil on canvas, 36⅝ × 26 in. Pushkin Museum of Fine Arts, Moscow. © 2005 Estate of Pablo Picasso/Artists Rights Society (ARS), New York. Photo: Scala/Art Resources, New York.

three themes, the mutually exclusive goals of different nineteenth-century traditions, reverberate in Picasso's early masterpiece: it is an impossible synthesis, the attempt at which energizes the painting but ultimately leaves it unresolved.

But Picasso's *Portrait d'Ambroise Vollard* (fig. 3.2), from the spring of 1910, is different. If nineteenth-century themes are necessary and sufficient to parse *Les Demoiselles d'Avignon,* they are neither for the *Vollard.* Though taken by many at the time to be just another example of fauvism, this is not a generic noble savage, but a specific person—the portrait of the distinguished (and pompous) art dealer Ambroise Vollard, a leading proponent of fauvism and one of Picasso's early supporters. There is an exaggeration of color and line in the portrait, but it does not have an expressionist aim. Rather than an expressionist's "emotion of an ardent temperament," there is a cool analysis of space, although certainly not the cylinders, cubes, and cones that Cézanne would have recognized. According to Palau i Fabre, this painting was very important to Picasso, and he worked on it for months. Detached from his earlier sources, Picasso must have found a new inspiration, a missing link. In 1983 Henderson proposed, and now many agree, that the secret inspiration was four-dimensional geometry. Henderson compared the *Vollard* to a figure in Esprit Jouffret's *Traité élémentaire de géométrie à quatre dimensions* (1903; fig. 3.3). She found in Picasso's faceted and disintegrating figure a close resem-

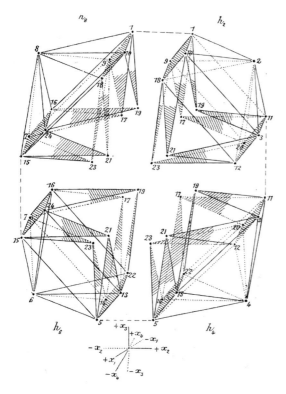

Fig. 3.3. In 1983 Henderson compared the *Vollard* to a drawing from mathematician Esprit Jouffret's *Traité élémentaire de géométrie à quatre dimensions* (1903).

octahedra that do not quite meet. The effect is to open up, or unfold, the component planes of the figure, as if to say that their assembly would conflate too many substructures and render invisible too many parts that need to be distinct. A similar treatment of the pointed shoulders, themselves vertices of the human figure, shows that this is not an improvisation but rather a clear intention on the part of Picasso.

But if Picasso had left it at that, cubism would not have developed into the consciousness-expanding force that it became. Six months later, in the fall of 1910, Picasso's *Portrait of Henry Kahnweiler* (pl. 2) was as big a departure from the vision and philosophy of the *Vollard* as the *Vollard* had been from *Les Demoiselles*. In the *Kahnweiler*, the analysis of the head is completely different. While the *Vollard* is, in effect, an exploded technical drawing of planes, the *Kahnweiler* is composed of multiple transparent, interpenetrating cubes that cannot be brought together. Multiple cubes make up the head rather than a single cube defining it, and even taken all together, the head seems incomplete. The rectilinear cells are again seen in the torso, the still life, and the background, showing the programmatic nature of the spatial analysis in the painting.

One way to understand the difference between the *Vollard* and *Kahnweiler* heads is to consider the now-forgotten pedagogic technique for teaching cubism to painting students: students were instructed first to sculpt a head in clay and then to whack it with a piece of lumber to "find the planes," to facet the modeled clay. The technique could well produce an image like the *Vollard*, but it could never render an image close to the *Kahnweiler*, with its aggressive, distorting manipulation of interpenetrating volumes.

It is fitting that when Picasso made his most important conceptual breakthrough, it was with a portrait of Kahnweiler. Among Picasso's several dealers and patrons at that time, it was Kahnweiler that the young Picasso trusted, Kahnweiler who was Picasso's banker, Kahnweiler who went

blance to Jouffret's illustration, and she admirably documented the full presence of the fourth dimension in the popular imagination in Europe and the United States at the turn of the twentieth century.

Indeed, as a painter looking at the visual evidence I find that Picasso, even then the dominant force in his generation of painters, clearly adopted Jouffret's methods in 1910. Jouffret's drawing shows the parallel projection of the 24-cell with the faces of a few of its octahedral cells exploded out. Jouffret harked back to Stringham's exploded drawings of the 5-cell and the 24-cell, which showed tetrahedral and octahedral cells, respectively, that approach vertices but do not fully connect. In the *Vollard*, Picasso used color and value to emphasize the forehead, which is composed of

into Picasso's studio in his absence to gather Picasso's materials for him and to take away finished work, Kahnweiler to whom Picasso sent his most difficult paintings. Young, intellectual, foreign (German-Jewish), and scrappy, Kahnweiler would make his reputation with the new art of cubism, Vollard's exhibitions of fauvism having already become the establishment. Picasso formed strong bonds with a number of colleagues in his youth, mostly male painters and critics; Kahnweiler seems to have been the only dealer in this select group.

Picasso's new idea of space in the *Kahnweiler* is explained by looking more deeply into Jouffret's text and understanding the methods found in it. Jouffret's name does not surface often in subsequent mathematical literature. He was a synthesizer rather than an original thinker. Nor was Jouffret much of a firebrand; indeed, he was skeptical about the possibility of actually seeing the fourth dimension: "But, if with the help of projection to a plane, or better yet, with two projections to two planes, we can easily form a mental picture of the solid in space, it is impossible to mentally go from the projection of a four-dimensional body to the body itself, or to imagine its shape with any other method. Our mind is incapable of seeing such bodies with their forms and specific positions. None of the material images around us can give us a solid basis or means of comparison." Yet no contemporary undertook the descriptive geometry of four-dimensional figures with the thoroughness that Jouffret did, and the great breadth of illustrations in his text belies his modesty. Jouffret also quoted Hinton's claim that "the whole subject of four-dimensional existence became perfectly clear and easy to impart" and so conceded that the "impossibility [of seeing the fourth dimension] does not exist for everyone" (1903, xiv). The young Picasso was completely swept away by Jouffret's fourth-dimensional explorations.

In *Traité*, Jouffret uses four illustrations of a hypercube to demonstrate four different techniques for visualizing the fourth dimension. Close examination of these illustrations reveals a striking similarity to the techniques used by Picasso in the *Kahnweiler*, specifically the head (fig. 3.4). First, the eight separate three-dimensional cells of the hypercube are blown out; these are the sections, or three-dimensional slices, of the hypercube taken along the coordinate axes (fig. 3.5). The advantage of this method is that the cells are not distorted by perspective projection, and all are revealed. Additionally, the close proximity of their common vertices makes their reassembly in the fourth dimension easier to imagine.

Next is Jouffret's development of the Schoute technique of four-dimensional mechanical drawing (fig. 3.6; see box 1.3). Following Schoute's example, Jouffret imagined the hypercube to be inside a glass box, and the image that is visible through each pane of glass sticks on that pane (like a daguerreotype) as the glass box is unfolded and laid flat. There are six pairings of four axes, labeled $x_1, x_2, x_3,$ and x_4 (some planes have an edge in common, some only a point in common), and so there are six glass planes on the circumscribing box. The advantage of this technique is that it shows the apparent rotation of the figure from different angles. This technique is clearly visible in *Kahnweiler:* the cube of Kahnweiler's face is rotated 45 degrees to the cube of Kahnweiler's head. Such rotation could only have been inspired by Jouffret. Art historian Frederika Adam pointed out a further similarity: Kahnweiler's hair resembles the curved directional arrows in the Jouffret drawing.[1]

Jouffret also uses the projective model (fig. 3.7), where seven cells of the hypercube are shown nested inside an eighth, as in the Schlegel technique.[2] This drawing shows the progression from point to hypercube: a point is moved one unit length to make a line, the line is moved perpendicular to itself to make a square, the square is slid back to make a cube, and finally the cube is extruded into the fourth dimension to make a hypercube. The smaller cube only appears to be inside

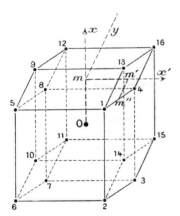

Top left. Fig. 3.7. Jouffret's perspective drawing of a hypercube, in which rear cells are shown to be smaller and thus appear to be inside.

Top right. Fig. 3.5. Jouffret's exploded drawing of the cells of a hypercube.

Middle left. Fig. 3.4. Picasso's *Portrait of Henry Kahnweiler* (1910) is not faceted; rather, it is composed of many interpenetrating cubes (as shown here in a detail of the head). Oil on canvas, 39¾ × 28⅞ in. Gift of Mrs. Gilbert W. Chapman in memory of Charles B. Goodspeed (1948.561). The Art Institute of Chicago. © 2005 Estate of Pablo Picasso/Artists Rights Society (ARS), New York. Photography © The Art Institute of Chicago.

Middle right. Fig. 3.6. Jouffret's mechanical drawing of a hypercube using the glass box approach.

Bottom left. Fig. 3.8. This figure by Jouffret accompanies a discussion of the boundary of a four-dimensional figure, which cannot be a two-dimensional surface.

the larger; it is actually behind it, in the fourth dimension, farther away from the viewer and drawn in four-to-three perspective projection.

Considering Picasso's deepening understanding of Jouffret's work, the move from the *Vollard* head to the *Kahnweiler* head can be seen as a move from the slicing model (exploded and unfolded drawings, such as Stringham and Schoute did) to an interpretation of the Schlegel projection model of four-dimensional space, in which all the cells are projected into the same space at the same time without interfering with one another.

Electrified by the pictures in *Traité,* Picasso must have also read the text and understood the mathematical point made by a fourth illustration: Jouffret's nonperspective projection of a hypercube (fig. 3.8). Even though this is not a perspective projection, the figure is rotated so that no cells are hidden, and the ones behind are noted with dotted lines. Here again (as in fig. 3.7), we can see cubes nested within cubes that are usefully compared to the *Kahnweiler*. But the accompanying text makes a different point that is also relevant to a full understanding of the *Kahnweiler*'s originality. Jouffret discussed the line extending upward from the origin, point O, passing from the inside of the hypercube to the outside of the hypercube. At point *m* it makes a right-angle turn to *m'*. Consider a line making a right angle to a plane; it can sweep around in a circle on that plane in an infinite number of steps and nevertheless remain stuck on that plane. But since it is in hyperspace, the bent part of line *m* can turn in any direction on a sphere and still remain perpendicular to its other segment, and it stays in that four-dimensional space even though the turn is made. Jouffret's argument means that the boundary of the hypercube is composed of three-dimensional cells. No two-dimensional surface is a skin of a four-dimensional cube any more than rods connecting the corners of a cube are a skin that fully encloses that cube. The odd way in which spaces are both inside and outside a four-dimensional figure is the subject of both Jouffret's illustration

and Picasso's portrait of Kahnweiler. For seven hundred years Western painters have been concerned with the skin of objects: how light reflects off the surface, how the surface defines volume. The four-dimensional projection model freed Picasso of the tyranny of the surface, and that eventually allowed him to fully present his emotional reactions to the world.

The *Kahnweiler,* then, brought cubism to its full realization; it was a formulation that, for the first time, fully distinguished cubism from fauvism. The powerful intellectual achievement of lasting influence that started with the *Vollard* and ended with the *Kahnweiler* could only have come from a reconsideration of the Jouffret text, and especially of the images discussed above. Only with the *Kahnweiler* did Picasso fully engage four-dimensional geometry to make it his own. By focusing his attention on the hypercube, he was able to discover the cubes in cubism. Perhaps it should be called hypercubism instead of cubism.

So who taught four-dimensional geometry to Picasso? Science historian Arthur I. Miller has suggested Maurice Princet as a likely source (box 3.1). As detailed by Henderson and Miller, the historical evidence seems conclusive that Princet, with his enthusiasm for, and knowledge of, four-dimensional geometry, was an early member of Picasso's scene. The problem with confirming Princet's influence on Picasso in 1910, however, is twofold. First, several early observers of the scene minimized Princet's importance, and Picasso later downright rejected it: "Il n'en imposait qi'aux cons!" ("He didn't influence fuckall!") Second, and more important, Princet was most present in Picasso's life between 1905 and 1907, the period of *Les Demoiselles d'Avignon* and just before; after 1907, his association with Picasso seems to have disintegrated. Miller defends his argument for Princet's influence by claiming to see elements of four-dimensional geometry in that 1907 work. But as discussed, *Les Demoiselles* was influenced primarily by African art, Cézanne,

Box 3.1 Maurice, Alice, Pablo, and Fernande

The first agent of the encounter between the art world and four-dimensional geometry was mathematician Maurice Princet (1875–1971), who showed Henri Poincaré's writings and, more importantly, Jouffret's *Traité* to Picasso and others. Maurice was six years older than Pablo, and died a man surprisingly little known or sought after by art historians. According to contemporary accounts, Maurice ate, drank, and smoked opium with la bande à Picasso; frequented the Bateau Lavoir and Le Lapin Agile; attended Leo and Gertrude Stein's salons; and because of his great passion for four-dimensional geometry was a welcome visitor to many artists' studios at this critical juncture.

Maurice was brought to this circle, at which he felt at home and where his presence was much appreciated, by Alice Géry (1884–1975), his mistress since her adolescence. In 1933, Gertrude Stein remembered Alice as "rather a madonna like creature, with large lovely eyes and charming hair." Stein added that Alice had "the brutal thumbs that were characteristic of workingmen," and that Stein "always liked Alice. She had a certain wild quality that perhaps had to do with her brutal thumbs and was curiously in accord with her madonna face." Also writing in 1933, Fernande Olivier agreed that Alice was a very pretty, dark brunette, but Fernande (who perhaps had an ax to grind) added that Alice had a "vicious, furious, passionate" mouth. In the spring of 1905, when she was 21, vivacious Alice, in all probability, had an affair with Pablo, who was then 23, and soon Alice brought Maurice to meet her new friend. Early in 1907, Maurice passed his exam to be an actuary, got a job at an insurance company (Stein says in a government office), and distanced himself from his bohemian friends to pursue a career in business. On 30 March 1907, with Pablo acting as an annoyed witness, Maurice married Alice, and moved her to the suburbs. But it did not last long; Maurice had picked the wrong girl. As his mistress, Alice had been there for Maurice when he needed her (when he was sick, for example), but otherwise she amused herself as she saw fit. As Pablo prophesied, "Why marry only to divorce?" Indeed, Alice stuck it out as a bourgeois housewife for only a few months, and by June she was reported to be "très emmerdée" (that is, bored out of her mind) and back with her old friends in Montmartre. During this time, Picasso introduced her to André Derain; it was love at first sight, and their relationship blossomed. By September, Alice left Maurice for good; her divorce became final in 1910 (Stein, 23–24; Daix, 256–57; Olivier, 42).

A friend also of the second-wave cubists known as the Puteaux circle, Maurice knew and gave informal lectures on four-dimensional geometry to Jean Metzinger, Albert Gleizes, Francis Picabia, Marcel Duchamp, Raymond Duchamp-Villon, and others, remaining on the scene after his marriage to Alice ended. But it is unlikely that he remained close to Pablo, whose loyalties were to the young, beautiful, and fun-loving Alice, who like Picasso himself had left home at a young age to make her own way in Paris. According to Stein, when Maurice heard that Alice was having an affair with André, he "tore up Alice's first fur coat which she had gotten for the wedding." No doubt Picasso and Alice were aghast at such drama; after all, Alice had always been faithful only in the Montmartre fashion, yet Maurice was suddenly playing the part of an old, jealous husband? Besides, André was Pablo's colleague at the Kahnweiler Gallery. In fact, André was still more famous than Pablo in 1910, and it would be natural for Pablo to retain his friendship with Alice and André at the expense of his contact with Maurice. Finally, Pablo led an active, even wild, social life in Paris at that time, and he depended on long, quiet, secluded summers out of Paris for periods of work and experimentation. Alice and André were permitted the rare privilege of spending summers with Fernande and Pablo, including the critical summer of 1910 in Cadaqués when Picasso made his creative breakthrough to true cubism. It is likely that Pablo took the Jouffret text with him that summer, but he certainly left Maurice behind.

Fig. 3.9. Alice in Paris, 1910.
Used by permission of
Archives Taillade.

nineteenth-century expressionism, and the idea of the noble savage; it is only years later that the work of Picasso looks anything like the illustrations in the Jouffret text.

It was the long summer of 1910 (late June through mid-September) in Cadaqués, in Picasso's native Spain on the Costa Brava near Barcelona, that fell between the spring of the *Vollard*, with its exploded drawing of the octahedral peaks, and the autumn of the *Kahnweiler*, with its interpenetrating transparent, yet somehow solid, cubes. That summer, Picasso was reported to be moody, fighting with his lover, Fernande Olivier, and preoccupied with his work. He drew frequently but did not produce much in the way

of finished paintings. Alice and André Derain came to visit that summer (fig. 3.9), as did the writer Max Jacob, Picasso's friend and a fourth-dimension enthusiast.

Now consider Picasso's *Seated Woman with a Book* (fig. 3.10; pl. 3). The woman is Alice, the date is 1910, and the book is Jouffret's *Traité*. None of these statements can be proven, but it would make sense if all of them were true. And if they were true, then this small, ignored painting is the Rosetta stone of cubism. The nude woman has a book in her lap, and she seems to be sitting on a balcony overlooking the sea: to the right, a far-off blue horizon line is clear, as is a spatial difference between the sea and the sky. To the left there

Fig. 3.10. Picasso's *Seated Woman with a Book* (ca. 1910. The pyramid of her reading is the most solid feature of the painting. Oil on canvas, 16¼ × 9½ in. © 2005 Estate of Pablo Picasso/Artists Rights Society (ARS), New York. Photography © The Museum of Art, Rhode Island School of Design.

might be a billowing blue drape and the pattern of a balcony's grillwork. Picasso's house in Cadaqués had such a balcony overlooking the sea, and his past lover Alice Derain, the former Madame Princet, was staying just a few doors down. Picasso had a commission to illustrate a text for Max Jacob that summer, and one of the images he used was of a seated woman reading a book, so the

image was on his mind. Alice is described in contemporary accounts as being a great reader—one who borrowed books from Guillaume Apollinaire's library. Stylistically, the painting could very well have been from 1910. There are lines on the painting that are not edges of shapes, but these are not letters or parts of letters as would be the case in subsequent years; rather, they seem to be part of the grillwork. Though various authors have estimated the date of the painting from 1910 to 1914, Picasso was either in the mountains or in Paris, not by the sea, during the years immediately following the heady summer of 1910.

But the best support for such a bold interpretation is in the painting itself: the most solid structure in the painting is the pyramid of consciousness, of concentrated seeing (not normally considered a solid thing at all), originating from the projection point of the woman's eye to the book flat in her lap. This firmly rendered pyramid of reading can be compared to the illustration that accompanies Jouffret's explanation of the projection method (fig. 3.11):

> This fact is not analytical fiction: our diagrams of Chapter VIII give it a solid body and make it tangible. Take one look at the diagrams and you will be able to verify again and again that all the points, straight lines and planes that belong to the same space are projected *on a single straight line* when that space is in a position we define (Chapters III and IV) as *perpendicular* to the plane of projection. Take for instance the following two drawings, which are portions of the drawings of paragraph #46. They both are projections of a *regular icosahedron* whose space E is in that position in the second drawing and near space E in the first one. Already considerably reduced in the first one, the lateral dimensions of the icosahedron disappear entirely in the second one: the projection is reduced to a straight line 2–13 which will collect all the other points of the E Space. As mentioned earlier, an eye located on point 1

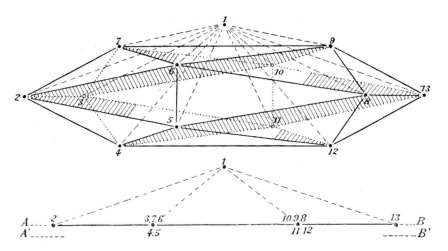

Fig. 3.11. Jouffret explains his projection technique with this introductory drawing. Direct lines of sight hid vertices behind vertices, but oblique lines of sight show the thickness in the fourth dimension.

outside the E Space would see, at the same level, the exterior and the interior of the entire solid; no part of it would hide any other parts because *none of the directions joining any two points of the body is outside the E Space* and therefore cannot coincide with 1–2, 1–3, 1–4 of the imaginary sightline. The difference between the imaginary vision of the icosahedron and our vision of it would be the same as between the perception of a *polygon* by an eye situated in the same plane and our normal perception of it. One now does understand the meaning of the expression we use for lack of a better one: *a depth in the direction of the fourth dimension;* it pertains to the area comprised between the two parallel lines AB, A'B'. It corresponds with the portion of the plane comprised of the two parallel lines following which the two spaces are projected on a plane perpendicular to the lines. The one and the other areas are equal to the shortest distance between the straight lines. (1903, xxix)

Jouffret's illustration is clearer than his explanation. The line at the bottom is a projection of a projection of an icosahedron. Jouffret showed

that, on the one hand, many vertices (for example, those labeled 8, 9, 10, 11, and 12) are all projected to the same point on a line. On the other hand, vertices at the extremities (those viewed at a perspective angle such as numbers 2 and 13) will be displaced by the angle of projection. That amount of displacement will show "the thickness in the direction of the fourth dimension." In contemporary usage, a four-to-three perspective projection reveals all hidden cells, while an isometric projection, especially a four-to-two projection, can hide cells behind cells. The pyramid of projection is a good way to see the fourth dimension, and *Seated Woman with a Book* has such a projection pyramid. It seems probable, therefore, that the painting is of Alice Dérain reading Jouffret's text and visualizing the fourth dimension, and, as often happens in Picasso's work, that it is also a painting about painting. With this interpretation of *Seated Woman with a Book*, Picasso graciously thanks Alice for her help and company in his search for the fourth dimension.

Picasso's private application of four-dimensional geometry to a formal issue in painting

Box 3.2 Gris, Braque, and Other Artists

During the period in which cubism was invented, Juan Gris (1887–1927) and especially George Braque (1882–1963) often worked side by side with Picasso (though not in Cadaqués). Thus it follows that their work should also contain similarities to Jouffret's images. For example, to make his point clearer, Jouffret drew cells as being transparent, using textures and dotted lines to distinguish different layers (fig. 3.12). Such notational devices were not lost on Braque, whose brush marks function similarly, indicating transparent layers in a diagrammatic way. Gris's drawing *Head of a Woman* (1911; fig. 3.13) is squeezed into a square that is the front view of a cube. The head is cut and rotated along a diagonal to bring forward parts originally hidden from view, just as Jouffret did in his example.

Jouffret's *Mélange de géométrie à quatre dimensions* (1906) does not seem to be mentioned by name in the historical accounts, but it is hard to imagine that this text was not also pondered. In it, Jouffret makes a suggestion that surely resonated in the work of Picasso, Braque, and Gris. Jouffret suggests that a "design could be made to illustrate the 'diverse circumstances' [of four-dimensional figures] by using two sheets of paper of different colors on a card, and moving them side by side from one to the other, to show the rotation of the three triangles that become the faces of a tetrahedra" (195). Thus collage, the stylistic innovation most associated with cubism, was perhaps suggested by Jouffret in 1906. (The color-coded units Jouffret suggested have an important precedent in four-dimensional studies: Hinton trained himself to visualize the hypercube by memorizing color-coded sections of the hypercube, using the colors to keep track of mated parts.)

Fig. 3.13. Gris rotates tetrahedral sections of a head in his drawing *Head of a Woman* (1911). Charcoal, 10⅜ × 10⅜ in. Kunstmuseum Basel. Kupferstichkabinett. © 2005 Artists Rights Society (ARS), New York/ADAGP, Paris. Photo: Kunstmuseum Basel.

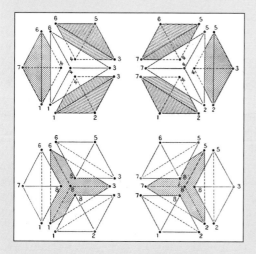

Fig. 3.12. Jouffret's drawings of the changing aspect of the 5-cell, as it is turned in four-dimensional space.

A word should be said for the influence of four-dimensional geometry on other modern artists in the first decade of the twentieth century. Kazimir Malevich, Claude Bragdon, and, on occasion, Marcel Duchamp used flat, geometric shapes to represent single slices of four-dimensional figures. Such a device depends on a title or note to divert the viewer's attention from the simplest, most direct interpretation of the shape to a visual interpolation of the shape as a separate slice out of a whole. One must also bring to such a work a well-informed enthusiasm for four-dimensional geometry, and be willing to help the artist a great deal in the completion of the experience. Other works by Duchamp, such as his *Nude Descending a Staircase, No. 2*, and by the futurist Umberto Boccioni use slices in sequence to represent an object moving in time as a four-dimensional object. But spacetime, as sliced into space-in-time, is a far less sophisticated understanding of four-dimensional geometry. Thus, the cubism of Picasso, Braque, Gris, and others, with its attempt to see multiple objects projected into the same place at the same time, is the most sophisticated of the formal strategies developed during this period.

Fig. 2884.
HALLS AND GALLERIES OF THE CARPENTER ANT.

Fig. 3.14. Cutaway drawings in a 1902 encyclopedia.

would have interested his colleagues (box 3.2), but why should it have such resonance with the public? According to Henderson in her essay "Modernism and Science,"

> Röntgen's publication of his findings at the end of December 1895 triggered the most immediate and widespread reaction to a scientific discovery before the mid-twentieth-century explosion of the first atomic bomb. The ability to see through clothing and flesh to the skeleton offered a startling new view of living beings. X-rays made solid matter transparent, revealing previously invisible forms and suggesting a new, more fluid relationship of those forms to the space around them. That lesson was not lost on Cubist and Futurist painters, who adopted a similar transparency and fluidity in their approach to form. "Who can still believe

in the opacity of bodies?" the Italian Futurist painter Umberto Boccioni queried in his "Technical Manifesto of Futurist Painting" of April 1910. (Henderson, 2005)

With the discovery of X-rays, science proved that visible light, being only one small part of the electromagnetic spectrum, did not reveal all the truth there is to "see," and specifically that there was a world of visual information behind the opaque surface of things.

X-rays give $n-1$ dimensional projection views, and several must be superimposed in the mind's eye to reassemble the full image. For example, an X-ray from the top and another from the side are necessary to examine a broken wrist. Jouffret's projection method is a kind of four-dimensional X-ray: it blasts through a four-dimensional figure with straight lines to capture on a plate (or *carte*) an $n-1$ dimensional section, noting where the vertices of one section coincide with the vertices of other sections taken from different angles. As Jouffret pointed out, without such multiple projections we would have no better mental image of a four-dimensional object than a two-dimensional being would have of a three-dimensional object.

This fascination of looking beyond the surface is also found in the technical drawings of the first decade of the twentieth century. A perusal of a 1902 encyclopedia shows it to be illustrated with cutaway drawings (fig. 3.14) and images from stop-motion photography. The cutaway technique specifically supported the goal of telling more of the truth about objects by seeing beyond the surface. Jouffret assumed his reader's ability to comprehend these devices. If the Jouffret drawings are the specific spores, technical illustrations are the general humus out of which cubism grew.

Before cubism, Western painting relied exclusively on the external appearance of things: how the light on a surface depicted three-dimensional form, how light reflecting off different surfaces

communicated the texture of these surfaces, and how these three-dimensional surfaces blocked out three-dimensional space. But in 1910, Picasso became the champion of a new culture that was told by science that the essence of things lay in structures that skin hid. Picasso's private use of the fourth dimension—specifically the projection model—spoke to so many, then and now, because it accomplished a goal of the whole culture. The projection method of modeling four-dimensional space puts more than one three-dimensional space in the same place at the same time; no two-dimensional surface can encompass this space. Cubism was no vacuous formal improvisation; it rocked Western painting because it offered a new way of seeing space that was considered to be truer to life. Picasso used the technical drawing of four-dimensional geometry to show his audience the reality they knew existed but could not otherwise see.

The Truth

Before Hermann Minkowski gave his famous paper "Space and Time" to the 80th Assembly of German Natural Scientists and Physicians, in Cologne on 21 September 1908, the idea that space could be described by four-dimensional geometry was just that, an idea. After his speech, it was the truth. To see how it became the truth, we must trace how the contemporaneous quandary of the ether was redefined to be a problem in four-dimensional geometry. At the turn of the twentieth century, the nature of the ether (the hypothesized all-pervasive medium that propagated light waves) was the paramount puzzle in science. Like the current mystery of quantum gravity, whoever solved it would be famous forever.

In 1881, American physicist Albert Michelson attempted to clock the speed of the ether (and find its orientation) by splitting a single light beam into two parts bent at right angles to each other (fig. 4.1), then comparing the arrival times of the two parts. Michelson hypothesized that the part that ran parallel with the ether would be affected differently than the part traveling perpendicular to it. The necessarily delicate timing was measured by returning the split beam to a central location after bouncing it off two mirrors and observing the interference pattern when recombined: wave peaks arriving together would be especially bright at a known location, whereas late-arriving peaks would be in phase and be bright at a shifted

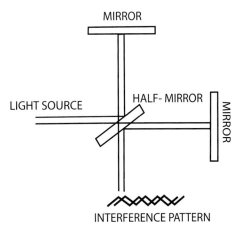

Fig. 4.1. The Michelson-Morley experiment. A beam of light was split by a half-mirror and recombined after passing through two perpendicular paths.

location. It was thought that light traveling with the ether's movement would be boosted in velocity, light traveling against the ether's movement would be retarded by drag, and light traveling across the ether flow would be unaffected.

The experiment was a subtle one. The outward boost and return drag did not completely cancel out, and only the difference between the two effects could be observed. The speed of light compared to the length of paths was so fast that the greatest effect to be measured was only one part in 100 million. Temperature variation of only a hundredth of a degree could create a false effect

three times the expected observation; adding only thirty grams of mass on one of the arms holding the mirror could throw the system out of alignment—in an apparatus weighing tons. Worst of all, Michelson found that stamping one's feet on the ground one hundred meters from the laboratory destroyed any observation. Finally, since the rotation of the earth on its axis and also around the sun added velocity to the apparatus, measurement at different times of day and at different times of year from the same apparatus in exactly the same state had to be compared. Michelson concluded that his first apparatus was not sensitive enough to overcome such experimental noise, and that consequently his inability to find the effect of the ether on the speed of light was inconclusive. Moreover, Nobel Prize–winning Dutch physicist Hendrick Antoon Lorentz had noted that the transverse path would also be affected by the ether flow, just as swimming across the current of a river, while not the same as swimming up or down the river, nevertheless would have an effect on the swimmer. With this consideration, the effect to be observed was calculated to be one part in 200 million.

A second apparatus was built six years later in collaboration with American chemist and physicist Edward Morley. The Michelson-Morley experiment used a massive block of sandstone 1.5 meters square and 35 centimeters deep floating in a trough of mercury to isolate the apparatus. Multiple mirrors lengthened the light paths to 22 meters; longer paths with shorter apparatus arms reduced interference of thermal and other effects. When Michelson could still not find any effect of the ether on the velocity of light, he abandoned the apparatus as a second failure and did not bother repeating the experiments at different times of the year, dejectedly assuming (correctly) that the results would be no different.

In spite of (or unaware of) the experimental difficulties of building a sufficiently sensitive apparatus, English physicist Gerald Francis Fitzgerald and, separately, Lorentz considered the

Michelson-Morley data of 1887 to be valid, and they sought to confirm the ether and to explain the null results with a creative, even an outlandish, theory. First to publish was Lorentz. In 1892–1893 and again in 1895, Lorentz postulated that the apparatus arm moving against the ether was shortened by resistance the same way that the velocity of light would be slowed by drag: slower velocity over a shorter path makes a round trip equal to a faster velocity over a longer path. "One would have to imagine," Lorentz argued, "that the motion of a solid body . . . through the resting aether exerts upon the dimensions of that body an influence which varies according to the orientation of the body with respect to the direction of motion." He continued that such a contraction "is by no means far-fetched, as soon as we assume that molecular forces are also transmitted through the aether. . . . Now, since the form and dimensions of a solid body are ultimately conditioned by the intensity of molecular actions, there cannot fail to be a change of dimension as well" (6).

To Fitzgerald and Lorentz, the null results of 1887 presented a disturbing problem: all other waves were propagated in media—sound waves in air, impact waves in water. It seemed to be the very definition of a wave that it propagated by locally transferring energy from substrate unit to substrate unit. To say that light waves, of all waves, were somehow exempt from this physics seemed ad hoc and unsatisfying. Maintaining the idea of an ether, then, seemed to be an urgent necessity, and the proposition that the space between the molecules of matter contracted, in turn contracting seemingly rigid bars in the direction of their motion like a sponge, would be almost parsimonious. If there must be a medium, it must affect the velocity of light, and therefore the length of the bars must shorten to compensate.[1]

The theory did not seem parsimonious, however, to Henri Poincaré (1854–1912). In 1895, Poincaré began a debate in print with Lorentz. Though generally endorsing aspects of Lorentz's

approach, Poincaré complained that Lorentz's solution was too pat; for one thing, it was by definition unobservable, and thus untestable. It was a hypothesis and was likely forever to remain so. Lorentz's motivation was even more distressing to Poincaré; rather than seeing "contraction" as a way to defend the existence of ether, Poincaré was only too happy to discard the ether, as he philosophically rejected the idea of absolute motion and thus the absolute frame of reference that a stationary ether would be. Moreover, if the ether could act on matter, then matter must be able to act on ether, and another as-yet-undefined force must be hypothesized. Action and reaction, without reference to an absolute frame of reference, meant that universal time was somehow under attack. Although he did not emphasize the relativity of simultaneity, as Einstein did, Poincaré did see that separate frames of reference meant time must be a fourth variable, truly a variable, in the equations relating one frame of reference to another.

For Poincaré, the problem of the Lorentz transformations was better studied in the abstract: how to turn one set of numbers into another set of numbers. He saw that by a mathematical operation with the familiar signature of a rotation (a matrix multiplication with sines and cosines), such a transformation could occur (see appendix). Poincaré then realized that if the space and time coordinates were plotted on a four-dimensional grid, a geometric object could be obtained, and this object would be rigid, unchanged when rotated (that is, when processed by the Lorentz transformations). Thus, when Poincaré described the Lorentz transformations as the rotation of a rigid four-dimensional geometric object around the origin, he invented the invariant, four-dimensional spacetime object—the integral origin of the multiplicity of the transformations. It is hard to conceive of the development of relativity theory without this important intermediate step. As Poincaré later put it, "Everything happens as if time were a fourth dimension of space, and as if

four-dimensional space resulting from the combination of ordinary space and time could rotate not only around an axis of ordinary space in such a way that time were not altered, but around any axis whatever. For the comparison to be mathematically accurate, it would be necessary to assign purely imaginary values to this fourth coordinate of space. The four coordinates of a point in our new space would not be x, y, x and t, but x, y, z and $t\sqrt{-1}$" (1913, 23).

Poincaré's rotation formalism gives the illusion that the rotation is analogous to regular, rigid rotations in three-dimensional space only by converting the time coordinate to a Euclidean coordinate (by multiplying t by the imaginary unit i—the square root of -1). This device obscures the mathematical fact that these Lorentz rotations are different: without imaginary units, the rotations distort as they move. Poincaré did not present his rotations graphically, perhaps because he realized that it would be pushing his analogy of a rigid three-dimensional structure too far.

Albert Einstein (1879–1955) did not mention the Michelson-Morley experiments or Poincaré in his paper "On the Electrodynamics of Moving Bodies" (1905), but he did bring them both up indirectly. There are "asymmetries" in the current formulation of the electrodynamics of moving bodies: "For if the magnet is in motion and the conductor at rest, there arises in the neighborhood of the magnet an electric field with a definite energy, producing a current at the places where parts of the conductor are situated. But if the magnet is stationary and the conductor in motion, no electric field arises in the neighborhood of the magnet. In the conductor, however, we find an . . . electric current of the same path and intensity as those produced by the electric forces in the former case." This was exactly the sort of asymmetry problem that so troubled Poincaré. In addition, there were "unsuccessful attempts to discover any motion of the earth relative to the 'light medium' "—the, by then, very well-known null re-

sults of Michelson-Morley. Taken together, these two anomalies suggest there are "no properties corresponding to absolute rest," and so the ether must go, it now being "superfluous." Instead of the ether, Einstein now presented two postulates: (1) "that the laws of electrodynamics and optics will be valid for all frames of reference for which the equation of mechanics hold good," and (2) "that light is always propagated in empty space with a definite velocity c which is independent of the state of motion of the emitting body" (37–38).

Einstein realized that these two postulates alone (and by 1905 each postulate seemed reasonable) force the notion of local time: "A mathematical description . . . has no physical meaning unless we are quite clear as to what we understand by 'time.' . . . It is essential to have time defined by means of stationary clocks in [each] stationary system." Because it must take some amount of time to compare one local clock with another, there can be no universal "common time" (39).

Two very important results followed immediately in the argument: the "Relativity of Lengths and Times." Einstein instructed his audience to imagine a moving bar sliding along the x-axis of a measuring coordinate system. Measuring the length of the rod means noting the "time" the end points of the rods pass the measuring gates on the x-axis. But by the arguments above, the elapsed time must be different for an observer resting on the x-axis as compared to one riding with the moving bar: "So we see that we cannot attach any *absolute* signification to the concept of simultaneity, but that two events which, when viewed from a system of co-ordinates, are simultaneous, can no longer be looked upon as simultaneous events when envisaged from a system which is in motion relative to that system" (1905, 42). In other words, we cannot measure length except by measuring time, we cannot measure time except by looking at clocks, and time readings are not instantaneous. Thus, length readings cannot be the same for a moving observer and a stationary observer.

Einstein then showed that these distortions

of length are exactly those described by the Fitzgerald-Lorentz contractions. Lorentz and Fitzgerald were right for all the wrong reasons; they correctly computed the contractions, but such contractions occur not due to any resistance of the ether but precisely because there is no ether—no universal frame of reference and no universal time. In addition, Einstein showed that considering time and length as a function of velocity had implications for "electromotive forces" and mass, and that both electrodynamics and classical Newtonian physics must be modified.

Hermann Minkowski put Poincaré's four-dimensional geometric approach together with Einstein's analysis of slowing clocks and changing lengths of measuring rods to construct the geometric model that fully explained special relativity. Minkowski began his 1908 paper "Space and Time" with the claim that he would proceed from mathematical considerations and make purely mathematical deductions, and that when applied to physics these purely mathematical statements would explain the Lorentz transformations and their further development by Einstein. He stated that through this deductive, synthetic method he could present a deeper understanding of the results—in effect, an explanation rather than a mere description. Furthermore, the same mathematical method would better establish the distinction between Newtonian physics and relativity: acceleration, force, mass, charge, and field could all be redefined in this way. And finally, Minkowski claimed for himself an insight that escaped both Lorentz and Einstein: that space itself, as well as time and length measurements, are modified by relativistic velocity. All this is possible, Minkowski claimed, because geometry, the mathematical description of space, was welded to experiment, the empirical description of events in space, in such a profound and mysterious way that he could only begin to marvel at the connection.

Minkowski wished "to show how it might be possible . . . along a purely mathematical line

of thought, to arrive at changed ideas of space and time" (1908, 75). He lamented that physicists had gotten there first ("such a premonition would have been an extraordinary triumph for pure mathematics") but reasoned that "mathematics, though it can display only staircase-wit, has the satisfaction of being wise after the event, and is able, thanks to its happy antecedents, with its senses sharpened by an unhampered outlook to far horizons, to grasp forthwith the far reaching consequences of such a metamorphosis of our concept of nature" (79). All this was possible because of a "pre-established harmony between pure mathematics and physics" (91). Indeed, Minkowski's philosophical musing about the fungible quality of space was as important to the future of physics as his reformulation of the Lorentz transformations.

That reformulation began with a restatement of Einstein's observation that the laws of physics are invariant with respect to uniform motion: "Their form remains unaltered . . . if we change its state of motion, namely, by imparting to it any *uniform translatory motion*" (75, Minkowski's italics). This means that girls playing jacks on the deck of an ocean liner have exactly the same skills, with the same results, as girls playing jacks on the sidewalk at home. Minkowski said the implications of this fact had not been fully realized before. In a two-dimensional spacetime graph, where space is horizontal and time is vertical, a constant uniform motion can be pictured as a slanting time axis: going up the vertical axis, a little later in time, moves one along the distance axis, a little farther away in space. "We may give the time axis whatever direction we choose towards the upper half," Minkowski stated, taking his cue from Poincaré's view of the Lorentz transformations as rotations (77). He had been intensively studying Poincaré just before Einstein's paper was published.

Then Minkowski drew the plot of a curve, a hyperbola, and added the constraint that the rotated time axis, representing uniform motion, can

only be turned such that it intersects a point of this hyperbola. In his drawing, the vertical t-axis and the horizontal x-axis describe the space at rest; slanting the t-axis describes the space in continuous, uniform motion, reaching a maximum rotation as it approaches the speed of light. As the time axis rotates clockwise, it stretches, just as Einstein described (box 4.1).

Then Minkowski delivered his insight: he said that in rotating the time axis, the space axis must also be rotated, but rather than rotated away from the t-axis as in a rigid rotation of a coordinate system implied by Poincaré's Euclidean formulation, it is rotated *toward* the time axis, closing up the space. Tilting the time axis toward the asymptote (the line that represents the speed of light) also tilts the space axis toward the asymptote; space and time are connected in this elastic way. Minkowski then claimed that "neither Einstein nor Lorentz made any attack on the concept of space. . . . Nevertheless, this further step is indispensable for the true understanding of [spacetime]" (83). These changes to "space" are the exact changes seen in the observations of "things" that led to the Lorentz transformations and the interpretations of Einstein.

Minkowski claimed important results from what he sometimes referred to as merely improvements in the mathematical notation of Einstein, Poincaré, and Lorentz, but he never completely articulated the sea change he had brought about. In showing that the geometry of space itself is changed by motion, he showed the way that mathematics and physics are integrated. By moving, a mathematician can change space that was, at that time, a quasiphysical entity. Considering space to be, at the very least, a completely blank screen on which mathematics projects magic lantern images establishes the conceptual capability and procedural model for the warping of space by gravity, as in general relativity, as well as contemporary string theories. It is a great pity that Minkowski died six months after his 1908 presentation, of a ruptured appendix at age forty-four,

Box 4.1 Minkowski's Formulation

The end of the *y*-axis defines a location (point T; fig. 4.2): the speed of light in a specific direction multiplied by a duration. This location can alternatively be defined by the Pythagorean theorem, as the square root of the sum of the squares of the three-dimensional coordinates: $ct = \sqrt{(x^2 + y^2 + z^2)}$. Maintaining this relationship is what requires the folding in of the spatial axis. Minkowski completed the parallelogram under the curve (using vector addition; fig. 4.3) and said that this skewed and modified grid is an exact description of the relativistic space under consideration (fig. 4.4).

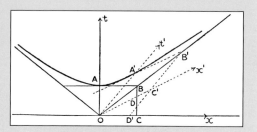

Fig. 4.3. Minkowski's drawing to explain special relativity. As the measurement vector T rotates, it stretches and reaches a maximum length and maximum rotation at 45 degrees, which is the speed of light.

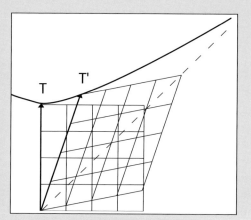

Fig. 4.4. Minkowski's assault on space. The whole coordinate system, all of space, is stretched and squeezed by the processes of special relativity.

Fig. 4.2. The vector T in two different coordinate systems, one a rotation of the other. Poincaré noted that traveling at a constant velocity is equivalent to being in a rotated reference frame. The length of vector T is defined either by the Pythagorean theorem in the stationary coordinate system or by the passage of time in the rotated coordinate system.

unable to see the influence of his thought on our consciousness, and unable to give us a leg up on the conceptual challenges to come.

We have yet to explore the crucial question of what mathematical models Minkowski used to imagine this special space. There are three possibilities: he thought that space was primarily four-dimensional, or non-Euclidean, or projective.

Historian of science Peter Galison argued that the visualization of four-dimensional geometry was the engine of Minkowski's creativity, and that this four-dimensional "world" was only fully developed in his 1908 paper. Galison noted that in this paper Minkowski stated unequivocally that "henceforth space by itself and time by itself are doomed to fade away into mere shadows, and only a kind of union of the two will preserve an independent reality" (75). And Minkowski spoke of spaces, not space: "We should then have in the world no longer *space,* but an infinite number of spaces, analogously as there are in three-dimensional space an infinite number of planes" (79). And again, Minkowski referred to " the everlasting career of the substantial point, . . . a *worldline,* the points of which can be referred unequivocally to the parameter *t.*" In other words, every point in space is really just a location on a line in four-dimensional space, and these locations cannot simply be a moment of time in three-dimensional space. Instead, the four-dimensional nature of the line must be considered. "In my opinion," Minkowski stated, "physical laws might find their most perfect expression as reciprocal relations between these world-lines [the lines that define four-dimensional space]" (76).

Scott Walter, although accepting much of Galison's interpretation, emphasized the non-Euclidean components of Minkowski's argument. Walter, an historian and philosopher of science, based his argument on a lesser known paper by Minkowski, "Das Relativitätsprinzip" (The Relativity Principle), first given as a talk to the Göttingen Mathematical Society on 5 November

1907, and published by Arnold Sommerfeld in 1915, after Minkowski's death. This paper is not included in anthologies, and no English translation could be found, yet it contained not only the first but also in some ways the most mathematically sophisticated derivation of Minkowski's formulation of relativity. Instead of talk about world-lines (which are not mentioned at all), there was this remarkable statement, based on Max Abraham's theory of electromagnetic radiation: "The entire condition of the electromagnetic spectrum in space at any given moment in time can be demonstrated [brought forth] by the behavior of a single four-dimensional vector" (929). The fourth element of this vector is imaginary, which gives the vector the +, +, +, − signature of the Lorentz transformations. Two spaces are described by Abraham's theory: the space that travels with the moving radiation and the rest space of the viewer. Minkowski concluded the all-important first section of his 1907 paper as follows: "The way I transcribed the [Abraham] equation, a mathematical fact became apparent that is related to the Principle of Relativity. . . . Through a purely real linear transformation . . . the orthogonal transformation of four-dimensional space is allowed by [is revealed by] the basic equations of electrotheory without contradiction" (931). The hyperbolic signature of the Lorentz transformations is revealed in the Abraham equation, a seemingly other set of considerations.

The non-Euclidean approach is based on the property of non-Euclidean geometry that objects moved around in such a space may change their shape. For example, in the case of positive curvature, a small triangle on a globe could have its three angles add up to 180 degrees (or just a bit more). But that same triangle when moved and enlarged to include the north pole as a vertex and the equator as a base could have angle sums as high as 270 degrees. As Walter said, "Many mathematicians in Minkowski's audience probably recognized the equations of a pseudo-hypersphere [of negative curvature]. . . . We have the premises

of an explanation for Minkowski's description of the world as being—in a certain sense—a four-dimensional non-Euclidean manifold" (99).

Furthermore, Walter noted that Felix Klein preferred this 1907 formulation. As Klein said, "I liked it best of all," as it contained Minkowski's "innermost mathematical, especially invariant-theoretical thoughts, while in [other works] in order not to assume any previous knowledge he selects the cool, ad hoc discipline of the matrix calculus [that emphasized the four-dimensional approach rather than the non-Euclidean], which though superficially accessible hides its inner workings" (Klein 1926, vol. 2, 74). Klein suggested that, far from being an immature exposition that preceded the sophistication of four-dimensional "world-lines," the 1907 paper was superior. Minkowski's later de-emphasizing of the non-Euclidean aspects in favor of an exclusively four-dimensional exposition, Klein implied, was merely a hook for Minkowski's nontechnical audience. Four-dimensional geometry was part of the popular imagination in a way that non-Euclidean geometry was not. It is reasonable to assume that in the 1908 paper Minkowski was reaching out to his general audience with images, metaphors, even clichés that would at least serve to get his audience beyond the first point—that space and time were reciprocally bound in a four-dimensional system—even at risk to his ultimate insight.

In 1907, Minkowski referred to his new space as both four-dimensional and non-Euclidean. It is likely that projective geometry was also on Minkowski's mind. As his notebook shows, in the summer of 1904 Minkowski reviewed projective and affine geometry and referred to projective geometers Julius Plücker and Felix Klein by name, in preparation for courses to be taught during the next academic year.[2] Walking to his office at the university in Göttingen, Minkowski passed case after case of Brill models. Moreover, as physicist Englebert Schucking explained to me in an interview, mathematicians of Minkowski's time considered all geometry to be fundamentally pro-

jective geometry, and specific types to be subsets of projective geometry derived by different choices of events and structures at infinity. Specifically, I propose that Minkowski used the projection model of higher-dimensional figures to solve two important problems.

The issue presented by Einstein is not exactly the conversion of one set of numbers to another set of numbers but rather how things in one frame of reference are seen by observers in another frame of reference (another state of uniform motion). These two spaces are being slammed together, and the frequent use of the word *projection* suggests that Minkowski thought it was just that: "Since the [relativity] postulate comes to mean that only the four-dimensional world in space and time is given by phenomena, but that the projection in space and in time may still be undertaken with a certain degree of freedom" (1908). Comparisons of our spacetime to their spacetime involve the projecting of our unit vectors (with our four coordinates) onto their unit vectors that are distorted from ours. Furthermore, the distortions described by special reality are the skewed projections of more simple four-dimensional forms; the Lorentz transformations are a way of relating one skewed projection to another. And "we are compelled to admit that it is only in four dimensions that the relations here taken under consideration reveal their inner being in full simplicity, and that on a three dimensional space forced on us *a priori* they cast only a very complicated projection" (Minkowski 1908, 90). As Peter Galison put it, "There is the visual imagery of shadows, projections, and planes that Minkowski transfers from three dimensions to the new, four-dimensional space" (118).

The second of Minkowski's problems to be solved by the projection approach was how to describe the dilation of time mathematically. Time had already been connected to space in seventeenth-century calculus, one of the most successful mathematical systems of all time. But at the beginning of the fourth paragraph of "Space and

Time," Minkowski said, "The concepts, space and time, cause the *x, y, z*-manifold *t* = 0 and its two sides *t* > 0 and *t* < 0 to fall asunder." The verb *auseinanderfallen* can be translated to mean "to fall to pieces," as an argument falls to pieces. In other words, the calculus slicing model is insufficient as a description of events when speeds are a significant percentage of the speed of light. But in a more specific translation, the verb could mean "to split apart," meaning that the continuous manifold is split apart and must be made whole by some other mathematical system. Minkowski encouraged us to reform our thinking and substitute a line, in fact a line of varying length, for a world-point: "a world-line corresponding to a stationary point" (1908, 87). Equating lines with points, especially lines with elastic markers of distance, is a fundamental gambit of projective geometry.

To understand the idea, consider this example. Alice's trips around town (a different Alice, someone who used to be called Observer A but who is now personified by physicists as Alice) can be sliced up into instantaneous sections (*t* = 0, *t* = 1, *t* = −1) of where she will be and how fast she will be traveling at those moments. In relativity theory, however, even if Bob and Alice had perfectly synchronized clocks, it makes no sense for Alice to tell Bob to look out his window at exactly 1:00 p.m. when she will be driving by his house to give him a wave. Only by hearing her whole itinerary will Bob be able to figure out how fast Alice will be traveling for how long, thereby figuring out how slow Alice's clocks will be running relative to his and, thus, when she will *really* pass by, according to his clock. A slice of Alice's itinerary, which makes perfect sense to her, cannot be taken out of her whole trip and given to Bob with the expectation that, by itself, the information will be useful to him (fig. 4.5).

To recapitulate how four-dimensional geometry became the solution to a problem in physics, and thus became a description of objective reality, we must first remember that Michelson and

Fig. 4.5. Alice's trip around town. Alice cannot give the 1 p.m. slice to Bob and expect him to be waiting for her, because their separate histories mean that their separate clocks will not be synchronized.

Morely could not find any evidence of the ether. Lorentz and Fitzgerald suggested that this was because objects contract in the direction they are moving. Poincaré discovered a more satisfying, global solution of rotating the graph of events in four-dimensional space to generate the Lorentz transformations, and in doing so he invented the four-dimensional invariant spacetime object. Einstein postulated that there was no location at absolute rest and that the velocity of light was constant regardless of the location or speed of its emitter, and he concluded as a result that events were only relatively simultaneous. Einstein then showed how this necessitates clocks running slow and rigid bars contracting proportionally to their velocity. Minkowski put Poincaré's four-dimensional geometry together with Einstein's changing clocks and rods to create a geometric vision of relativity. The transformations are revealed when one geometric description of space is projected onto another.

Commentators routinely mention that Minkowski established a four-dimensional matrix of space and time considered together. Although four-dimensional geometry has been given the status of objective reality by Minkowski's work, that is not the same as saying that the rigid slicing model of four-dimensional geometry has been

given objective reality. In fact, Minkowski explicitly rejected the slicing model as being outmoded and discredited; instead he favored a more elastic relationship between space and time in relativistic circumstances. The slicing model of four dimensions comes to culture through Newtonian physics, hyperspace philosophy, and science fiction, not the new relativity physics. If Minkowski referred to the slicing model at all, it was only as a reference for a nontechnical audience. That the slicing model is still fixed in the popular imagination as the only truth about four-dimensional geometry and spacetime is a testament to how powerful the hyperspace philosophers were, and how slow culture as a whole is to change such deep structural intuitions as the nature of space.

Entr'acte

A Very Short Course in Projective Geometry

In artist's perspective, parallel lines converge to a vanishing point, and systems of one, two, or three vanishing-point perspectives were well developed by Renaissance painters. It was German astronomer Johannes Kepler (1571–1630) who first suggested that these vanishing points be considered points at infinity and that such points be included in the geometry handed down by the Greeks. Perhaps only an astronomer could make such a suggestion, as Greek geometry was rooted in land-based problems such as architecture, agricultural fields, and roads; there were no provisions for locations or spaces that one could not imagine measuring oneself. But as even the early students of the new system understood, placing infinite points inside the reach of axioms and theorems changes geometry from a system of measurement to a system of incidence alone: points are incident with lines—a point (every point, even a point at infinity) lies on a line, two points define a line, an intersection of lines defines a point. Points at infinity are points like any other, and since this is the case, there is a problem with giving them number values—for example, in ordering a series of points when the one in the middle is infinity. If there is no number order, then neither specific line segments, distances, angles, nor congruences can be a natural part of this geometry. Yet the implications of this seemingly sparse geometry are elegant and surprisingly rich.

Synthetic Projective Geometry

While writing a book on perspective, Gérard Desargues (1593–1662), an architect from Lyon, also included points at infinity in his geometry, as the meeting points of parallel lines, and discovered what became one of the fundamental theorems of projective geometry: If the vertices of two triangles can be connected with three straight lines, then the triangles are *perspective from a point*. Also, if the three edges of both triangles can be extended so that these extended edges meet on the same line, then the two triangles are said to be *perspective from a line* (fig. 5.1). Desargues's theorem says that these two types of perspectives are dual: if case one is true, then case two is also true. It is a subtle thought, one not immediately obvious, and it generalizes the problem of drawing the distortion of a specific object in perspective to the progressive distortion of an entire class of objects, and furthermore finds a hidden symmetry in that large class of distortions. In other words, think of the two triangles as skewed slices of a triangular prism: any two such skewed slices will have edges that, when extended, meet on a line.

In Desargues's theorem a statement about points (vertices) is exchanged for a statement about lines (edges), and this establishes the basic feature of dualism in projective geometry. Everything one can say about a point, one could instead

As Poncelet discovered, this dualism reverberates up and down the dimensions: points to lines in two-space, points to planes in three-space, points to spaces in four-space.

A *perspectivity* relates a *range* (an initial, arbitrary selection) of points on one line to a range of points on another by drawing a *pencil* (a collection of lines from a point) connecting those respective points—the familiar one-point artist's perspective. A *projectivity* results from a number of perspectivities: for example, two ranges of points on two lines projected from two different points are both projected to the same range of points on a third line. (Or think of a pencil of points bouncing off the target to converge at a second point; fig. 5.2.)

Through such a series of projectivities, a projective line can be projected onto itself: at most, two points remain the same (known as hyperbolic projection), or one point can remain the same (parabolic), or none (elliptical). A projectivity of a line to itself that interchanges two points is said to be an involution: if the projective line is modeled as a circle, this is the equivalent to starting at a different point in the ring and proceeding in a different direction to find the ordered series of the range (fig. 5.3).

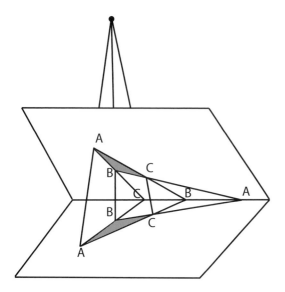

Fig. 5.1. Desargues's theorem. As the fold opens and closes, the two shaded triangles remain projections of each other, and the extensions of their edges still meet on a line. Adapted from Fishback.

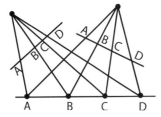

Fig. 5.2. A *projectivity* relates a range of points in multiple projections.

say about a line, and vice versa. In 1822, however, Victor Poncelet claimed this discovery for himself, in his *Traité des propriétés projectives des figures* (Treatise on the Projective Properties of Figures), considered to be the first real book of projective geometry (and largely written during Poncelet's captivity as a prisoner of war in Russia from the Napoleonic War). Poncelet was, in any case, the first to fully develop the idea of projective duality.

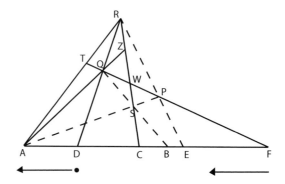

Fig. 5.3. By adding the extra points T, Z, and W, a line can be projected back onto itself in such a way that projectivity ADCF is transformed to DAFC. Adapted from Coxeter 1961.

Analytic Projective Geometry

The *cross ratio* began the analytic study of projective geometry (as opposed to the synthetic treatment of a geometry made up of rulers without scales). Known to Desargues and emphasized and developed by Poncelet, the cross ratio is a number derived from the coordinates of four points on the projective line. If four locations on a projective line are labeled *a*, *b*, *c*, and *d* and the distance between these numbers is *a–c*, *a–d*, and so on, then the cross ratio is defined as follows:

$$\text{cross ratio} = \left(\frac{a - c}{a - d} \times \frac{b - d}{b - c} \right)$$

Because the cross ratio uses numbered coordinates, it might seem to be a system of a measurement, but the remarkable fact is that the cross ratio is the same regardless of the coordinate system used; it is background independent. Indeed, there are two ways to arrange the ratio, and they both work. For either computation, the point (x, y) is the same as the point $n(x, y)$, and the result of the cross ratio is a dimensionless number. Moreover, the cross ratio is preserved under projective transformation.

Karl George Christian von Staudt (1798–1867) is considered by many scholars of the subject to have contributed the most to making projective geometry an independent mathematics. His technique, which he called the *throw*, makes use of the properties of the cross ratio to generate an ordered series of points: these are ordinal points that do not depend on any underlying metric system at all, even a transient and relative one (fig. 5.4). Later work proved that a line generated in this fashion could be considered continuous.

August Möbius (in 1827) and Julius Plücker (in 1830) invented homogeneous coordinates; however, it was Felix Klein who brought the idea to its glory, in 1871. Such a coordinate system maintains the background independence necessary to preserve the cross ratio and also allows

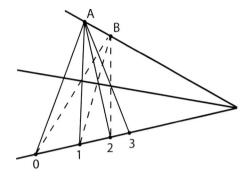

Fig. 5.4. Staudt's *throw* constructs a series of points on a projective line.

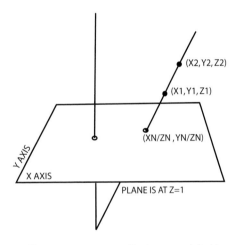

Fig. 5.5. Homogeneous coordinates are related to projection. A projective point is a line in higher-dimensional space. Adapted from Klein 1908.

points at infinity to enter the number system of the coordinates without absurdities. All projective points of a plane are numbered with a triplet of numbers (x, y, z) as long as not all of them are zero; to convert homogeneous coordinates (in this example, a triplet) to ordinary Euclidean coordinates, one would make every $X = X/Z$, and every $Y = Y/Z$ (if Z were 1, for example, then $X = X$ and $Y = Y$; fig. 5.5). More generally, points on a line in three-dimensional space have three coordinates. Since they are on a line, dividing any of the first

two coordinates by the third renders the same two numbers in every case. These two numbers can be thought of as the coordinates on a two-dimensional plane at location 1 in three-space. If point (x, y, z) does have $z = 0$, then it is an ideal point at infinity, but it is treated in the same manner and with the same coordinate system as any other point.

From Projection to Projective

As Klein pointed out, homogeneous coordinates allow for an analytic projective geometry that is even more abstracted from numbering and metrics than is the cross ratio. With homogeneous coordinates, projective geometry becomes a powerful analytic tool, one that is often disassociated in the contemporary geometer's mind from spatial projection. There is, however, always a relation between projective and projection. To give a specific example, the Euclidean point $(3, -2)$ is a point on a plane. If this point were labeled as a projective, then it would have homogeneous coordinates of $(3, -2, 1)$ or $(6, -4, 2)$. A projective point, then, is a (nonprojective) line in a higher dimension. Sometimes mathematicians will projectivize data as a way of reducing a mathematical object to a more manageable number of dimensions while retaining enough useful information for study. The converse tack can be useful as well: systems described by projective homogeneous coordinates can be extended to higher dimensions, where their properties are fully revealed.

The Topology of the Projective Plane

In Klein's *Developments of Mathematics in the Nineteenth Century,* he stated that beginning in 1861 he "at once grasped" that there was a connection between projective geometry and the new non-Euclidean geometries, but he was repeatedly told that "these were completely different spheres of thought." After ten years of active debate, his colleagues finally focused their argument on the

fact that in the non-Euclidean geometry on the surface of a sphere, lines intersected twice, not once. Klein countered by arguing that "the example shows that when interpreting any metrical geometry on a curved surface, one must take into account the connectivity of the surface. The projective plane has a connectivity that is unusual and essentially different from that of the sphere; the former is one-sided like a Möbius strip, only it is closed" (1926, 141–142). The fact that parallel lines meet at a point infinitely far to the right does not preclude those same parallel lines from meeting at a point infinitely far to the left. But by the most basic axioms and definitions of projective geometry, parallel lines meet only once. Therefore, as Klein explained, these two distant points must be the same point, and that could be the case if the projective plane were a closed surface. It is the same surface as a two-dimensional sphere whose antipodal points are *identified* (brought together); thus, every circumference is a Möbius band. Such a surface embeds in four-dimensional space as the cross-cap model, a sphere where the upper hemisphere is shown to fold through itself (see fig. 5.6).

Projective lines are often represented by circles; such representations assume that infinity to the left is the same as infinity to the right, and that infinity is just another point on the line. There is a clear distinction between going around a circle clockwise or counterclockwise. Going clockwise from the top of the circle, a right hand stays a right hand; going left, a left hand stays a left hand; the line is said to be *orientable*. Looking through a

Fig. 5.6. The projective plane. Antipodal points of the sphere are identified, turning every diameter into a Möbius band.

transparent globe, however, silhouettes of right hands appear to be left hands, and if those two antipodal locations on the sphere are considered to be the same point, the projective plane can be seen (with a little work, granted) as unorientable. Topologically, a projective plane is a Möbius band with a disk sewn in so the band becomes a closed sphere-like object; one needs to go around twice to get back to where one started right side up, because a twist is built into the geometry (fig. 5.6).

The projective plane, and its related distortions, have long been a favorite subject of topologists. Today its projections are studied by Thomas Banchoff, Jeffrey Weeks, George Francis, and other mathematicians using computer-generated technical drawings.

The Complex Projective Line

A complex projective line is a projective line with complex numbers as its homogeneous coordinates. Being complex, with coordinates of the form $a = x + yi$, the line is modeled in two-dimensional space as a plane. Usually the real part (x) lies on a horizontal axis and the imaginary part (yi) on a vertical axis. Being projective it has one

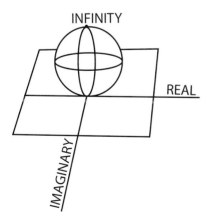

Fig. 5.7. The Riemann sphere. Adding one point at infinity rolls up a plane of real and imaginary coordinates into a sphere.

and only one point at infinity. The plane, therefore, rolls up to be a sphere known as the Riemann sphere, usually with the north pole labeled as the point at infinity (fig. 5.7).

Projective Three-Space

Projective three-space is elusive and difficult to imagine concretely. But as Coxeter reminds us, "if metrical ideas are left out of consideration, elliptical [spherical] geometry is the same as real projective geometry" (1942, 15). So, to imagine projective three-space, we must imagine solid spheres with their point identified in peculiar ways: "The Projective Plane can be thought of as a disk with opposite boundary points glued; we can think of Projective Three Space as a solid ball with opposite boundary points glued" (Weeks 1985, 213). "For a given solid ball, there is the space within it and without it. The space without the solid ball contains a point that is antipodal to a point in the ball, the surface of the ball is identified via an antipodal identification, and this surface can be thought of as a projective plane" (four-dimensional topologist Scott Carter, in an e-mail to the author, 2005).

When thought of this way, it is possible to see that crossing the boundary (going through it once) reverses left-right and also top-bottom. As Weeks puts it, "The projective plane is nonorientable: when a Flatlander crosses the "seam" he comes back left-right reversed. Projective three-space, on the other hand, is orientable. When you cross the "seam" you come back left-right reversed and top-bottom reversed. In effect, you get mirror-reversed two ways, so you come back as your old self! The only difference is that you've been rotated 180 degrees" (1985, 213).

Carter's analogy of the soccer ball further explains the nature of projective three-space:

A rotation of three-dimensional space can be thought of in terms of a soccer ball spinning on an axis. The axis of rotation and the angle of rotation, the amount of turning, define the

new orientation. A similar procedure can define a point in projective three-space. It is obtained from a solid ball (not the hollow soccer ball) by identifying the diametrically opposite points on the boundary of the ball to determine a line interior to the ball [as the axis of rotation]. The angle of rotation (as a fraction of 180 degrees) determines a radius within the ball. A point on that line at a depth of given radius corresponds to a point in the projective three space. A rotation of 180 degrees corresponds to a rotation of −180 degrees, and so the diametrically opposite points on the surface of the ball are identified since they determine the same rotation. The surface of the ball, with its diametrically opposite points identified, is a projective plane within the set of rotations of three space. (e-mail to the author, 2005)

Perspective, projection, projectivity, projective—the progression is from a specific scene, to a generalized depiction of objects (of any dimension) in a lesser space, to an analysis of constant relations in a changing space, to an internal cohesive structure independent of any background metric description.

As a safeguard against a "logically impeccable position" that nevertheless fails to provide "sufficient insight," Klein valued visualization. "No true geometer will be satisfied [without] it: for him the charm and value of his science lies in his being able to *see* what he is thinking of" (1926, 125). This statement should be on every projective geometer's membership card, as a reminder of the origins of projective geometry.

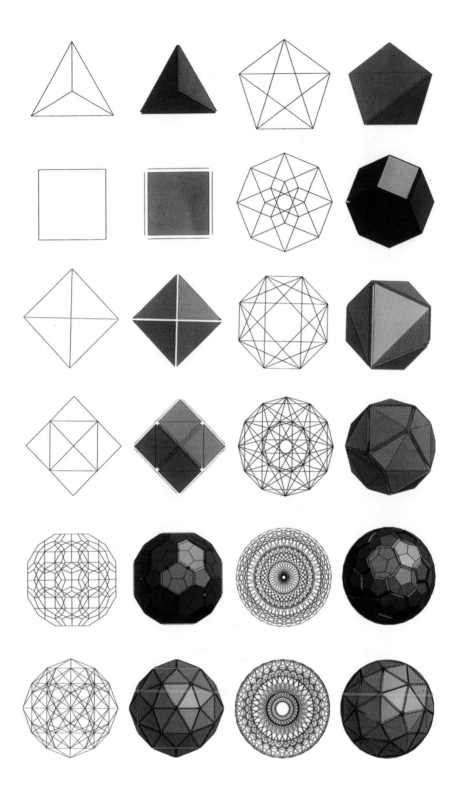

1. The regular figures in four dimensions. Computer drawing by Koji Miyazaki and Motonaga Ishii, used by permission.

2. *Portrait of Henry Kahnweiler,* by Pablo Picasso (1910). Oil on canvas, 39 3/4 x 28 7/8 in. Gift of Mrs. Gilbert W. Chapman in memory of Charles B. Goodspeed (1948.561). The Art Institute of Chicago. © 2005 Estate of Pablo Picasso/Artists Rights Society (ARS), New York. Photography © The Art Institute of Chicago.

3. *Seated Woman with a Book,* by Pablo Picasso, ca. 1910. Oil on canvas, 16 1/4 x 9 1/2 in.
© 2005 Estate of Pablo Picasso/Artists Rights Society (ARS), New York. Museum of Art,
Rhode Island School of Design. Museum Works of Art Fund. Photography by Erik Gould.

4. The quasicrystal at Denmark Technical University, before its destruction by the university in 2004. Built by the author in 1994; engineered by Erik Reitzel. Photo © Annette Hartung.

5. *1979–8,* by Tony Robbin (1978). Acrylic on canvas, 70 x 120 in. Collection of the artist.

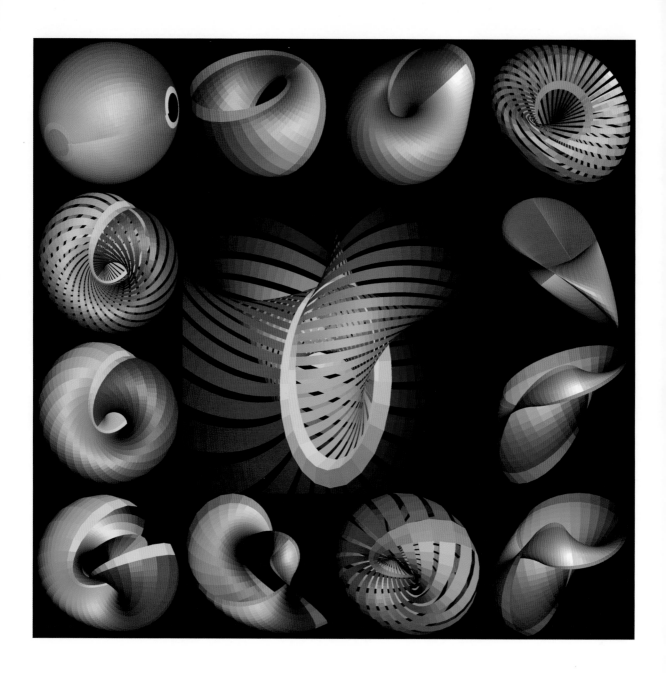

6. *Snail,* by George Francis (1992–2005), at the Beckman Institute/University of Illinois at Urbana-Champaign. Collaborators included Stuart Levy, Cary Sandvig, Glen Chappell, Chris Hartman, Alex Bourd, and Mathew Woodruff. Used by permission.

7. *ZYspace,* by George Francis (1994–2003), at the Beckman Institute/University of Illinois at Urbana-Champaign. Collaborators included Stuart Levy, John Sullivan, Jeff Weeks, Mathew Woodruff, and Ben Schaeffer. Used by permission.

8. *2002–5,* by Tony Robbin (2002). Acrylic on canvas, 56 x 70 in. Collection of the artist.

PART TWO

Present Uses
of the
Projective Model

Patterns, Crystals, and Projections

For 30,000 years humans have made patterns. We put patterns on practically everything we make. In *The Sense of Order*, art historian Ernst Gombrich argued that this is because patterns are fundamental to the way humans think: the propensity for making patterns is hardwired in the right brain. For all these years, *pattern* meant a motif that repeats at a regular interval. The mechanics of the loom enforce a periodic repeat, as does the roller that prints patterns on wallpaper, although human patterns predate these technologies. But in 1964 Robert Berger discovered that one could make a pattern using 20,000 differently shaped tiles that completely covered a surface exactly once yet did not repeat. The search began to find nonrepeating patterns with ever fewer tile shapes. By 1974, Roger Penrose had created a nonrepeating pattern using only two shapes, which he called a kite and a dart; later he did the same using two different shapes, a fat rhomb and a skinny rhomb (fig. 6.1). Both the kite and dart set and also the fat and skinny rhomb set can be assembled in either a regular repeating pattern or a nonrepeating pattern. Marks on the edges of the tiles are needed (called local matching rules) that tell which juxtapositions produce the aperiodic patterns, and are thus "legal" (fig. 6.2). Penrose's method was one of trial and error: fit the tiles together using the matching rules he discovered for a nonrepeating pattern, then if trouble develops where no legal

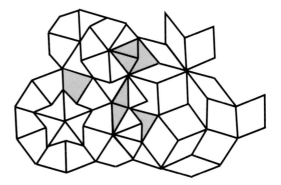

Fig. 6.1. Darts and kites transition to fat and skinny rhombs. This drawing shows that the two sets of tile shapes are really the same. By decorating one set of tiles with lines, the other nonrepeating tile pattern is constructed. Triangles are not separate tiles but are shapes created when the two patterns overlap. Adapted from Senechal 2004.

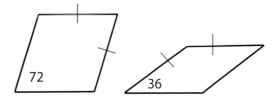

Fig. 6.2. Matching rules. If the fat and skinny rhombs are assembled mark to mark, the pattern will be nonrepeating. There is no guarantee, however, that the use of local matching rules will not lead to an impasse.

Fig. 6.3. Ammann built his dart-and-kite pattern with nodes placed in the spaces between his bars. Adapted from Senechal 2004.

Fig. 6.4. The fat and skinny rhombs can be decorated to produce the Ammann bars. Adapted from Janot.

tile can fit, take apart some tiles and try something else. Although these patterns clearly are not regular, they are not crazy quilts either: only two tile types are needed. They are quasi-regular, crystalline structures—quasicrystals.

Working separately from Penrose, reclusive mathematician Robert Ammann discovered that the tiles could be decorated with line segments that are continuous when properly assembled (figs. 6.3 and 6.4; box 6.1). These lines also function as local matching rules. Unfortunately, these rules are not foolproof either, and it can come to pass that legal moves must be undone and another tile placed, also a legal alternative, so that the tiling can progress. Still the Ammann lines (or bars) are useful: they tell more about the hidden structure in the seemingly random pattern. In the

Mathematician Marjorie Senechal, an expert on quasicrystals, told the strange, sad tale of Robert Amman in "The Mysterious Mr. Ammann" (2004). As one of the few mathematicians ever to meet him, and certainly the only one to have him to dinner, she was uniquely qualified to tell his story. Born in 1946, Robert Ammann showed signs of brilliance at an early age. He could read, add, and subtract by the time he was three. He also showed signs of the mental problem that would haunt him all his short life: by age four he had stopped talking; only gradually did he learn to speak again. Pestered by classmates, ignored by exasperated teachers, Ammann led a lonely childhood, computing the stresses on the Golden Gate Bridge while his classmates struggled with fractions. The one bright spot in his young life seemed to be the post office, where Amman spent hours looking at maps and memorizing state capitals while his mother went shopping. Senechal summarized his contact with institutions of higher learning: "MIT and Harvard invited him to apply, but turned him down after the interview. Brandeis University accepted him. He enrolled, but he rarely left his dorm room and again got low grades. After three years, Brandeis asked him to leave." Ammann supported himself as a computer programmer in industry and later, when that did not work out, as an employee of his beloved U.S. Postal Service.

Ammann's first contact with the math world came in the form of correspondence with science writer Martin Gardner, who had reported on Penrose's remarkable tiles in 1976. Gardner sent Ammann's letters and drawings to experts in the field, who immediately saw the author's originality and mathematical depth. Ammann had independently discovered the quasicrystal made up of fat and skinny rhombs that Penrose had found. He discovered tiles that could tessellate for only a limited number of rows, a nonrepeating tiling of squares and rhombs, four blocks that could fill three-dimensional space aperiodically, and other items of interest.

But Ammann's lasting contribution was his discovery of the Ammann bars, as they are now called, or continuous lines running through the tiling pattern that form the basis of the matching rules for two-dimensional quasicrystals: each kind of tile is "decorated" the same way, such that when the tiles are assembled the decorations make continuous straight lines (the Ammann bars). Ammann saw that these bars form the hidden structure in quasicrystals.

Ammann was a pioneer in what has come to be called visual math. Although he never wrote a single proof, the mathematical insight and original content in Ammann's drawings were plain for all to see. Unfortunately, the disintegration of Ammann's personality due to mental illness ultimately cost him his life. Robert Ammann died of a heart attack in May 1994, at age forty-seven.

group of tilings shown here, there are five sets of parallel lines, demonstrating a long-range order: although the pattern is nonrepeating, all the edges of the tiles are lined up in one of these five directions. Originally, the Ammann bars were equidistant, but later they were spaced apart in wide and narrow gaps, the dimensions of which match those in the *golden ratio*. The whole series of wide and narrow gaps is a *Fibonacci series*.[1] The Ammann bars showed that what was once considered a random trial-and-error pattern did have a subtle, global structure.

It was long thought to be impossible to have a tiling made up of pentagons or have a tiling that had fivefold rotational symmetry (that is, the pattern would remain unchanged when rotated 72 degrees). Squares can tile a plane because the 90-degree corners of four squares fit around a point to make a full 360 degrees; turning the pattern of

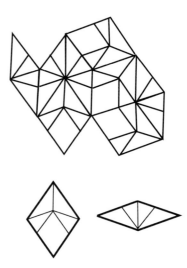

Fig. 6.6. A quasicrystal inflation decoration of the fat and skinny rhombs.

squares by 90 degrees results in a pattern identical to the original. Equilateral triangles can also tile a plane because six of their 60-degree angles add up to a full 360 degrees: rotating that pattern by a sixth of a circle leaves the pattern unchanged. But the angles that make up a pentagon are 108 degrees; three of them are too few and four are too many to add up to 360 degrees. Although Ammann's and Penrose's patterns did not include pentagons, other figures of fivefold symmetry, such as five-pointed stars and decagons, do appear in the patterns. Furthermore, the patterns themselves have a kind of fivefold symmetry, because rotating the patterns by 72 degrees still leaves all the sides of all the rhombs lined up along one of the five axes of the Ammann bars.

Ammann discovered other ways to decorate the tiles—and Penrose had done the same—whereby the assembled tiles would present a pattern of drawn lines that was similar to the original pattern, also nonrepeating, but on a smaller scale. The smaller units could be "inflated" and the process begun again, and in this way arbitrarily large nonrepeating patterns could be formed (figs. 6.5 and 6.6).

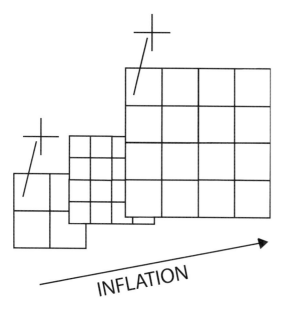

INFLATION

Fig. 6.5. Inflation. Tiles can be decorated so that when assembled a self-similar pattern is seen. When blown up so that the elements of the pattern are the size of tiles, the process can be repeated to create an arbitrarily large pattern.

Only three years after Penrose and Ammann separately announced their aperiodic patterns, the Dutch mathematician Nicolaas de Bruijn discovered a foolproof method for constructing what otherwise appeared to have only an improvised, catch-as-catch-can assembly.[2] For the first time a repeating system of steps led to a perfect nonrepeating pattern. De Bruijn's was a general method that could be applied to two-dimensional Penrose patterns, their three-dimensional analogs, and a larger class of two-dimensional nonrepeating patterns with different tile shapes. Since it was an algorithm (a logical sequence of mathematical steps), the method could be automated on computers. Several researchers wrote such programs, and the study of quasicrystals was quickly disseminated.

De Bruijn's first algorithm, the *projection method*, used projection from a higher-dimensional space. How de Bruijn made the conceptual leap necessary to find the algorithm of projection from higher dimensions has never been fully explained; de Bruijn has given different accounts. The basic concept, however, is that the quasicrystal begins as a stack (or lattice) of regular cubes in a particular dimension (a lattice of four-dimensional cubes, or five-dimensional cubes, and so on). In general, one needs a stack in twice the number of dimensions of the final quasicrystal; for example, to end up with a three-dimensional Penrose tiling, one needs to start with a stack of six-dimensional cubes. The vertices of this lattice are put to a mathematical test and those that pass are preserved and will become the vertices of the final quasicrystal; the others are discarded. The selected vertices are then projected at a special angle to the final lower-dimensional space. Astoundingly, when connected by lines of equal length, these vertices become the nodes of a perfect quasicrystal.

De Bruijn also invented a second algorithm, the *dual method*, to identify the dual, or underlying, net of the pattern. The dual net is a mathematical device that is often used to analyze pat-

tern. Early on, de Bruijn discovered the Ammann bars for himself, calling them "pentagrids," and realized that these were the dual structure for the tessellation of the fat and skinny rhombs. With the dual method, a star of vectors is established. A dual net is constructed from this star of vectors, in the two-dimensional case, by drawing many lines perpendicular to each vector of the star. Each node of the dual net will be the location of one of the cells of the quasicrystal. Next, some combination of vectors in the star is transported to each dual location, and from them a cell is built. The algorithm continues, making cell after cell, until eventually—and seemingly miraculously—all of space is perfectly filled by quasicrystal cells.

The two de Bruijn methods are really the same, a mathematically equivalent reordering of the same steps. Both methods involve two steps—selection and projection to a space of half the original dimensions, the $N/2$ space. The methods differ in the order in which these steps are taken. The projection method first selects some nodes of the lattice, then projects those selected to the $N/2$ space at the golden ratio angle. But if a node of a six-dimensional cubic lattice were so projected, its rays would be the same star of vectors found in the dodecahedron that begins the three-dimensional dual method. Thus the dual method works in an order opposite that of the projection method by first projecting to the $N/2$ space, then selecting some of the many (once cubic) cells for the quasicrystal (box 6.2).

If one is willing to abandon fivefold symmetry and the requirement that there be only two unit tiles or blocks (characteristics that I think give quasicrystals their special magic), then the projection method can be generalized to produce many more patterns. For example, projecting seven-dimensional cubes to two dimensions will result in a tiling that uses three rhombs. Any irrational angle of slice used in the projection algorithm will deliver an aperiodic tiling; any rational angle will produce a periodic tessellation. The cube can be escalated to any dimension, and all of these

Box 6.2 The de Bruijn Algorithms

In 1980, Nicolaas de Bruijn discovered a way to convert the nonrepeating sequence of digits of an irrational number into a geometric nonrepeating pattern. His method, known as the projection method, used an irrational number as the slope of a line: the change in *y* divided by the change in *x* (that is, the rise over the run of the staircase that defines the slope). This construction was an imaginative leap because it portrayed as a geometric ratio a number that by definition cannot be a numeric ratio (that is, a number such as π [3.1416 . . .] or τ [1.6180 . . .] that does not have a repeating sequence of digits, unlike 0.3333 . . . , which can also be expressed as 1/3). The technique involved a dimensional escalation, wherein divisions on a one-dimensional line are defined by placing that line in a two-dimensional grid. Nevertheless, it provided an "algebraic theory" and consequently an algorithm for generating a nonrepeating tiling (fig. 6.7).

If a two-dimensional quasicrystal is desired, a packing of five-dimensional hypercubes is often constructed. When symmetrically projected to the plane, five-dimensional hypercubes naturally result in the fivefold set of Ammann bars. (A tessellation of four-dimensional cubes can also be used, maintaining the "twice" rule for starting and ending dimensions, but in the four-dimensional case the lattice is not cubic.) This grid is then sliced by a plane; in the case of the nonrepeating patterns with fivefold symmetry, the slope is the golden ratio, $1:(1+\sqrt{5})/2$. A new plane perpendicular to this is then constructed, and on it a geometric figure is drawn. Points of the original hypercubic lattice are first projected to the second plane to see if they fit inside this "gate." If they do not, they are discarded, but if they do, they are kept. When projected on the original bisecting plane, these selected points are nodes of a perfect Penrose tessellation (fig. 6.8). Connecting all the nodes that can be joined by members of

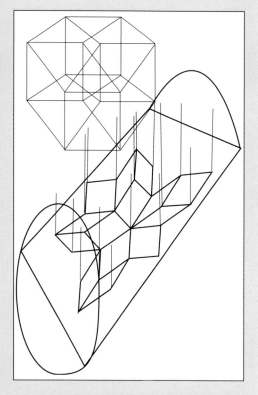

Fig. 6.8. The de Bruijn projection method is applied to a grid of hypercubes to produce a Penrose tiling. Only one hypercube is shown here.

equal length produces a pattern of fat and skinny rhombs, whose acute angles are 72 and 36 degrees, respectively. They fill the plane exactly once (that is, without overlaps or gaps). The resulting pattern has a kind of rotational symmetry in that it can be rotated about any node by 72 degrees, and although the pattern will not be identical, all the edges of all the rhombs will still be lined up to one of the original five lines of sight. Parts of the pattern will form repeating subassemblies, such as decagons, but they will not repeat at regular intervals. Moreover, these subpatterns can be as large as one likes; they will always be repeated somewhere in an infinite pattern.

To generate a three-dimensional quasicrystal by this method, a six-dimensional cubic lattice is first created, then sliced by a hyperplane, which is a three-dimensional space. The gate is a triacontahedron. Points that can be projected to the inside of the gate are

Fig. 6.7. The de Bruijn projection method is applied to a two-dimensional grid to produce a quasicrystal division of a line.

then projected into the three-dimensional hyperplane that cuts the six-dimensional lattice at the angle of the golden ratio; when connected by lines of uniform length they form three-dimensional cells that tessellate in a nonrepeating, space-filling pattern. All the properties of two-dimensional quasicrystals are also properties of three-dimensional ones, and in addition there is a remarkable multiplicity of twofold, threefold, and fivefold symmetry as the structure is rotated.

De Bruijn's second algorithm, the dual method, is a superior algorithm because it identifies more of the hidden structure in the pattern. This algorithm first defines a star of vectors: in the three-dimensional case, these are the rays from the origin through the centers of the faces of a dodecahedron. Planes are constructed normal, or perpendicular, to these rays at unit intervals (other intervals give different or imperfect quasicrystals). Three planes intersect at a point in space, and this point can be discovered with linear algebra—three unknowns and three equations. If the three original vectors are transported to that location, and the vector addition is performed, then either a fat or skinny rhombohedron will be constructed at that point (fig. 6.9). By cycling through all the combinations of intersecting planes generated normal to all the axes, the tessellation will be constructed—without gaps and without interlacing cells. But there are locations when four, five, or even six of these oblique planes will intersect at a point in space, and at these locations a rhombic dodecahedron, a rhombic icosahedron, or a rhombic triacontahedron will be constructed, respectively. Together with the golden rhombohedron, these figures constitute the four golden zonohedra,

which float in a three-dimensional quasicrystal. This method, then, identifies the location of the subassemblies of the pattern, or lattice, and thus illuminates the deeper, more complex structure residing in the quasicrystals.

In three dimensions, only the four golden zonohedra can be decorated and inflated, and some feel that the four zonohedra should be considered the fundamental building blocks of three-dimensional quasicrystals. But the three larger figures are composed of two smaller unit cells: the rhombohedron itself (often called the fat 3-D cell) and an oblate rhombic hexahedron (the skinny 3-D cell). These smaller unit cells are constructed by adding the vectors $(-1, \tau, 0; 1, \tau, 0; 0, 1, \tau)$ and $(-\tau, 1, 0; \tau, 1, 0; 0, \tau, 1)$, respectively, where τ is in the golden ratio. Two fat cells and two thin cells make up the rhombic dodecahedron; three more of each added to the rhombic dodecahedron compose the rhombic icosahedron, and five more of each added to the rhombic icosahedron make up the triacontahedron. All the faces of all unit cells are identical rhombs with acute angles of arccos $(1/\sqrt{5})$, about 63.44 degrees. It is startling to see that the two small unit cells, objects of limited symmetry, are generated from identical faces, and that they can, in turn, be assembled into larger figures that exactly fill a given space (fig. 6.10).

Fig. 6.10. The golden zonohedra. Smaller shapes are nested in the larger ones. Three-dimensional quasicrystals are nonrepeating patterns of these subassemblies.

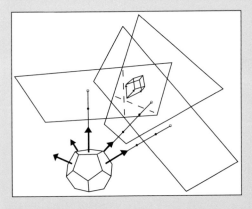

Fig. 6.9. The de Bruijn dual method in three dimensions. Planes are constructed perpendicular to a star of vectors. Three planes intersect at a point in space. At that point a cell is constructed from the three vectors.

n-cubes will tessellate in their own space; there is no end to the two-dimensional patterns that can be made by this method.

Mathematicians now understand that there are three basic ways to make a tessellation. The first is the matching rules system. Here, identifying marks on individual unit cells dictate the next legal steps to take in placing a tile; these rules act locally, from individual cell to cell. All of the original rules and categories of symmetries of repeating patterns can be seen as examples of local matching rules. (For example, "shift left and flip top to bottom" is a rule applied to a unit cell locally as it makes its way across as the plane.) It is usually assumed that local matching rules describe the processes by which real, physical crystals self-assemble. The problem is with quasicrystals: local matching rules are not foolproof for quasicrystals and following them sometimes involves undoing and redoing. It is hard to imagine electrical, magnetic, or nuclear bonds forming as the crystal grows and then, when an impasse is reached, undoing themselves to try another seed assembly. Yet the logical appeal of local matching rules continues to drive research: some hope to discover foolproof local matching rules that could represent physical forces, but the consensus— including a mathematical proof by Hao Wang—is against them. There are regional rules whereby the local rules are applied while attention is given to the vertex figures being constructed, or where attention is given to the inflation pattern being made simultaneously (as in de Bruijn's up-down method). These regional matching rules greatly improve the efficiency of the local rules, but also have occasional awkward limitations or require some lucky initial choices.

Second, patterns can be generated by inflation, or hierarchy, as it is now more frequently called. Here, a seed pattern is decorated with a self-similar pattern; it is then blown up in size and the process repeated. In this way a pattern of arbitrary size can be made, including a quasicrystal pattern in two or three dimensions. Hierarchy seems ad hoc, however, and reveals even less about the structure of the tessellation than local matching rules, with their intimation of long-range order. Consequently, hierarchy may be of limited use.

The third basic method is the projection method, and it is now understood that this method is the most general, informative, and foolproof of the three.[3] Indeed, so powerful is the projection method that it has become the very definition of a physical crystal: these are the objects that when bombarded by X-rays produce diffraction patterns with sharp bright spots, the locations of such peaks being directly computable by the projection method. Although some patterns can be made by all three techniques, there is a large class of patterns that can be made perfectly only by projection. The study of this method is by no means finished, but it appears to offer the deepest understanding of patterned structures, and it does so by reference to a higher dimension. The projection method, and the philosophy that it embodies, will be de Bruijn's legacy.

If quasicrystals are generated and explained by projection of higher-dimensional lattices, it presents a philosophical problem, then, that they exist in real life. Crystalline structures have atoms arranged in rows and columns, regular, periodic patterns where far-apart sections are exactly alike and separated by some multiple of a common distance. When illuminated by a collimated beam, say of X-rays, the rays interfere when reflected off these rows of atoms, the wavelengths of these rays sometimes adding and sometimes canceling, resulting in a refraction pattern of sharp peaks and valleys known as Bragg peaks.[4] These Bragg peaks have been well studied to provide information on crystalline materials. Since the long-range order required to produce Bragg peaks was thought to derive only from periodic structures, it was a shock in 1984 when Dan Schectman illuminated certain samples of synthetic alloys of aluminum

Box 6.3 The DTU Quasicrystal

For the Center of Art, Science, and Technology at Denmark's Technical University (DTU), I made a large quasicrystal sculpture, which was completed in 1994 (fig. 6.11; pl. 4). I wrote programs that generated quasicrystals using the de Bruijn method and used these programs to design the DTU quasicrystal. The sculpture, large enough to be a test of applications to architecture, demonstrated all the major properties of quasicrystals, as the sculpture was an aperiodic filling of three-dimensional space, with fivefold symmetry and a hierarchy of self-similar intermediate assemblies at different scales. The DTU quasicrystal had the properties that it did because it was a projection from six-dimensional Euclidean space. Imagine a quasicrystal as a selection of cells from a regular packing of six-dimensional hypercubes that is then projected to three-space, and all is explained. The nodes are all dodecahedra in the same orientation because each vertex of the six-valent generating lattice has been affected the same way by projection. Even though this is a non-repeating pattern of two different cellular units, the nodes of the lattice are all identical; they are lined up in rows and columns, each facing the same way. Take any node out of the box and it will work for that location, with no question of which way is up. All the rhombs of the quasicrystal are identical for the same reason, and the cells tessellate because though projection may distort angles, it leaves topological continuity intact: the cells were adjacent before, so they are adjacent now. Every face of every cell is the same, just as in a stack of cubes; there is no mystery as to why these oblique, asymmetric cells fill space perfectly. Because cubes can always be stacked to make larger cubes, it should hardly be surprising that quasicrystals grow to make self-similar solids (the golden zonohedra). Fivefold symmetry is induced by the precise angle of projection, where the slope is the golden ratio that is deep in all fivefold structures including the pentagon. If dodecahedral nodes are used, fivefold symmetry is inevitable.

Fig. 6.11. The quasicrystal at Denmark Technical University, before its destruction by the university in 2004. Built by the author in 1994; engineered by Erik Reitzel. Photography by Poul Ib Henriksen.

and magnesium and discovered the fivefold symmetry of the pentagon. As mentioned, pentagons and their three-dimensional analogs, the icosahedron and dodecahedron, do not fill space seamlessly but leave little gaps that would frustrate the coherence of the diffraction beam and destroy the sharpness of the peaks. Schectman turned the samples in various ways and discovered them to have twofold, threefold, and fivefold symmetry depending on how they were illuminated, and so he concluded that the samples had the symmetry associated with the icosahedron (or its dual, the dodecahedron). Solid-state physicists proposed that in a quasicrystal, even though each cell was not lined up exactly the same way, the rows and columns of the Ammann bars were regular enough overall to produce the sharp Bragg peaks that had been observed. Gradually, a consensus formed that these samples were quasicrystals.

Synthetic metal alloys, then, seem to have the magical, quantum, or anthropomorphic property of knowing how to self-assemble into very large-scale, near-perfect quasicrystals, even though it has not been proven that any local rules are foolproof. Quasicrystals seem to know what is happening far away—or, more dramatically, what will be happening far away—as they assemble themselves using atomic, electrical, and magnetic forces that can act only locally. But, as we can see from the de Bruijn algorithm and its clear manifestation in the DTU quasicrystal (box 6.3), all these seemingly irrational properties are a direct and inevitable consequence of projection from a higher-dimensional geometry to a lower one. Once one accepts the counterintuitive notion that quasicrystals are projections of regular, periodic, cubic lattices from higher-dimensional space, all the other counterintuitive properties soon become clear in a wave of lucid understanding.

The apparent puzzles are that quasicrystal unit cells seem to know what other unit cells far away are doing; that they know how to subassemble into groups that will themselves always tessellate; that their boundaries—both edges and faces—are all the same, so that they fit together seamlessly; and that they always line up according to the same axes. But in a stack of cubes, such things are not mysterious. If one knows the orientation and size of one cube in a stack, then one knows the orientation and size of all the other cubes. A cube would know how to fit together with another cube; the faces are all the same shape and size. It is clear which way is up, and the corners of interactions are all the same. Nor is it a mystery that 27 of them form a larger (obviously self-similar) cube and that the larger cube could in turn be nested in an assembly of 64 or 125 cubes. The only adjustment required to see quasicrystals as nonlocal is to say that they are *really* higher-dimensional objects, even though experienced in their lower-dimensional projections. With this point of view, quasicrystals in four dimensions could be investigated with the same mathematical methods (box 6.4).

Quasicrystals are now an intense topic of study by chemists and materials scientists. There may soon be a quasicrystal near you. Techniques have been developed for mass-producing them, sometimes from a single ingredient, and with scalable procedures. Consequently, a great many different quasicrystals materials are now manufactured. They share the properties of having low friction, high resistance to oxidation, and a hardness comparable to silica, which makes them suitable for coatings and surfaces. It is easy to imagine how these properties could result from the patterns of their atoms: start a rip in a cotton cloth made from a plain weave of woof and warp, and it is easy to keep going. Nonrepeating patterns do not "run" in this way. Once thought of as a mathematical model of fluids, quasicrystals may have odd structural properties when applied to architecture, either as node-and-rod structures or as plate structures, which could be exploited for truly remarkable visual effects (fig. 6.12).

As quasicrystals become common, however, it is hoped that they do not become commonplace. Regardless of their use, the value of quasicrystals

Box 6.4 The Case for a Four-Dimensional Quasicrystal

There is a natural progression of unit cells with fivefold symmetry. The de Bruijn projection method delivers a one-dimensional quasicrystal where the unit cells are two line segments whose lengths are in the golden ratio, τ:1. In two dimensions, the rhomboid unit cells produced by this method have sides, or bases, that are the same, but their altitudes are in the golden ratio, and so their areas are in the golden ratio. The fat and skinny blocks of the three-dimensional quasicrystals have identical bases, and their altitudes are in the golden ratio, so their volumes are also in the golden ratio. Both the projection method and the dual method could be applied to higher dimensions; for example, by having a cubic eight-dimensional grid sliced by a four-dimensional hyperplane to make a four-dimensional quasicrystal composed of skewed hypercube blocks as unit cells whose hypervolumes would be in the golden ratio. Viet Elser and Ned Sloane have written a paper defining the projection matrix needed for this construction. There is a problem with the next higher-dimensional escalation, as an analog of the triacontahedron, the essential mathematical gate used in the method, does exist in four dimensions (the semiregular 720-cell) but not in greater dimensions.

De Bruijn's dual method begins with a star of vectors, and these same vectors can be used to construct the unit cells. The star vector for the two-dimensional quasicrystal is made by taking the vectors from the center to the vertices of a pentagon, two at a time, and doing the vector addition. Only two tiles are made this way, the fat and skinny rhomb. In three dimensions, vectors normal to the faces of a dodecahedron are used, and no matter which three (noncolinear) rays are chosen, only the fat and skinny blocks are made. In four dimensions, the star vectors could be derived from the {3, 3, 5}, one of the figures in four dimensions with fivefold symmetry. This figure is described by Coxeter and others as the four-dimensional icosahedron and has 600 cells made from 120 vertices. Vectors from the origin to any four vertices would be star vectors that, when added together to form hypercubes, will make hypercubes analogous to the fat and skinny cells of the three-dimensional quasicrystal.

If these hypercubic unit cells are truly analogous to the three-dimensional unit cells, we can deduce things about them. As mentioned, the ratio of the volumes of the three-dimensional cells is τ:1 because all the faces of both cells are identical and the altitudes of the fat and skinny blocks are τ and 1, respectively. It is probably easier, however, to calculate the volumes of the three-dimensional cells by finding the determinant of the star vectors, taken three at a time, to verify the

ratio of their volumes. We can now anticipate that the four-dimensional altitudes and the four-dimensional volumes of our two candidate hypercubic unit cells would also be in the ratio of τ:1. I wrote a computer program to compute the hypervolume, via the four-dimensional determinant, of legal choices of four vectors. The program gives a variety of volumes, not just two, though interestingly this series is in the golden ratio, so the idea of a four-dimensional pattern of only two skewed hypercubes must be abandoned.

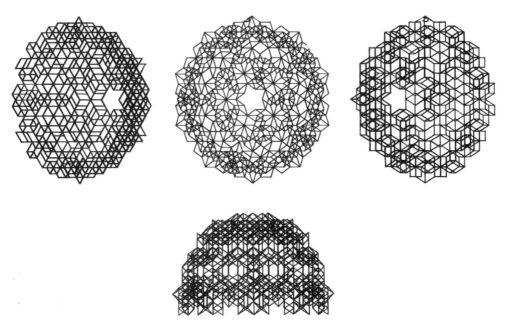

Fig. 6.12. The threefold, fivefold, and twofold symmetries of the quasicrystal dome (shown at bottom) in elevation.

will remain in the philosophical questions they pose and in the answers they provide. Quasicrystals show us that objects and systems described by projective geometry cannot be made Euclidean without inducing the most mystical and anthropomorphic properties into the system. Making what is generated or accurately modeled by projective geometry into a traditional Euclidean static model takes us away from science and moves us toward fetishism.

Twistors and
Projections

Is space really composed of dimensionless points? High school math and common sense say that it is, but there is other math, and common sense has been wrong before. To illustrate a fallacy of common sense, Einstein gave the example of a chair being pushed across a stage. Common sense says that the pushing moves the chair, because when the pushing stops, the chair stops. Cause and effect could not be clearer. But one could give the chair a little shove such that it continues moving when no one is pushing. This small counterexample posed a problem for common sense. Prolonged consideration of the counterexample ultimately led to a study of friction (Newton's first law, which says that things set in motion continue in motion until stopped), which led to an understanding of the motion of planets around the sun. In a similar way, physicist Roger Penrose focuses on the apparent paradox that lines are sometimes points. Working around this paradox, too, leads him to a whole new conception of space and has the promise of uniting separate, seemingly irreconcilable, branches of physics.

To begin the examination of Penrose's paradox, consider the *light cone*, consisting in part of all the light that converges on a point in time and space. In addition, a flash of light expands from a specific location at the present moment, and the sphere that is the front edge of the rays of light traveling outward forms the upper half of the light cone. Because it is hard to visualize four-dimensional figures, the convention is to draw the light cone as double dunce caps, where the circles represent spheres of light and the sides represent the time-elapsed history of light. For many points of discussion, the reasoning is the same in the lower-dimensional case as it is in the higher, and the drawing is easier. The "pinch point" represents the present moment at a specific location in space. To travel along the vertical time axis of the light cone is to stay put while time passes; to travel along the horizontal axis is to be everywhere at once, to move at infinite speed. These axes can be calibrated so that one tick on the vertical is equal to one second and one tick on the horizontal is 300,000 meters. With this calibration, to move on a 45-degree diagonal is to travel at the speed of light (fig. 7.1).

Because a downward-facing light cone is composed of all the light rays that come together at a specific spot at the present moment, all that can be known by an observer at that pinch point is information inside the cone. Inside, rays traveling slower than the speed of light could reach the observer; outside, rays or information would have to travel faster than the speed of light to reach the observer, which is impossible. Consequently, the downward-facing light cone represents the causal past. Likewise, the upward-facing light cone depicts all the possibilities of the causal future at that spot from that time onward. The surface of the

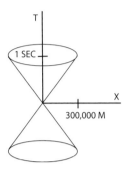

Fig. 7.1. A light cone. The axes are calibrated so that the speed of light is represented by lines at 45 degrees.

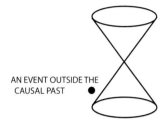

Fig. 7.2. The downward-facing light cone depicts the causal past. Events outside the causal past can have no influence on the pinch point (that is, the present moment at that location).

light cone represents light rays, or information, traveling at exactly the speed of light (fig. 7.2).[1]

Penrose points out that there is a paradox created by such drawings of light cones: "The *Min-kowskian distance* of OQ of a point Q, with coordinates, t, x, y, z from the origin is given by $OQ^2 = t^2 - x^2 - y^2 - z^2$. Notice that $OQ^2 = 0$ if O lies on the light cone of O" (1978, 111). For the photon (the basic unit of light considered as a particle) itself, traveling by definition at the speed of light, there is no distance at all between the location of its creation and that of its destruction, and there is no time interval between those two events.[2] A photon is everywhere it will ever be at the same instant. There may be a distinction between past, present, and future for some viewers, but there is no distance as far as the photon is concerned between this ordered series of points.

Lines must sometimes also be points. To represent this state of affairs accurately, the light cones must be redrawn so that some of the lines are just points, or redrawn so that the circular base of the downward-facing cone and the circular base of the upward-facing cone are not separated by any distance. Penrose expressed the true circumstances of the light ray from its point of view with a drawing in which two light rays become two dots on a sphere, their lengths having been reduced to zero (fig. 7.3).

To make the argument concrete, consider a photon created in a nuclear explosion in a star 4.3 light years away that ends its existence as it is absorbed in the eye and turned into chemical energy. Its path is about 4.06×10^{13} meters in length. But that same path, if traveled by someone moving at a very high speed, could be only half as long; trav-

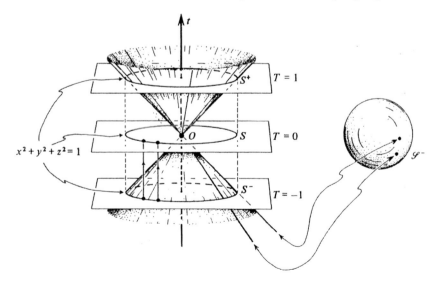

Fig. 7.3. Penrose's drawing of a light cone. Lines on the surface of the light cone represent paths of travel at the speed of light. Relativity shows that these paths have zero length to those travelers; they are null rays and can also be represented by dots on a sphere. Used by permission.

eling at 95 percent of the speed of light, the path is only about 30 percent of the original distance. Consider the famous example of two twins who would be different ages if one took a trip in a spaceship traveling at a speed close to that of light while the other stayed home on earth. Or, for those less fond of hypothetical physics riddles, consider particle accelerators where the half-life of a sample of radioactive material is actually slowed down according to stationary clocks (and in comparison to the rest of the batch) when the material is accelerated to a significant percentage of the speed of light. There is physical reality to the distortions described by the equations of special relativity, and drawings of light cones must account for that fact.

Penrose's alternative to the light cone also gives misleading information as it does not show the sphere of all light-rays-as-points to be shrinking or growing outward from the present moment, as is the case when a flash of light is created. The paradox of light rays having various lengths, including zero, is created by the spatial model used to describe them; if they are considered to be lines in space, problems in the model are inevitable. It was Penrose's creative leap to realize that there is another geometric object that can model light rays: the projective line can accommodate all the various lengths of a light ray. (To keep terminology clear, I will call lines in projective geometry "projective lines" and lines in other geometries "lines in space," a distinction to emphasize that projective lines are background independent.) The projective line may superficially look like a line in space, but it is far different, far richer. In projective geometry there is a fundamental dualism of the line and a point; whatever could be said about one could be said about the other. A projective point is described by a ratio (homogeneous coordinates), and all the points in higher-dimensional space that satisfy the ratio are considered to be that same point.[3] Once that leap of imagination takes place, projective lines seem more and more to be an accurate description of light rays. Projective lines may have an ordered series of points, but—like

light rays—they do not have a definite length. For that matter, the points in a range on a projective line could be legally reordered by multiple projectivities that project a line back on itself, something inconceivable for points on a line in space. The achievement of nineteenth-century projective geometry was to gradually remove projective geometry from the Cartesian x, y grid and to track what remained constant in figures as their measurements changed due to different projections. Consequently, there is no one grid that is the exclusive definition of a projective line, or of a light ray.

The prospect of an event space without an underlying grid of space is appealing to physicists in general. For some time, they have been uncomfortable with the idea that the drama of physics should be played out on a predefined stage of space, no matter how curved or distorted. According to the theory of general relativity, space is a creation of matter. According to particle physics, matter is created out of space, bubbling up from virtual particles of spacetime, units that can have hardly any matter in them at all. Now string theory proposes matter to be ultimately made up of one-dimensional entities that have far more affinity to pure geometry than to any three-dimensional unit of matter. Loop quantum gravity has value over other forms of string theory, says Lee Smolin, one of its inventors, primarily because "we really can treat space and time in a background independent way, and see them as nothing but a network of relationships" (179). For Penrose, those units of the network of relationships are built from projective lines: "We consider spacetime to be a secondary concept and regard twistor space—initially the space of light rays—as the more fundamental concept" (Hawking and Penrose, 110). "Ordinary spacetime notions . . . are to be *constructed* from twistors" (Penrose 2004, 963).

As Penrose frequently writes, imagine a viewer looking at the night sky; the universe of stars appears as a sphere (known as the "celestial sphere"

or "sky map") in which the viewer is at the center. Another viewer standing a distance away from the first also sees a celestial sphere. Often, these two spheres can be brought together simply by rotating one to coincide with the other. If, however, the second viewer is traveling at a fair percentage of the speed of light, this method will not work; there is a distortion of the light in the sphere and a simple rotation will not produce coincidence. For example, if the second viewer passes directly beside the stationary first viewer but is moving toward the North Star at a great speed, the stars on the celestial sphere will appear to be squeezed up toward the north pole; if the second viewer passes by off to the side of the first viewer, the stars on the celestial sphere will be rotated to the side as well as squeezed to the north. Of course, an application of the Lorentz transformations will recompute one set of star positions from the other, but Penrose has noticed that a simpler set of transformations, the Möbius transformations (unconnected with the Möbius band), will also do the trick.

For the Möbius transformations to work, positions on the celestial sphere must be renumbered with complex numbers: numbers of the form $a + bi$, where i is the imaginary number $\sqrt{-1}$. Complex numbers are often portrayed on a plane where the first number, the real part, is a location on the horizontal axis and the second number, the imaginary part, is a location on the vertical axis, and the complete complex number is a location on the plane defined by using these two axes as map coordinates (see fig. 5.7). This entire two-dimensional plane, which represents a related collection of complex points, could be considered a complex line.

Projective lines behave as though they are closed and so are often modeled as circles: infinity to the left is the same as infinity to the right. "The chosen axioms [of projective geometry] are sufficiently general to allow the coordinates to belong to any *field:* instead of real numbers we may use rational numbers, complex numbers" (Coxeter 1961, 231). Thus, a projective line need

not be merely a line of real points but could be one composed of complex numbers. And if it is both complex and projective, a line has only one point at infinity. The complex line, modeled as a plane with only one point at infinity, rolls up to be a sphere, called the Riemann sphere. For the Möbius transformations, the celestial sphere is mapped onto this mathematical sphere. The computations are further simplified if polar coordinates (derived from angles from the center of the sphere) are used instead of longitude and latitude coordinates.[4] This change to complex numbers and polar coordinates turns out to be an unexpected boon. Not only are the computations of the Lorentz transformations easier to perform, but Penrose states that computations in general relativity are also easier to perform. Moreover, complex numbers in projective spaces are the preferred mathematical system for working in quantum physics; at the very least these two disparate branches of physics can now use the same mathematical language.

As Penrose argued, "In the basic twistor correspondence, light rays in (Minkowski) spacetime are represented as points in (projective) twistor space, and spacetime points are represented as Riemann Spheres" (Hawking and Penrose, 111). When expressed in homogeneous coordinates, lines in space become points (see fig. 5.5). When made projective and complex, a point becomes a complex projective line, which is a Riemann sphere. Penrose combines the relevance of the projective model of light rays with the convenience of complex numbers to build complex projective three-space, the definition of twistor space (fig. 7.4). Twistors are not massless particles, no more than a vector is a massless particle, but twistors are a description of the possibilities of massless particles, and thus a description of space (fig. 7.5). In many writings and lectures, he has marveled at how organic the connections between the elements are: special relativity's Lorentz transformations of the celestial sphere are also Möbius transformations; Möbius transformations assume the Riemann sphere with its im-

Fig. 7.4. Projective lines, drawn as circles, connecting the (past) celestial sphere with the (future) celestial sphere.

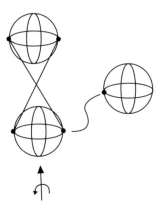

Fig. 7.6. Compactification occurs when the past sky map is glued to the future sky map. The gluing is inevitable when the lines that connect corresponding points have zero length.

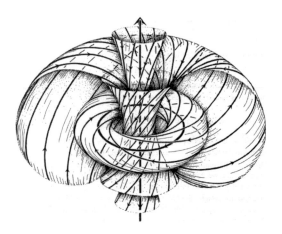

Fig. 7.5. Penrose's drawing of a twistor, a nested series of inked circles that fills all of three-dimensional space. Used by permission.

plicit complex projective geometry; light rays are best modeled as projective lines.

There is further a synergy to the combination of projective geometry and complex numbers, a cohesive whole that is far greater than the seemingly innocuous sum of its parts. The natural way in which the spin of massless particles is described is one of these happy results.

The viewer is always in the center of the light from the celestial sphere, because the light rays converge on a specific location at the present

moment to compose the viewer's sky map. Those rays, if continued into the future, make up the future half of the light cone, or the viewer's anti-sky map. For the light rays themselves, these two sky maps are "identified," meaning that they are brought or "glued" together, by the fact that the light rays have zero length. Penrose is careful to say that this *compactification* (a mathematics term meaning "the completion of a system") of the past and future light cones is only a mathematical "convenience," but one that is informative. As the light rays pass through the pinch point, their positions are reversed in the top half of the light cone. Compactification is equivalent to adding a twist to the light rays (fig. 7.6).

Another way to think of compactifying the light cone is to add a light cone at infinity to Minkowski space (fig. 7.7). Adding an element at infinity is a time-honored trick of the projective geometer to close a space. The result of this compactifying is to construct complex projective three-space. Penrose realized that a compactified light cone, composed of closed loops, was a Hopf fibration (a set of linked circles) of a three-sphere (a four-dimensional analog of a sphere; box 7.1). It is a long-known mathematical fact that certain parallel paths on the three-sphere twist as they

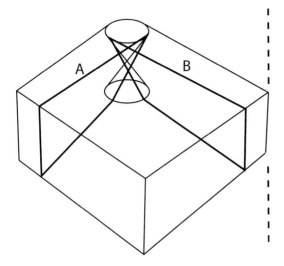

Fig. 7.7. Placing a light cone at infinity turns null rays into circles. Placing a light cone at infinity also compactifies the space.

progress. Penrose believes that this geometric fact must explain the origin of the spin of massless particles, although all the details have not been worked out. It is necessary for depictions of light rays to have an additional structure in order to define the direction of their twist, and this is accomplished by adding flags: think of the rays as flagpoles and the flags as rigid pennants attached to the poles (fig. 7.8). (Spinors, vectors that rotate as they progress, are depicted this way, and twistors are built on spinor mathematics.) It is now possible to keep track of the twist of null rays (light rays of zero length) and to see the twist as the inevitable result of the compactification that is itself the inevitable result of light rays having zero length in their own frame of reference and being therefore a projective entity.

Another happy result of the melding of projective geometry with complex numbers is a clearer picture of the arrow of time. Although nothing could seem more obvious than a distinction between what has happened in the past and what is yet to take place, such a distinction is not obvious

from either a geometry or a physics point of view. To give an example from physics, imagine the morning sun warming a patch of fog. As the sun's rays strike molecules of water in the fog, they are heated and begin to move around with increased energy. As the molecules move around and strike other molecules, the cloud expands and its density decreases, until eventually the cloud evaporates. But by focusing on the molecules of water bouncing around, the big picture of morning fog is lost. If a close-up film were taken of just a few molecules, one could not tell if the film were running forward or backward, as the laws of physics would not distinguish between events running to the future or events running to the past. Locally, the collisions of molecules could condense the fog in isolated patches, even though the fog overall was dissipating. In this example, there is a clear global arrow of time and a confused local arrow.

There is also the opposite situation. One could examine light rays locally to see if they were moving forward or backward in time by examining their spin. Right-turning screws are labeled positive and move forward in time, while left-turning screws are labeled negative and move backward in time. Now the problem is to struc-

Fig. 7.8. As they pass from past to future, tangents and perpendiculars to null rays rotate around the rays. As with the mathematical objects known as spinors, the twist is noted by attaching flags to the rays so that their orientation is clear.

Box 7.1 Twistors and the Three-Sphere

In topology, the sphere is called the two-sphere be-
cause it is composed of all the points that are an equal
three-dimensional distance from an origin. Likewise,
the three-sphere is composed of all the points that are
an equal four-dimensional distance from an origin. To
more fully envision this, imagine slicing an egg with an
egg slicer; throw away the yolk and the result is a series
of hollow rings. These rings are like the lines of latitude
on a globe map of the earth; they result from, and con-
sequently describe, the two-sphere. The analogous
egg-slicing of the three-sphere results in a series "of
concentric spheres nested like Russian dolls. The radii
of the spheres increase and subsequently decrease like
the lines of latitude or the slices of eggs. There is an al-
ternate way of slicing the three-sphere, a way that is
peculiar to 4 dimensions, for which the slices become
interlocked circles" (Carter, e-mail to the author 2005).
Taken together these linked circles are called a Hopf
fibration of the three-sphere (also called Clifford paral-
lels or Clifford circles). To visualize Hopf fibration, con-
sider the three-sphere squared off so that it becomes
a hypercube and the hypercube's cells become a
tessellation of the three-sphere. (A tessellation of the
two-sphere is the covering of the sphere with poly-
gons, like the hexagons and pentagons that cover a
soccer ball.) Four of the hypercube's eight cells make a
toroid band around the middle, and the other four

make another toroid band rising vertically and mush-
rooming over all the others. Thus the three-sphere can
always be sliced into two linked solid torii, whose inter-
face is a torus. Any two circles on this interface that go
through the hole are linked (fig. 7.9).

Penrose's drawing of a twistor (see fig. 7.5) is im-
mediately recognizable to topologists as a Hopf fibra-
tion. A twistor sits comfortably in the three-sphere
because the paths it represents are closed by compac-
tification. A twistor, however, emphasizes a hidden
structure in Hopf fibrations. The circular paths of a
Hopf fibration have a helicity: their tangents and per-
pendiculars rotate to either the left or right. The lines
that make the Hopf fibration are like spinors in that they
have an orientation that can be defined by an attached
pennant. When Penrose visualized this geometry as
the null rays of light cones, the twistor was invented. It
is Penrose's belief that modeling light cones as Hopf
fibrations of the three-sphere accounts for the spin in
massless particles.

If he is correct, there are now two ways of saying
the same thing: twistor space is like a Hopf fibration of
the three-sphere with its helicity twists, and photons
and other massless particles have by nature an intrin-
sic helicity. The first statement is a description of space
paths, the second is a description of properties of phys-
ical entities. If you happen to be in such a space, the

Fig. 7.9. In Davide Cervone's drawings, cubes of the hypercube are considered a tessellation of the hypersphere. A torus is the
interface between two sets of four cubic cells, four horizontal and four vertical. Circles on this torus are linked Hopf circles.
The hypersphere can be considered to be filled with two linked solid torii. Drawing © Davide P. Cervone, used by permission.

second statement might seem to be the most natural way to describe your observations. Relativity physicists, however, prefer a formulation that defines physical properties to be the properties of space.

A further intuition about twist in elliptical space develops by considering another tessellation of the three-sphere. It is possible to tessellate the three-sphere with 120 dodecahedra: this is a platonic solid in four-dimensional space (see fig. 1.2 and pl. 1). The three-dimensional dodecahedral cells of the 120-cell all fit together cell by cell, that is to say pentagonal face adjacent to pentagonal face. But look at a single dodecahedron. True, its opposite faces are parallel, and an unfolded four-dimensional figure could stack these dodecahedral cells parallel face to parallel face, one after another in a row. But, they rotate as they stack— the opposite faces of a dodecahedron are parallel but not oriented the same way. Finally, to a three-dimensional viewer in a three-dimensional dodecahedral cell of a three-sphere, there is only one three-dimensional world; it's just that the front face (future infinity) and the back face (past infinity) are identified. Looking forward far enough is to look from behind, except that everything is twisted. Jeff Weeks has proposed that this is exactly the case with our own universe, and that there will soon be experimental data to confirm or deny this premise (Weeks 2004). This is the same configuration as Penrose's light cone at infinity that compactifies the future half cone with the past half cone. Is the universe one big twistor?

ture the global arrow. As Penrose explains, "Quantum Field Theory requires a splitting of the field quantities into positive and negative frequency parts. The former propagates forward in time, the latter backwards. To obtain the propagators of the theory, one needs a way of picking out the positive frequency (i.e., positive energy) part. A (different) framework for accomplishing this splitting is *twistor theory*—in fact, this splitting was one of the important original motivations for twistors" (Hawking and Penrose, 107).

Penrose recounts the exact moment, a car ride on 1 December 1963, when he realized that there was a way to structure these local observations into a full global picture that would describe the arrow of time. He realized that the real line divided the complex plane into positive and negative imaginary parts and that this essential splitting is also modeled by use of the Riemann sphere. Projections from the north pole to points on the southern hemisphere identify negative frequency, going backward in time, whereas projections from the north pole to points on the northern hemisphere identify positive frequency, going forward in time in the direction of the upper part of the light cone (the anti-sky mapping). This analysis gives a global picture of the direction of time. As Penrose proclaimed, "I found my space!" (1987, section 8; 2004, 993 ff).

The celestial sphere defines only one point in spacetime, the location of the viewer at the present moment. All the light rays of the light cone come together at a single point in spacetime. Each twistor, then, defines only a single point. The question becomes how to assemble these points into a coherent space of discrete elements, and further, how to do this without the preexisting framework of a coordinate system. In other words, the goal is to define a space that, first, has a quantum graininess and therefore is not infinitely subdividable, and second, is fully composed only of itself, without reference to any other system. In the terms that physicists use, the space should be combina-

toric and background independent. As early as 1958, Penrose proposed the idea of *spin networks* to articulate such a space, a topological tiling with an internal counting system attached. By 1968, he began publishing the idea, and ten years later spin networks were well known in the mathematical physics community. Penrose described the idea as follows:

> The "directions" that emerge in the theory described here are things which are defined by the systems in relation to one another and they will not generally agree with the directions in a *previously* given (and unnecessary!) background space. The space that is obtained here is to be thought of (indeed *must* be thought of) as being the one *determined* by the systems themselves.
>
> It is to be hoped that some modification to the above scheme might enable the effects due to relative velocities of systems to be taken into account so that perhaps a four-dimensional space-time might be constructed. (Time is absent from the above theory even to the extent that the time ordering of events is irrelevant!) (1979, 306)

Later development of spin networks proved that, in large aggregates, they look and function like space and therefore are compatible with experience. Various modifications of the scheme have evolved, including a higher-dimensional spin-foam. But the goal has remained "to obtain the entirely discreet and manifestly 'combinatorial' framework that . . . is necessary in order that we may come to terms with Nature's workings at the tiniest of scales" (Penrose 2004, 958).

Penrose's hope for twistors is that they could be used to bridge the most serious gap in contemporary physics between relativity and quantum physics, first of all by casting them both in the same numbering system (box 7.2). There is still a big gap to span. Quantum physics is a story about the past. Backward-facing light cones describe the

Box 7.2 The Twistor Program

Roger Penrose has devoted forty years to the development of twistors. He hopes that they will restructure physics. According to Penrose,

> The four-dimensionality and the $(+, -, -, -)$ signature of space-time, together with the desirable global properties of orientability, time-orientability, and the existence of spin structure, may all, in a sense, be regarded as *derived* from two-component spinors, rather than just given. However, at this stage there is still only a limited sense in which these properties can be so regarded, because the manifold space-time [of] points itself has to be given beforehand, even though the nature of this manifold is somewhat restricted by its having to admit the appropriate kind of spinor structure. If we were to attempt to take totally seriously the philosophy that all the space-time concepts are to be derived from more primitive spinoral ones, then we would have to find some way in which the space-time points themselves can be regarded as derived objects.
>
> Spinor algebra by itself is not rich enough to achieve this, but a certain extension of spinor algebra, namely twistor algebra, can indeed be taken as more primitive than space-time itself. Moreover it is possible to use twistors to build up other physical concepts directly, without the need to pass through the intermediary of space-time points. The programme of twistor theory, in fact, is to reformulate the whole of basic physics in twistor terms. The concepts of space-time points and curvature, of energy-momentum, angular momentum, quantization, the structure of elementary particles, with their various internal quantum numbers, wave functions, space-time fields (incorporating their possibly nonlinear interactions), can all be formulated—with varying degrees of speculativeness, completeness, and success—in a more or less direct way from primitive twistor concepts. (Penrose and Rindler, vol. 2, 43)

causal past. As mentioned, all the events that could have influenced the present moment must be inside the light cone as only then could any information or influence have time to reach the present moment. Any event in the past outside the light cone would have to travel faster than the speed of light to reach the specified place at the present moment. From the point of view of the relativist, physics is a story about the future. Events are influenced by gravitational interactions; mass warps local space at the present moment, which changes the future. Future light cones are tilted toward the gravitational mass; even timelike paths (that go nowhere in space but just pass the time of day) lean toward the mass.

The paradox of quantum mechanics is that events outside the past light cone do seem to influence, or be *entangled* with, measurements made at the present moment. To account for the paradox of events outside the cone of causality, one popular view is that light cones must be *fuzzy;* their indistinct surface includes points that might erroneously be considered to be outside the light cone. Penrose imagines that there are many adjacent and superimposed light cones, and that events are fuzzy until they snap onto one or another of them: "In a twistor-based approach it is now the 'light rays' that are left intact whereas 'events' become fuzzy" (2004, 966). Such quantum multiplicity is resolved into definite classical results by way of gravitational interactions "about the scale of one gravitron or more" (Penrose 1989, 367).

Another proposal is to consider light cones to be rigid, so that tilting the future light cone tilts the past light cone as well, thereby sweeping into the light cone and causal past events that were outside. If one pauses to think about it for a moment, the rigid rotation of a light cone is completely counterintuitive: the past is the past, lost to us forever, while the future is influenced by present events. There is no reason for events that start in the present to affect conditions in the past; surely light cones should snap at their pinch

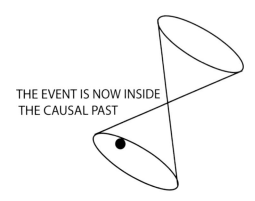

THE EVENT IS NOW INSIDE THE CAUSAL PAST

Fig. 7.10. Rotating a rigid light cone brings events outside the light cone into the causal past.

points. Certainly if light cones are made up of lines in space, they should break apart. I propose that the interpretation of light rays as projective lines explains how light cones remain rigid when rotated. From the point of view of the null ray, there can be no separations in the path from the past to the present to the future, as there is no distance between these points. The projective nature of light rays means that light cones cannot snap at their pinch points and therefore must be rigid. Tilting the future light cone to change the possible future inevitably tilts the past light cone, bringing events outside the light cone into the causal past (fig. 7.10).

Penrose's twistor program can be summarized as being largely based on three insights. He realized that the paths of light rays are more like projective lines than lines in space, that Lorentz transformation could also be done as Möbius transformation, and that a full picture (a compactified picture) of light cones depicts them as linked, parallel circles (a Hopf fibration) on a three-sphere. At least four promising results follow. All of physics, including relativity, can use the same complex numbers as a measuring system. The origin of spin in particles is seen as a function of geometry. The global arrow of time, with its implications for entropy, is integrated with the de-

piction of space. And finally, the twistor program promises a background-independent, combinatoric construction of space. Penrose admits that although the twistor program, which is large and unfinished, has a more complete success to date in pure mathematics than physics, different parts of the program continue to be pursued by separate researchers. Spin networks, with their depiction of a noncontinuous space, are particularly inspiring. Furthermore, in the past two years, Edward Witten found a way to combine twistors and string theory, and through the fusion of these ideas he can do string theory in the more believable four dimensions instead of string theory's usual eleven.

Though often labeled as a Platonist for his focus on the primacy of geometry to define what is possible, Penrose is really more of an Aristotelian, insisting that what we observe is the reality and that our problems come from applying faulty models. "For theories whose spacetime dimensionality exceeds what we directly observe (namely 1 + 3)," Penrose argues, "I see no reason to believe that, in themselves, they carry us much further in the direction of physical understanding" (2004, 1011). At times Penrose seems to state that twistors are only an alternative formulation: "It may be seen simply as providing new mathematical techniques for the solution of problems within standard physical theory." Conversely, twistors may be viewed as suggesting an alternative framework for the basis of all physics, characterized by the "relegation of the concept of event (space-time point) from a primary to a secondary role" (Penrose and Rindler, vol. 2, viii). In this formulation, twistor values are far reaching; Penrose wants to swap the counterintuitive complex and projective for the counterintuitive higher-dimensional. Since they are mathematically equivalent, take the spatial model that is closer to our experience. A projective model that rids us of the false notion of spaces stacked on spaces puts us on the road to reality.

Entanglement, Quantum Geometry, and Projective Reality

"Give me a break, I can't be in two places at the same time!" A more commonsense notion could hardly be found, but the essential mystery of quantum reality is precisely that things *are* in more than one place at the same time. And no matter how quantum facts are described (quanta tunnel through space; they jump; they have multiple, concurrent histories; they are in multiple states; they have a smeared-out reality), quantum facts butt against our everyday experiences. Quantum reality would suggest, for example, that one could unlock the front door and the back door at the same time with the same key. Both locks are real, mechanical, made of solid brass, and exist on opposite sides of the house. The front and back locks are not opened in rapid succession, and they are not connected by any kind of communication system; rather, they are isolated and opened simultaneously. True, the double unlocking would be a reconstructed observation, after the fact, but the reports would be of directly observed facts that cannot be questioned. The only satisfactory explanation of this unexpected result is that somehow the key is at the front door and at the back door at the same time. To accept this explanation is to accept quantum reality.

This essential quantum paradox is the modern version of the Young double-slit experiment, originally designed to show the wave nature of light. In 1805, to demonstrate this property, British physician and physicist Thomas Young shone light against a barrier perforated with small slits. Because it is a wave, light fans out after passing through a narrow slit. If only one slit is open to allow the passage of light, a natural gradation of light appears, bright at the center and graying to dark at the edges. If two slits are open, however, the two fans of light interfere, so that when peaks hit peaks, bright spots occur, but when peaks hit valleys, the waves cancel and dark appears. When Young's double-slit apparatus produced bands of light and dark as expected, the wave nature of light was proven. The conceptual problem came later when experimenters were able to weaken the light so that only one wave packet, or photon, at a time was able to reach the barrier with the slits. With the light so weakened, it takes longer, but over time, photon by photon, a light and dark pattern is produced on the screen, a photographic plate. The startling result was that the experimental outcome was the same. Only one slit produced a single fan, but two slits open produced an interference pattern. Yet only one object was in the apparatus at a time (say, one photon each second), meaning that the object had only itself to interfere with, and it could do that only if it passed through both holes at the same time.

Although Albert Einstein otherwise argued effectively against using notions of common sense

in the physical sciences, he could not abide the idea that real objects with an independent, prior existence could be in two places at the same time. In 1934, Einstein, with Boris Podolsky and Nathan Rosen, created a thought experiment, now known as EPR (Einstein, Podolsky, Rosen), to show the absurdity of quantum reality by using entangled particles. Two particles can be created in a singlet state, or entangled, which means that they are part of a single entity and remain so even when widely separated. The entangled state is due to the wave nature of particles—each particle is a superposition of various waveforms; created together two particles are in a superposition. (It is also possible for more than two particles to be entangled together.) EPR states that, according to quantum theory principles, one can make an arbitrary choice to measure one component (position or momentum) of an entangled particle pair and, by doing so, know something definite (or effect something permanently) about the other particle; this is done instantaneously. Since nothing is considered to be instantaneous (that is, nothing can travel faster than the speed of light), this must mean either that the two particles did not exist prior to one being measured (both particles being created to order after the fact) or that there were hidden variables that preprogrammed into the particles all the possible outcomes of all the possible choices that might later be made. In other words there are three possible explanations of EPR: (1) the particle pair spans space, through faster-than-light communication or some other method (that is, the particles are *nonlocal*), (2) the particles did not exist until measured (that is, the particles are *unreal*), or (3) the whole quantum theory, otherwise very successful, is incomplete because in some way all future events are preprogrammed (that is, there are *hidden variables*). EPR claims that the last option is true, the first two being completely unacceptable. The long history of entanglement since the Einstein, Podolsky, and Rosen paper has been a campaign to show what is now the consensus: that there are no hid-

den variables and that these quantum events are both real and nonlocal.

In 1966 John Bell wrote a paper that catalogued the possible outcomes of a hypothetical EPR experiment. Bell's remarkable paper noted that there would be a way, after many trials, to distinguish between a hidden variable scenario and a nonlocal scenario. The *Bell inequality* results from a count, after the fact, of correlations observed at two separate locations between members of many entangled pairs of particles. Hidden variables could account for only a certain number of correlations, but if an experiment provided evidence of more correlations, as quantum mechanics predicted, then there would be evidence of nonlocality. Bell's theorem caused a sensation because it provided a mechanism whereby Einstein's thought experiment could actually be performed. Bell experiments were undertaken by several teams, and results varied, but on the whole Einstein seemed to be wrong. Many believed that entangled particles were both real and nonlocal.

Two conceptual and technical improvements to the experiments enhanced the results and made believers out of many more. Princeton physicist John Wheeler realized that the observation choices made by observer A (the physicists' Alice) and observer B (Bob) could be executed *after* the entangled pair was created and emitted, dealing a further blow to the hidden-variables proposal. If Alice measured something about her particle (the angle of spin, for example, or its momentum) after the pair was created, and Bob found a correlation in his particle, then the preprogramming would have to be impossibly long, taking into consideration any variable that Alice might choose to measure in the future. Alternatively, time would have to flow backward to reprogram the hidden variables after the fact, challenging the reality of the particles. Or, one final possibility, some signal could be sent from Alice's particle to Bob's, giving information to Bob's particle on how to behave. French experimental physicist Alain Aspect canceled that last option with experiments that in ef-

fect separated Alice and Bob far enough and coordinated their observations closely enough so that information would have had to pass between their particles at three or four times the speed of light. And later experimenters pushed that number up to ten million times the speed of light (Aczel, 236).

Even though Bell's logic has withstood great scrutiny, the delayed-choice option has dealt a further blow to the notion of a preprogrammed system, and Aspect's experiments have proven that the connections between entangled particles or sets of entangled particles is instantaneous, the statistical nature of the experiments continued to impede the widespread acceptance of such a counterintuitive idea as entanglement. Of the massive numbers of particles created, only some were entangled, only on some occasions would the apparatus capture the separated entangled pair in such a way to test nonlocality, and only a statistical analysis of very many of these relatively few hits proved the result. Skeptics found solace in these vagaries. It was a shock, then, when in 1990 a paper entitled *Bell's Theorem Without Inequalities* was published by Daniel Greenberger, Mike Horne, Abner Shimony, and Anton Zeilinger (collectively known as GHZ—Shimony joined after a previous paper on the subject). The authors proposed an apparatus with four entangled particles, each one of which faced its own detector. Having so many elements as part of the entangled system allowed for a nonlocal event to be in evidence each and every time a set of entangled particles was captured in a particular way. Later the thought experiment was refined to work with three entangled particles, and before long, physicist Padmanabhan Aravind investigated the linkage of the three entangled particles (box 8.1). In 2001, an experiment using three entangled particles was realized by Zeilinger and his group of experimentalists in Vienna. Zeilinger got strong results: real, nonlocal entangled particles worked in concert even when separated by a prohibitive spacelike (acausal) distance. Gone was the unease about statistical inequalities, and in its place

was a greater unease: that quantum reality—real and nonlocal—was a fact.

In 2001 and later more completely in 2004, Aravind proposed a new thought experiment that also demonstrates Bell's theorem without the need for statistical inequalities. Based on David Mermin's earlier red-green thought experiments, Aravind's experiment imagines that Alice and Bob are quite a distance from one another. Two entangled pairs of particles are created at a central source, and one particle of each pair is sent to Alice while the other goes to Bob (say, a left sneaker and a right boot to Alice, a right sneaker and left boot to Bob). After this happens, Alice sets the switches on her particle-detection apparatus. She has six options, as does Bob, who also selects one of six options randomly and without consulting Alice. The display panel on each receptor consists of nine squares arranged in three rows of three. Each of the nine squares can light up either red or green when the detector is activated by receiving the two particles (one from each pair). When Alice gets her particles, her panels light up red and green, and Bob's panels light up red and green when he gets his particles. If the colors of the panels light up the same way on both receptors, then the particles are acting in concert.

More specifically, Alice can choose either a row or a column to be the active part of her receptor, as can Bob. If Alice happens to choose a row and Bob a column, then it is guaranteed that at least one square will be shared by both receptors. It will be red on both, or green on both. When Alice and Bob later meet to tally the results, they will discover that this is the case. If it happens that both Alice and Bob both choose the same row (or the same column) to be active, then they will have three squares in common and will later discover that all three squares were lit the same way. No matter how many squares are shared by the two receptors, they will be lit the same each and every time, meaning that the particles that light up these sets of squares are acting as a single entity even

Box 8.1 Rings and Things

In 1990, Mermin refined the GHZ experiment to work with three entangled particles. Then in 1997 Aravind discovered that the three particles can be entangled with the connectivity of the Borromean rings, meaning that if one particle has a particular type of measurement carried out on it, then the other two are no longer entangled. And this is true no matter which of the three particles is chosen to be measured. (The Borromeo family chose these interlocking rings to be part of their family coat of arms to show the interdependency of all parts of their large family; if deserted by one faction the others have no cohesion.) Alternatively, a choice of a different measurement on any one of the particles of a GHZ triple shows the particles to be entangled in a way that is modeled by Hopf rings: cutting any one of the rings leaves the other two linked (fig. 8.1).

Aravind's discovery meant that the entangled GHZ triple—before it is measured and disrupted—has both the Borromean and Hopf connectivity, and it is this *multiple object* that is studied as the full description of this quantum reality. Projected one way, the reality is that of the Borromean rings; projected another way, the reality is that of the Hopf rings.

Imagine the following experiment: Create an entangled triple. Flip a coin to test for Borromean or Hopf rings. Then flip another coin to see which of the three loops to cut. Then see if the two remaining loops were linked or not. If one always found Borromean rings when one looked for them, and one also always found Hopf rings when one looked for them, then the premeasured, entangled, higher-dimensional state must have contained both linkages.

GHZ triples have quantum states with six coordinates; they are in an eight-dimensional Hilbert space, a space with fourteen real parameters. Both the Borromean linkage and the Hopf linkage are possible outcomes, and both possibilities must somehow be contained in the unmeasured state. Would it be possible to identify three curves in fourteen-dimensional space such that projecting them into three-dimensional space one way produces them as Borromean rings, while projecting the same loops into three-space another way produces them as the Hopf rings?

No one has tried to find such an arrangement of rings in higher-dimensional space, but it would be an interesting geometric exercise. If one were found, then a philosophical question could be raised as to what this might say about particles in a GHZ triple. The question leads one astray if it encourages the notion that there would be access to the rings in higher-dimensional space; the rings are by definition unobservable in their quantum, premeasured state. On the other hand, if it were proven that no such arrangement of rings was possible then the mystery of nonlocal, quantum reality might be further restated, and further deepened.

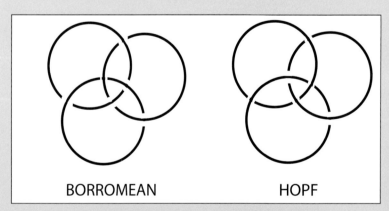

BORROMEAN HOPF

Fig. 8.1. The Borromean and Hopf rings. The outer crossings are the same on both sets of rings, but the triangles of inner crossings are exactly opposite.

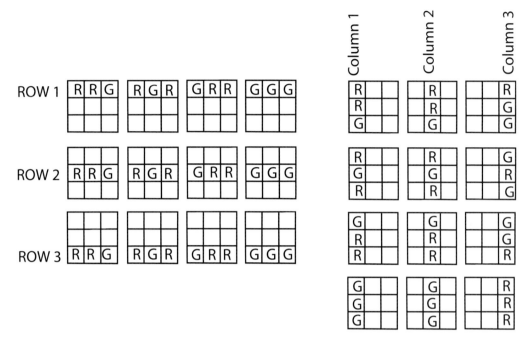

Fig. 8.2. Because of the odd-even rules, there are four possible arrangements of red and green panels for each choice of row or column, and twenty-four possible combinations altogether. Adapted from Aravind 2004.

though widely separated; this correlation rule is never violated. Only in the cases when Alice and Bob both choose different rows or both choose different columns will there be no square in common, and hence no "test." So on average, two out of three runs will result in a test.

Alice's and Bob's receptors have a built-in constraint, termed a "parity rule." To state this rule some notation must be introduced: rows are labeled R1, R2, and R3 from top to bottom; columns are labeled C1, C2, and C3 from left to right. The rule states that for detector settings R1, R2, R3, C1, or C2 an even number of squares light up red and an odd number light up green, while for C3 an odd number of squares light up red and an even number green. There are twenty-four possible combinations (fig. 8.2). The rule does not interfere with the test results stated above, according to which any common panels on Alice's and Bob's detectors always light up the same in any particu-

lar run. Consider four specific runs that Aravind illustrated: in run 1, the top-left square in each receptor is red, and also the red-green rule is observed (an even number of red squares in Alice's row and an even number of red squares in Bob's column). In run 2, Alice and Bob both choose column 2 as their settings, resulting in all three squares being lit the same even number of red squares in each panel. In run 3, there are no squares in common, and consequently there is no test. Run 4 shows the bottom-right square lit green; although the even-red constraint applies to Alice and the even-green constraint applies to Bob, there is no violation of the rule (fig. 8.3).

The odd-even parity rule precludes the possibility of panels (hence particles) being preprogrammed to allow for all the possible combination of choices that Alice and Bob might make. The particles cannot carry an instruction set with them to activate the colored panels in every pos-

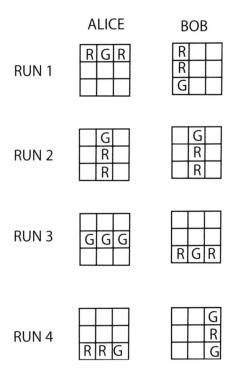

ALICE BOB

Fig. 8.3. Four sample runs illustrated. Adapted from Aravind 2004.

sible case that Alice and Bob might choose after the particles are in flight. The panels cannot be so preprogrammed because "the total number of red panels . . . is required to be even (if one sums the red panels over the rows) but, on the other hand, it also requires this number to be odd (if one sums the red panels over the columns" (Aravind 2004, 5). If the colors (representing aspects of particles) cannot be preprogrammed at the source, the particles are not made up after the fact, and the detectors cannot communicate with each other during the test, then the particles are nonlocal, acting in concert in a delayed choice experiment each and every time there is a test. By the way, Alice and Bob are not the only imaginary friends playing these instructive games (box 8.2).

To understand the connection Aravind found with four-dimensional projective geometry, the

Box 8.2 Lucy and Ricky Bake Cakes

In 2000, P. G. Kwiat and L. Hardy published a particularly clear and sparse entanglement thought experiment based on David Mermin's previous work. Presented here as another example of just how hard it is to swallow quantum reality, the thought experiment imagines two subjects, Lucy and Ricky, baking cakes. Two cakes come from the prep room on conveyer belts to opposite sides of the kitchen in their own mini-ovens that bake individual cakes. The couple can make digital judgments about the cakes that separately come to them: good or bad in taste, and risen or not risen when peeked at during the baking. But opening the mini-oven during baking ruins the cake and ensures that the cake will taste bad later when fully cooked, so only one "quality" can be checked on a given cake. The authors catalog all the possibilities. "When Ricky's cake rose early, Lucy's tasted good," and so on. But it never happens that in a single run both cakes taste good. One would expect that in a random series of runs, it would happen at least once that both cakes taste good, no matter what Lucy and Ricky did. And it could not be true that the recipe is bad and always produces awful cakes, because both Lucy and Ricky got cakes that tasted good, just not at the same time. It must be that the cakes are entangled, and that effects on one are coordinated with effects on the other. That is why both cakes never taste good in a single run.

As with the red light–green light experiments, each feature of the thought experiment has an exact physical analog with a feature of entangled quantum reality. The unexpected result—that in no case do both cakes taste good—is rigorously proven to be the certain outcome given well-known features of quantum mechanics. The unexpected result would be impossible unless the cakes *were* somehow acting together in a singlet state, even though they are on opposite sides of a large kitchen. Given that the point of the experiment is to defeat a prejudice against nonlocal action, physicists think that such thought experiments are complete in themselves, and that it is not necessary to actually perform any kitchen work.

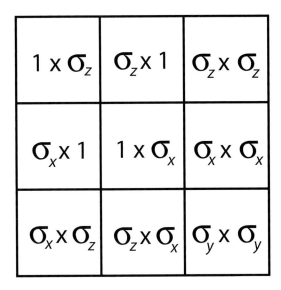

$1 \times \sigma_z$	$\sigma_z \times 1$	$\sigma_z \times \sigma_z$
$\sigma_x \times 1$	$1 \times \sigma_x$	$\sigma_x \times \sigma_x$
$\sigma_x \times \sigma_z$	$\sigma_z \times \sigma_x$	$\sigma_y \times \sigma_y$

Fig. 8.4. The physics behind the panels. Adapted from Aravind 2004.

physics behind the receptors must be unmasked (fig. 8.4). When Alice chooses a row or a column she elects to make as many as three separate measurements on the two particles that come to her. For example, in column 2, Alice sets her apparatus to measure the spin in the z direction on the first particle, and in the next box, she measures the spin in the x direction of the second particle. Reading down column 2 to the last box adds no new measurements. Choosing row 3, Alice instructs her apparatus to measure the spin of the first particle in the x direction and the spin of the second particle in the z direction, then to measure the z of the first and the x of the second, and finally the y of the first and the y of the second. Granted, such a complicated series of measurements on two particles would be quite an experimental feat, but it is now technologically feasible.

Measuring the spin in a given direction is a yes-no, up-down measurement. In an arbitrary alignment of detectors, detecting spin is usually a matter of probabilities, sometimes yes, sometimes no, according to precise percentages. The cleverness of Aravind's arrangements of detectors

is that the measuring apparatus always gives discrete results, without probabilities. The squares are either red or green, and those observations tell something *definite*—not something probable— about the quantum state of the particles. That is to say, Alice obtains discrete results; when measured, the superposition that was the state of her particles collapses to an unambiguous manifestation of the multiple, original possibilities.

Mathematically, the observables (the measurements to be made) are represented by a two-by-two matrix on each of the two particles, which generates a four-by-four matrix. It is in this sense that the fourth dimension is the "space" in which both particles are measured. The "state" of each of Alice's tests is represented by a four-dimensional column vector: this vector represents the one state out of several possibilities that Alice makes manifest by her combined measurements on both particles. If such a column vector delivers a discrete result in the form of a red or green square without probabilities, then that vector is an *eigenvector*, and the discrete result is the *eigenvalue* (box 8.3).

Since Bob's apparatus is set up just like Alice's, his column vector will also be discrete (that is, it will be an eigenvector of the matrix of observables resulting in a discrete eigenvalue, red or green). If Alice has chosen a row and Bob a column, it is the magic of quantum reality that they will both make manifest one of the possible eigenvectors that will produce the same eigenvalue, red or green, on the common squares. If entangled, the eigenvectors representing the quantum state of the particles are working in concert instantaneously though separated far apart. It is the further magic of quantum information theory that should Alice and Bob happen to pick the same row or column, then by making their measurements they will collapse their superposition particles to exactly the same state, the same eigenvector, to produce all three colored panels the same.

Aravind made the amazing discovery that all the possible eigenvectors (the outcomes of all the possible runs that are a test) of this particular

Box 8.3 Matrix Algebra and Eigenvectors

Matrix algebra is straightforward, which is mathspeak for something that is not hard conceptually but is tedious and error prone. Invented by Arthur Cayley around 1858, when he was 37, matrices were later given impetus by Werner Heisenberg, who used them to define the attributes of physical particles. One essential feature of matrices is that they are not commutative, meaning that matrix A multiplied times matrix B is not the same as B multiplied times A; likewise, measuring the observables of particles is noncommutative, meaning that measuring the position of the particle and then its momentum is not the same as measuring the momentum first and then the position. Computer functions that automate the numerous persnickety steps have been a great boon, because once the function is defined, any like matrix can be plugged in. Matrix multiplication is often used to calculate a rotation, where a column vector is multiplied by a matrix that defines the rotation:

$$\left\{ \begin{array}{c} c - s \\ s + c \end{array} \right\} \times \left\{ \begin{array}{c} x \\ y \end{array} \right\} = \left\{ \begin{array}{c} cx + sy \\ -sx + cy \end{array} \right\} = \left\{ \begin{array}{c} x' \\ y' \end{array} \right\}$$

In this matrix multiplication the column vector is x above y. The variables c and s are the cosine and the sine, respectively, of the angle by which this arrow is rotated. The result of this multiplication is a new column vector, with new values of x and y.

Eigenvectors are special column vectors that when multiplied by their matrices have as their product the same eigenvector as one began with, though there may also be present an eigenvalue (a constant) that extends or shrinks the vector, or reverses its direction. There is no exact analogy in arithmetic: the zero multiplication always returns zero, but this result is not specific to the multiplicand, while multiplication by the number one does not yield the multiplier. In the example given by Aravind, the four-by-four matrix, which would be on the left, represents the detectors and the measurements they make, while on the right, the column vector of four elements represents the state of the two separate particles in combination. The eigenvalue is the result of the measurement.

arrangement of receptors compose a regular four-dimensional figure, the 24-cell. That is, the twelve of the eigenvectors, along with their negatives, identify the vertices of the four-dimensional polytope made up of 24 octahedral cells. Workers in four-dimensional geometry have a special fondness for this figure; it is the sixth polytope, the extra one, whose three-dimensional analog is the semiregular cuboctahedron. Further, the 24-cell is a figure of unusual stability because the distance from the origin to any vertex is the same as any edge length. This figure is a self-dual, meaning that, unlike a cube whose dual is an octahedron (made by connecting the centers of its faces), joining the centers of its 24 cells produces just another 24-cell. Aravind found both the figure and its dual in the collection of eigenvectors, one for rows, the other for columns. In a mathematically concrete sense, the 24-cell is the object that models the quantum reality of two pairs of entangled particles, when probed as Alice and Bob do with their receptor setups.

The column vectors that make up quantum state space are projective. Physicists often use the term *ray*, rather than *vector*, to note their projective quality. Vectors are arrows that have a direction, a length or magnitude, and a location in a coordinate system. Vectors commonly refer to forces and paths in the space of our experience. Physicists emphasize that rays which define a quantum state are more abstract and do not refer to the space of our experience. Different quantum state rays of the same direction, or slope, all define the same quantum state. That is to say, rays of different lengths, and rays pointing in the opposite direction, cannot be distinguished from one another in quantum computations. Reversing a state ray does not change the description of the quantum state it represents; the results of the matrix calculations are the same, including the calculation of the eigenvalue—the red or green result. Further, these abstract rays are not housed in an external coordinate system, but are entities only of themselves. In the most general case, the indi-

Box 8.4 Reye's Configurations

In 1999, Aravind found a model of the nineteenth-century Reye's configuration in the Boston Museum of Science. According to Aravind, "That was the most fruitful museum visit of my life: I realized after staring at that figure for a long time that it held the key to a new proof of Bell's theorem without inequalities. A Reye's configuration is a set of twelve points and sixteen lines with the property that four lines pass through every point and three points lie on every line. A very simple model of Reye's configuration is obtained by taking the sixteen lines to be the twelve edges of a cube plus the four body diagonals. The points are taken to be the eight vertices of the cube, its center, and three ideal points. In projective geometry, these ideal points are at infinity, and in this case they are the points where each set of parallel lines of the edges of the cubes meet" (Aravind, e-mail to the author, 2004; fig. 8.5).

A Reye's configuration, studied by Theodor Reye (1838–1919), can also be obtained by projecting the 24-cell from its center onto one of its octahedral cells. Therefore, the twenty-four possible states that come to Alice's receptor could also be modeled as a Reye's configuration. There are two 24-cells, dual to each other,

in all the possible entangled states: one obtained by taking the vectors from the columns of the four-by-four matrix, another obtained from the rows. The two respective Reye's configurations are also dual to one another. It is now possible to examine the red-green coloring problem (the parity rule) in a projective three-dimensional model rather than in the four-dimensional model. The result is the same as before: the reds are required to sum up to an even number by one counting procedure and also required to sum up to an odd number by another equally valid procedure. As a model of quantum reality, the Reye's configuration can set itself up with a point-coloring system only after the decision is taken which way to start the count.

Fig. 8.5. A Reyes configuration. This figure of discrete geometry consists of twelve points and sixteen lines, with four lines passing through each point and three points lying on each line.

vidual components of these rays, which commonly are complex numbers, are percentages that must sum to one hundred percent, as they refer to the chance of finding or not finding the observable in a test. To *normalize* each separate coordinate so that the probabilities do add to 100 percent, the coordinates are all divided through by the same term, in effect turning the coordinates into homogeneous ones.

Aravind discovered that a figure from nineteenth-century projective geometry can be an alternate model for his thought experiment (box 8.4). Moreover, Alice and Bob's receptors could be restructured to measure different combinations of directions of spins, and Aravind discovered that if done appropriately, other four-dimensional polytopes pop out as models of the quantum entanglements: the 600-cell, where each cell is a tetrahedron, and the 120-cell, where each cell is a dodecahedron. All three four-dimensional polytopes can be used to provide proofs of Bell's theorem. As Aravind says, "This hints that the connection between four and higher-dimensional projective geometry and quantum theory have not yet been fully unearthed or understood" (e-mail to the author, July 2004).

Finding four-dimensional polytopes in the abstract state space of quantum information theory is intriguing. That this state space is projective is also intriguing. How these intrigues might be related and what further insight this relationship might give to quantum reality are not as yet known. Speculation on the nature of quantum reality is fraught with danger, and as a careful scientist, Aravind is constrained not to say more than he knows. But I am not so constrained, and I respect four-dimensional geometry enough to doubt any mere coincidence; Aravind's discoveries must be an important clue about the nature of our three-dimensional experience and our four-dimensional reality. As more and more particles are entangled and held indefinitely in that state, more and more possibilities occur, including the possibility of finally understanding the higher-dimensional, projective geometric structure of the quantum state.

Category Theory, Higher-Dimensional Algebra, and the Dimension Ladder

The embarrassing thing about equations is that the good ones are not true. Mathematical physicist John Baez has startled his audiences with the following rhetorical claim: to say that $x = y$ is to fabricate an oxymoron as either $x = x$ or $y = y$ but x is not identical (hence equal) to y or else it would have the same name. Mathematicians working in category theory avoid such contradictions by modifying the equal sign to mean that there is a process that unites x with y, or that there is a process that brings x to y, or that there is a process that maps x to y. Objects (sources and targets) and morphisms (the processes joining objects) make up this mathematical world: there are points and arrows that connect the points. A morphism (F) brings source A to target B; target B is itself a source for another morphism (G) that brings B to C, making a composition AC via morphism (FG). With this formalism, it is clear that A is not identical to C, but rather A is connected to C by a complicated but precise series of steps (fig. 9.1).

Logic dictates the adoption of this complication, but the strength of the formalism is its utility in showing that there can be different routes from a source to a target. Baez illustrates the possibility of hidden multiplicities with the associative law of addition: $(2 + 3) + 1 = 6$ but also $2 + (3 + 1) = 6$ (fig. 9.2). Each addition sequence can be represented by points on a line, and different equations group the numbers together in various ways. (Baez stra-

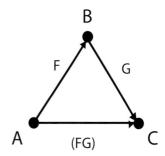

Fig. 9.1. A (de)construction of an equation. A is brought into coincidence with C by processes that take it through state B.

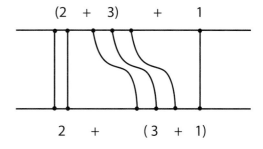

Fig. 9.2. The transition between two associative groupings of 6 is depicted in a higher dimension, the second. Adapted from Baez 2004.

tegically picks the associative law of arithmetic as an example because it will serve to represent the interactions of more complicated objects.) The evolution from one associative grouping to another takes place between two lines of points,

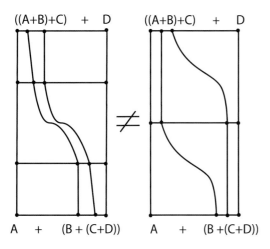

Fig. 9.3. Two different evolutions of an associative grouping. Both start and end with the same associations, but the histories are different because one has two intermediate steps and the other has only one. Adapted from Baez 2004.

one above the other. Points move from the top line to the bottom line, and in doing so they carve out paths from the first state to the second. The price one pays for clarity is the addition of a dimension, and what was originally a one-dimensional phenomenon (points on a line) is now a two-dimensional phenomenon ("worldlines" connecting points on two lines).

Baez goes on to illustrate the further complications of an additional element, D (fig. 9.3). Although the top and bottom lines are the same for the left box as for the right box, Baez says that an equal sign between them is surely unwarranted because the left-hand history is four steps long while the right-hand history is only three steps long. Thus a simple equal sign (or even a single arrow) from the starting position to the ending position would obscure the distinction between the two histories.

Reconsider this diagram by imagining the left box to be in front of the right box, separated by a distance in three-dimensional space (fig. 9.4). All four As are connected by a flat plane, as are

all four Ds. The four Bs, however, would be connected by a continuous curved surface, as would the four Cs. The lines that define this surface twist in three-dimensional space so that they mark out a curved surface. Such a continuous passage is called a homotopy, and spacetime diagrams that depict a continuous flow of time require that homotopies are used. These homotopies are like projections in that all of the figure is shown at once: starting and ending positions as well as a transitional step in between. The homotopy diagram is a still model of the evolution from one associative grouping to another. But there are more than these two ways to group four elements.

Indeed, even in this simple case the elements can be assembled in five different ways. There needs to be a symbolism to articulate such distinctions in a general way, and because a simple line of numbers connected by plus signs cannot contain all the possible intermediate states, it must be a diagrammatic symbolism. A pentagon is used to illustrate the five associations. The bottom (base) of the pentagon is the final construction of ele-

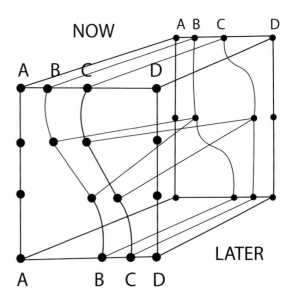

Fig. 9.4. Assembling the two previous histories into a single model requires an additional dimension.

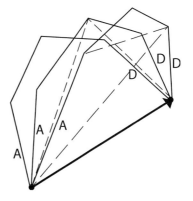

Fig. 9.6. Three possible routes from A to D super-imposed in a third dimension.

Fig. 9.5. Five possibilities of associating four elements by multiple compositions. Adapted from Baez 2004.

ments A, B, C, and D. The diagonals of the pentagon represent the intermediate associative constructions. More elements in an additive string require more sides to the associative polygon, yet only a two-dimensional polygon is needed to depict each of the possible combinations (fig. 9.5). A drawing in three-dimensional space is needed, however, to show that the different associations all refer to the same net result: a composition that brings A to D (fig. 9.6).

If the elements being assembled are themselves entities of a greater dimension, then the homotopies and diagrams must also escalate their dimensionality. For example, if the elements A and B are two-dimensional circles, then every *now* is an arrangement of these loops on a two-dimensional surface (fig. 9.7). The now and later of each loop, however, cannot be connected by a line but instead are connected by a two-dimensional surface, called a worldsheet. These wind around each other in a braiding in three-dimensional space. If there is more than one way to braid from a now to a later, then these multiple possibilities must be examined in a four-dimensional space. In four-

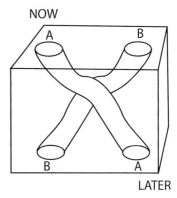

Fig. 9.7. If the elements being associated are circles, then the transitions from one to another are tubes, braided in a three-dimensional space. Adapted from Baez 2004.

dimensional geometry, two planes can be connected by different three-dimensional spaces.

In short, the elements to be associated can be of various dimensions. At any moment these elements (particles, loops, or spaces) make up a pattern in a space of higher dimensions than the elements themselves. The dynamic shift from one associative grouping to another is represented in a static model in a still higher-dimensional space. The patterns are momentary slices, and the paths between patterns are projections. Multiple intermediate associations are possible, as are multiple

routes to the same end. The emerging formalism of higher-dimensional category theory captures and structures this multiplicity.

Some mathematicians find analogies demeaning, but in a foreign country pantomime is sometimes the only option for communication. A category might be thought of as an architectural spaceframe—the lattice of metal nodes and rods that span such structures as big-box stores. To be rigid, all parts of the spaceframe must be connected; not only must there be a rod to every node, but there must be three of them: all shapes made by rods must be triangles, and all triangles must be part of tetrahedra. To be strong all of the rods must be more or less the same length and roughly equal in strength: if some are very much longer than the rest, the resulting shape is awkward and the strain in the rods is not uniform. If most rods are thick steel and a few are thin glass, the spaceframe will break at its weakest link. In a first approximation, category theory might look like a spaceframe of interconnected nodes and rods.

A more successful metaphor for something as abstract and dynamic as a mathematical category, however, might compare the rods of the lattice structure to something more like computer software, with arrows representing the structured paths of input and output. The rods are morphisms, generalized functions that process, or morph, a source into a target that will itself be a source for another target via a new arrow, thus leading to a composition of both functions. The nodes need not be individual items of substance or data but could instead be collections of many things that have in themselves a great deal of structure.

When a single rod will not describe in detail the connection between two nodes, these conceptual spaceframes need to be higher-dimensional. There may be more than one way to connect a source and a target, such as when, for example, intermediate steps from one to the other could be taken in a different order and yet deliver the same result. A three-dimensional spaceframe, when

seen from a four-dimensional vantage point, may reveal multiple cells—hidden in a three-dimensional view—stacked one on top of another. That is to say, each connecting rod might have four or five rods lined up behind it, and only by looking at the structure sideways—from a four-dimensional side—can the hidden structure be seen.

Architectural spaceframes are of limited utility; they are by definition repetitive, monotonous, and practical for only a few types of buildings. Likewise, strong mathematical categories with a rigid triangulated structure, or *nerve*, do not allow for a variety of applications, even if they are multidimensional. The current effort is to "weaken" categories, by which mathematicians mean strengthen the relevance of categories by making them more flexible and open-ended. There are at least ten different ways to do this, falling into a few general strategies: providing that some rods may be left out, that cells of different shapes may be introduced into the structure, that multiple connections can be made between two points, or that the relationship is one of equivalence rather than identity.

In general, younger mathematicians are willing to abandon the triangular cell structure (that comes from algebraic topology) for a more globular structure. Globules of different dimensions can be glued together, each globule representing the variety of routes from source to target. A contraction feature where the cells collapse to a line is more intuitive with a globular cell structure. The diagrams then drawn resemble biological structures more than spaceframes. The globular cell approach, these mathematicians imply, can build a more abstract intuition of a more flexible structure but still keep intact the rigorous formalism required.[1]

Another mathematical topic engaged by higher-dimensional algebra and category theory is the local-to-global problem. Though the following example is not part of the history of this mathematics, the local-to-global problem can be illus-

trated by Emile Durkheim's book *Suicide* (1897), in which he argues for the reality of "social facts" independent from human individuals. Psychiatry may be able to enumerate individuals who are at risk for suicide, but no one can predict with certainty who will take their own life. There is always free will and chance: maybe a random encounter on a bus can change a life. Still, the suicide rate for a society as a whole, a global entity, is remarkably stable. Obviously, society is composed of individuals, yet the suicide rate is a function of the whole and not of the individual parts. Physics, too, has entities, such as entropy, that are properties of whole systems and seem distinct from the assembly of individual parts.

Ronnie Brown, an early investigator of higher-dimensional algebra, emphasizes the local-to-global properties of his mathematics: "[There exist] algebraic structures which enable one to describe the behavior of at least some complex systems in terms of the behavior of their individual parts." Brown's intuition was that local-to-global properties in a mathematical system would best be revealed by analyzing that mathematical system in terms of *groupoids* rather than groups. *Groupoids*, a term coined in 1926 for other purposes, refers to mathematical groups whose elements can be connected by multiple paths and paths with intermediate steps, or links. Groupoids have the vocabulary of sources, targets, morphisms, and compositions. Because groupoids allow for paths from object to object to be compositions, they lead to investigations of the subdivisions of structures and relationships: "It is partly for this reason that groupoids have powerful applications to 'local-to-global' problems." Brown found that groupoids lend themselves to a diagrammatic approach that illustrates the simultaneous multiplicity of connections and the different series of links that can bring one element to another (Brown and Porter 2001, 34).

At times, category theory resembles projective geometry. Given a pattern of points and connections between them, one can construct a pro-

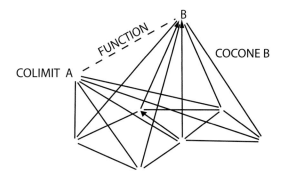

Fig. 9.8. A function carries colimit A to colimit B, allowing a new cocone to be constructed similar to the original. Adapted from Brown and Porter 2003.

jection, called the cocone, from a point, called the colimit. The only rule is that the arrows of the cocone are commutative compositions—that is, that the arrows act like vectors: two arrows add up to a third. Once established, a process can carry this point, the colimit, to another location (fig. 9.8). Using each of the original projection lines of the cocones and the line between the two projection points as two sides of a triangle, the original pattern of points can be reconstructed as another projection. Brown, who admires both artists and mathematicians who can visualize abstract concepts (box 9.1), illustrates with a concrete example. Say the pattern of points is the text of an e-mail. When an e-mail is uplinked to the Internet, various servers take parts of the message, even discontinuous, random parts; these parts are then sent to other servers along with information as to where the parts were sent from and how they were grabbed, so that the message can later be reassembled into its original form. "Notice," says Brown, "that there is an arbitrariness in breaking the message down, and in how it is routed through the servers, but the system is designed so that the received message is independent of all the choices that have been made at each stage of the process. A description of the email system as a colimit may be difficult to realize precisely, but this analogy does suggest the emphasis

Box 9.1 Visualization and Computer Algorithms in Brown's Philosophy

Ronnie Brown is committed to the proposition that visual culture is the context for mathematics. He talks enthusiastically about artists who use mathematics as content for art. He uses computer visualization to express mathematical ideas, and he is committed to using those visualizations to bring mathematics to the general public. Brown lauds computer visualization as a guide to mathematical intuition, and he concurs with the often-stated proposition that computers are useful in finding counterexamples of conjectures because of their ability to quickly process large quantities of data. However, Brown also states a more interesting proposition: that having such powerful tools available asserts a subtle pull on mathematical thinking. Mathematicians may prematurely search for algorithms in order to be able to use such a fantastic tool. While it is not wrong to crystallize ideas to the extent that they can become computer programs, Brown emphasizes that mathematical intuitions are about structure, not logical continuity. As he says, when giving directions to the train station, one gives general, global steps, and mentally skips over the cracks in the pavement that make such a path discontinuous.

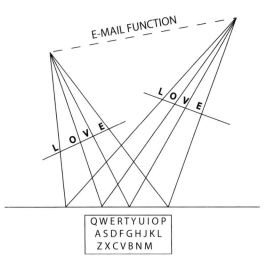

Fig. 9.9. An e-mail message as a cocone.

on the amalgamation of many individual parts to give a working whole, which yields exact final output from individual input, despite choices at intermediate stages" (Brown and Porter 2003, part 2).

Perhaps Brown's e-mail example can be interpolated so that the base set is the ASCII alphabet (fig. 9.9). Then a cocone would be a subset of the machine encoding of the alphabet that makes a meaningful message. In the language of projective geometry, the outgoing e-mail is a range of points, and an incoming e-mail is a projectivity of the original range of points. Projectivities maintain meaningful properties of the range of points no matter how they are bounced around: they are independent of any coordinate system in which they may be placed and also independent of any choice of projection points. The only requirement is that two perspectives making up a projectivity meet a range of points on a line common to them both. In this example, the common line is the ASCII alphabet. As Brown implies, the e-mail analogy may be stretching a point too far, and this interpolation perhaps takes one even further from category theory. Yet, the effort to retain global information in local details is a feature of both the

mathematics of projective geometry and higher-dimensional algebra.

Although higher-dimensional algebra and higher-dimensional category theory may find applications in fields as far ranging as computer science, logic, and neuroscience, the most important application would be a structure for the space in which quantum events can be depicted. The goal is to build a bridge between relativity (the study of many spaces in the same place at the same time) and quantum mechanics (the study of many states of matter in the same place at the same time). There have been several elegant attempts, including one by Baez, to construct "quantum foam," a self-constructed quantum space that in the aggregate resembles regular space. This chapter focuses on the work of Scott Carter, Louis Kauffman, and Masahico Saito in this area.

These mathematicians begin with a slicing technique and proceed to projections. Their first drawing shows a before and an after, side by side (fig. 9.10). Moving left to right, line B is joined to line A, and after moving through a central vertex it later diverges from line C. In the next drawing, *movie moves* (Scott Carter's term for a series of stills from an evolving phenomenon) show the sequence of a left-to-right progression in the two tree

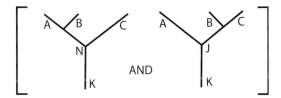

Fig. 9.10. A tree drawing shows the evolution of a system in side-by-side drawings. *Left to right:* line B joins line A, then line ABN joins line K and eventually splits apart into line B and line C. In another vocabulary, line B is associated with line A, then passes through a critical junction to become associated with line C. Reading these tree drawings left to right, and also right to left, shows two distinct histories for the critical junction, so point N is not the same as point J. Adapted from Carter, Kauffman, and Saito 1997.

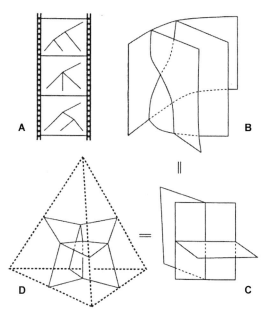

Fig. 9.11. (A) Movie moves of the previous evolution of line ABN; (B) the worldsheet static model of the same event; (C) the three planes at the singularity—the critical junction where the change in association takes place; and (D) the dual tetrahedron built around the critical junction. From Carter, Kauffman, and Saito 1997, used by permission.

drawings as steps in a continuum (fig. 9.11A). Reading the frames from top to bottom one can see a line (call it line B from the tree drawings) moving clockwise, first into the vertex, and then continuing through the vertex to split into two lines, B and C. The horizontal series of tree drawings and the vertical series of movie frames represent the same event. Carter, Kauffman, and Saito then present the static model of this event (9.11B). The movements of the lines are presented as sheets, as though the dislocations of the lines left traces in space; these worldsheets are housed in three-dimensional space. The advantage gained by this process is the same one that projections have over slices: the whole figure is shown at once so that the connectivity of the parts is always maintained. As Kauffman wrote in another context, "Sometimes I think that Mathematics is an

enterprise self-designed to do away with time. No matter that you start with a temporal process or a time series, by the time that you have formulated your data and the problem in mathematical terms, time has disappeared into structure" ("Time, Imaginary Value, Paradox, Sign and Space," part 4).

Consider the middle frame of the movie as compared to the middle of the worldsheet drawing. The movie frame depicts the moment in time that the three lines meet at a common vertex, while the middle of the worldsheet drawing depicts the location in space where all three planes intersect at a single point. In a manner similar to the functioning of the saddle surfaces in the Khovanov homology (box 9.2), the worldsheet intersection can be thought of as a machine to effect the change of position of the lines; in this example, moving down the worldsheet rotates the original line B clockwise, while moving up the worldsheet rotates the line counterclockwise. Likewise, the tree drawings can be read left to right or right to left. The intersection point is the unstable "critical juncture"; it can be "smoothed" in one of these two ways.

Next, the critical juncture is defined as the intersection of three planes; the worldsheets are flattened and squared up (fig. 9.11C). Finally, the authors construct the space surrounding the critical juncture. A tetrahedron is built dual to the three intersecting planes, encompassing the critical juncture (fig. 9.11D). Now all the elements are present to build a space of quantum events. The original lines of the tree drawings are meant to be paths of particles, and the tree drawings are Feynman diagrams, invented by physicist Richard Feynman to show particle interactions with their fusings and splittings. Worldsheets of the Feynman diagrams, their extensions in a higher space, show simultaneously their multiple states and multiple possible evolutions. Transitions are housed in geometric structures dual to critical junctures, and in large aggregates these dual, tetrahedral structures look like space.

The Khovanov homology describes the transformation of a three-crossing knot to an unknot (fig. 9.12). The knot is a one-dimensional object living in a three-dimensional space. Its crossings can be undone, one at a time, by passing the crossing up or down a saddle surface that is spliced into the knot. Each crossing is seen as the critical juncture of this saddle surface; moving up the surface transforms the crossing to a vertical opening, and moving down the surface transforms the crossing to a horizontal opening. The saddle surface, then, is a homotopy of the two kinds of uncrossings. To effect each change, this unknotting feature is cut out of one position and moved to another, and then to a third. Although the starting position (far left) and the ending position (far right) are the same no matter which route is taken, the trips are not identical, and a cube diagram is needed to house all the different combinations of sequences of the different routes. Because there are three crossings, each of the three perpendicular axes of the cube represents a different starting point for the sequence of splicing in the saddle homotopy. Each of the three first steps leads to two possible next steps. Consequently, there are six possible routes from the starting position to the ending position, just as there are six different routes along the edges of a cube from one vertex to its opposite. Thus a one-dimensional knot's evolution is described by moves on a two-dimensional surface (the saddle), and a catalog of all the sequences of moves on the two-dimensional surface is given by a three-dimensional diagram (the cube).

A KNOT

THREE CROSSINGS

EARLIER OR LATER

EARLIER OR LATER

SADDLE SHAPE

INSERT AT CROSSING

Fig. 9.12. The Khovanov homology. Each of the three crossings of the knot can be uncrossed (or smoothed) by splicing a saddle shape into the crossing. Moving up or down the saddle shape from the critical juncture smoothes the crossing differently. Consequently, there are different histories from the state of being knotted with three crossings (on the left of the cube diagram) to the state of being unknotted (on the far right). Adapted from Bar-Natan.

This construction of space out of the interaction of particles is background independent, embracing the goal of Penrose's spin networks. According to the authors, "The nets [we] build are indeed an abstract structure and a purely combinatorial structure that encodes certain aspects of the topology of three-space but does not (strictly, logically) assume the prior existence of three dimensional space or three dimensional manifolds. . . . We are continuing to work with the Penrose program in that we are looking at the relationship of generalized spin nets with both three and four manifold topology. We hope that four manifold topology will eventually interface with issues of space, time, and quantum gravity" (Carter, Kauffman, and Saito 1997, 33–34). The dual tetrahedra are the abstract space, or, after Penrose the spin nets, of particle interactions. But what is space if not an abstraction, and so perhaps it should just be called *space*.

Furthermore, there is an exact catalog of transitions from critical junctures. By peering through the faces of the dual tetrahedra, the associativity of the underlying events (worldlines) can be seen. *Pachner moves* are a codification of the processes of changing associativity (fig. 9.13). These moves—named after Udo Pachner, the German mathematician who first studied them—change the triangles dual to interactions according to a list of possibilities. That is, each set of three intersecting lines, which represent particle interactions, is surrounded by a triangle. When this triangle is rotated by a Pachner move, the changed picture shows a different association: a different set of paths, and thus a different interaction or history. Carter, Kauffman, and Saito note that these two-dimensional Pachner moves can be seen as rotations of a rigid (three-dimensional) tetrahedron; this one-higher-dimensional object holds all the possible two-dimensional Pachner moves in a single object. Next, they expand the two-dimensional Pachner moves to three and four dimensions. They use the rotations of ever higher-dimensional tetrahedra to catalog the legal evolutions of cor-

Fig. 9.13. The Pachner moves show the evolution of associations as a two-dimensional rotation of the double-triangle dual figure. Both double-triangle figures can be thought of as different views of the same three-dimensional tetrahedra. Adapted from Carter, Kauffman, and Saito 1997.

responding worldsheets. As rearrangements of the associativity of the underlying particle interactions, Pachner moves convert the passage of time (and the change of associativity that time brings) into a rotation in a higher-dimensional space.

The three-dimensional Pachner moves note the change in associativity of four underlying worldlines. Like the triangles of the two-dimensional Pachner moves, the tetrahedral cells of the three-dimensional Pachner moves are dimension microscopes that permit one to peer in from a higher dimension of space. The variety of possible three-dimensional tetrahedral moves can be construed to be different rotations of the four-dimensional tetrahedron, the 4-simplex. In an astoundingly informative diagram, Carter, Kauffman, and Saito show the evolution of a tree diagram as an associativity pentagon (fig. 9.14). They skip over the steps (shown in fig. 9.11B–C) in which the tree diagrams are shown as worldsheets that pass through one another and where dual simplexes are constructed about singularities (the multiple intersection points). Still, the associative pentagon can now be seen as a collection of three-dimensional Pachner moves (in tetrahedra), and the evolution of the associations as rotations of the whole 4-simplex in four-dimensional space, a rotation that presents a different tetrahedral cell to the viewer. (The escalation of dimensions can continue; box 9.3.) Granted, the power of this dia-

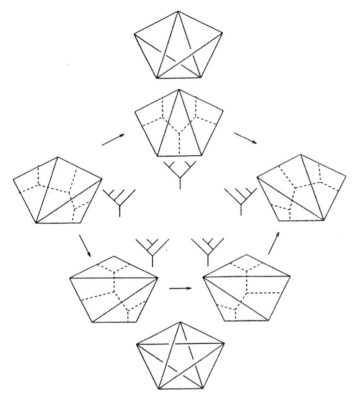

Fig. 9.14. Tree drawings of four lines changing their associativity, with the changes to their dual tetrahedra. These changes in the tetrahedra can be seen as the rotation of a four-dimensional simplex. This drawing represents the same information as fig. 9.5. From Carter, Kauffman, and Saito 1997, used by permission.

gram depends on viewers having a familiarity with the 4-simplex. An initiated viewer would recognize that the star pattern is a projection of the 4-simplex and that the variety of other views are different constituent tetrahedral cells. In discussions of category theory there is much talk of mathematical intuition as a guide to new formalisms, yet there is also a frequent discounting of the visualization of higher-dimensional figures in this work. Mathematical intuitions often *are* visualizations. Carter, Kauffman, and Saito could not be making such leaps of mathematical thinking without an internalized visual apprehension of four-dimensional geometry.

The evolving formalism of category theory assists in the development of these higher-dimensional spin nets. In the language of category theory, patterns of particles are objects, and the static models of their evolutions (their projections) are morphisms. As one moves up the dimension lad-

der, it is useful to have projections of projections, morphisms of morphisms, which can be related to one another in a more direct way than the original projections themselves. Category theory can directly support a discussion of these morphisms of morphisms (2-morphisms) and give structure to higher levels of abstraction.

At the risk of mixing analogies: In New York City, one can take the train uptown and then take the bus across town, or, alternatively, one can take the bus across town and then take the train uptown. These two different trips both get one there in the same amount of time. To make it clear that they are equal alternatives, each route might be drawn on a separate piece of glass and then both placed over a map of the city. These bus and train options work for a variety of starting and ending locations, and they also work for other cities with a transportation system on a grid. Consequently,

Box 9.3 Higher-Dimensional Pachner Moves

The Pachner moves in the fourth dimension escalate all components (fig. 9.15). Five worldlines are tangled; five worldsheets intersect forming a fivefold singularity; a 5-simplex is dual to this point forming the unit of spin foam. The dimension microscopes are four-dimensional simplexes. The engines that work the transformations are the four-dimensional Pachner moves, and these moves are housed in the rotations of the five-dimensional simplex. Working up the dimension ladder from solid results in the lower-dimensional case gives confidence in the results.

As is the case in lower dimensions, individual line elements are considered to be whole spaces of vectors in the next-higher-dimensional system. As Carter, Kauffman, and Saito state, "In this context associativity is no longer an equality between elements, but it is a

homomorphism between vector spaces" (1997, 67). Carter, Kauffman, and Saito proceed with several redundant techniques. The restatement of results in redundant formalisms gives further confidence. (This work confirms that of Louis Crane and Igor Frenkel of 1994.) Unlike some precedents, however, Carter, Kauffmann, and Saito give diagrammatic and ultimately geometric meaning to the subject by detailing the various associative diagrams, showing that these can be interpreted as the four-dimensional Pachner moves and that these moves are rotations of the 5-simplex. There is a visceral sense of space with their geometric approach: it feels like space. It is a space rich enough to house the multiplicity of quantum events but not a preexisting stage on which the drama of physics is played out.

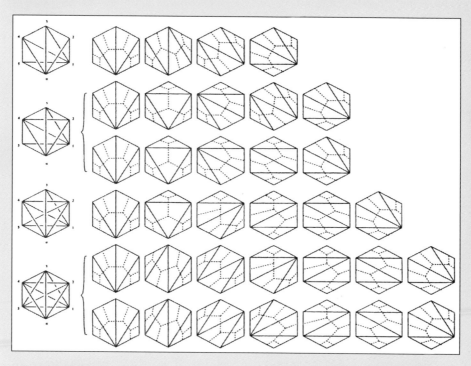

Fig. 9.15. Pachner moves in the fourth dimension. From Carter, Kauffman, and Saito 1997, used by permission.

the stacks of glass are general algorithms for navigating gridlike transportation systems.

There could be subtle differences in who usually chooses lateral-then-vertical trips as opposed to trips in the opposite order; perhaps some personality flukes in the riders are revealed in the metastructure that otherwise would be hidden in the singular "downtown to uptown" history. Or perhaps subtle differences in *when* each kind of trip is chosen are revealed: geometers realize that during rush hour it is better to first wait for the bus in order to take a less-crowded uptown express train, while statisticians find comfort in being part of the general flow—figuring that most resources will be allotted to the route used most. A multilayered structure could define the multiplicity of patterns and reveal hidden structures.

Who knows, even the morph may be relevant to the analogy; going uptown always changes me.

The prospect of spin foam is to house the multiple routes from past to future in a higher-dimensional architecture. The goal is to maintain information about the multiplicity of these many routes. Further, it is to treat all routes equally—the roads not taken as well as the roads taken—because with quantum phenomena it is not always clear which road was taken or even whether several roads were taken simultaneously. Detailing the routes, detailing the critical junctures when routes cross and paths switch, requires climbing the dimension ladder. It also means seeing spacetime as a projection.

The Computer Revolution in Four-Dimensional Geometry

Martin Kemp, the historian of the work of Leonardo da Vinci, refers to himself as a visual historian. The term is apt because it encompasses technical drawing as well as scientific and mathematical modeling and art, and it implies a relationship among these seemingly disparate ways of knowing. Technical drawing is the ground on which art, mathematics, and science stand. Because of the invention of computer graphics, technical drawing is evolving at its fastest rate since the invention of perspective in the Renaissance. Four-dimensional figures were among the very first objects drawn on computers. But technological revolutions are not caused by the machinery itself; rather, revolutions are created by individual men and women. Here are the stories of some of them.

Electrical engineer Michael Noll entered coordinates for his computer-generated hypercube program using punched cards, which tells how early in the history of computing was the first use of the new media to visualize four-dimensional figures. Noll came to Bell Labs as a summer intern, set his sights on eventually becoming part of this unique facility, was hired, and eventually connected with the august research division in 1962. In the early 1960s, under the enlightened leadership of William Baker and John Pierce, Bell Labs was a place that appreciated the synergy of art and mathematics. For example, some of the first computer music was created at Bell Labs. According to Noll, "There was much emphasis at the Bell Labs during the 1960s on educating artists and musicians about the potential for using computers" (1994, 43).

Noll had long been interested in art, and in 1962 he used the freedom provided by Bell Labs to make artwork with the new computer "microfilm printers." In 1960, there were only two Stromberg-Carlson SC4020 printers in the world: Bell Labs had one, and Livermore Labs had the other. These were cathode ray tubes (like a television tube) that had a metal plate with letters of the alphabet inside. First the computer selected a letter to print and instructed the display to shine its beam through the cutout, then it deflected the letter to its proper placement on the screen. At the end of the page, a film was automatically taken of the screen. It soon became obvious to scientists at Bell Labs that the microfilm printer could be modified to print x and y coordinates on the screen for the purposes of displaying scientific information, and the graphics computer was born. Noll realized that a sequence of these microfilm negatives could be an animated film. Ken Knowlton and Stanley Van Der Beek used the device to make the first computer-generated abstract films. The idea bounced back to Noll; he wanted to make animations of three-dimensional computer images that

could be seen as stereo pairs, but of what? Earlier, he had made an imitation Mondrian and compared it to a real one, but that did not seem like a proper use of this powerful new tool. Mathematician Douglas Eastwood suggested using the device to make pictures of hypercubes; Mohan Sondi helped with the equations. Thus, with the help of his colleagues, Noll made computer-generated animations of rotating hypercubes only a few years after the graphics computer was invented. This work, and the mathematics behind it, was first published in the *Communications of the Association for Computing Machinery* (1967) and was subsequently reprinted and cited many times.

Sondi and Noll established two matrix multiplications that rotated and projected the hypercube. Rotation of a cardboard square on a flat table can be defined by taking each two-dimensional vertex of the square and multiplying it with a matrix of the sine and cosine of the angle of rotation taken from a convenient coordinate system. The authors saw that this could also be a three-dimensional rotation in which the third dimension does not change: x goes to a new x, y goes to a new y, but z is the same old z. This process can continue to a fourth dimension: w is the same old w. But having the extra dimensions in the matrices permits different combinations of angles to remain the same while others rotate: xy, xz, xw, yz, yw, and zw are all legal combinations (rotations) in four-dimensional space. Likewise, they realized that the matrix that defined a projection of a three-dimensional object onto a two-dimensional plane could be daisy-chained from four to three to the two-dimensional computer screen. Noll consistently reported his disappointment that even with animated movies of these rotations and projections, no "profound 'feeling' or insight into the fourth spatial dimension" was obtained (Brisson, 156). Yet the mathematics of four-dimensional rotation and projection that they developed became the standard for most of the work that followed.

Noll continued to work in the visualization of four-dimensional figures until he left Bell Labs in

1971. He developed a prism device so that viewers did not have to cross their eyes to fuse the stereo images of hypercubes. He placed letters on the faces of the hypercubes so that one could better understand the four-dimensional rotations. And, most important, he made an interactive version of the rotating hypercubes. Noll also made a computer-generated four-dimensional sphere, a hypersphere. Dots on the surface identified the sphere, and a "fluid" inside rolled around with rotation, turning the object inside out when the rotations were four-dimensional. Noll's work was considered to be both art and math. Several of his computer-generated images were shown at the Howard Wise Gallery in 1965, and copies of the hypercube animations are in the collections of several museums, including the Museum of Modern Art in New York.

Heinz Von Foerster, the well-known early researcher in cybernetics, began his career as a physiologist of perception—a follower of Jean Piaget. Just at the time Noll left Bell Labs in 1971, Von Foerster began a series of experiments to test whether subjects could learn to see the fourth dimension using interactive computers. Von Foerster's original motivation was to use learning to see the fourth dimension as a model for infants learning to see the third dimension. Subjects looked through a stereo viewer that gave each eye a slightly different view of a hypercube; they could rotate the hypercube by turning knobs and immediately see the results on the computer screen. What makes Von Foerster's work compelling is that, as a social scientist, he was not satisfied with anecdotal reports from his subjects; rather, he wanted a quantifiable protocol. By Von Foerster's definition, a subject had learned to see the fourth-dimensional object when they met the following criteria: "Show no surprise about the results of legal four-dimensional maneuvers, can spot inconsistencies in figures, . . . can perform tasks in four-space, can anticipate the results of rotations in four-space[, and] . . . can manipulate one object

behind another or into four-space, as in a 'hyper-Soma cube.'" Von Foerster's written reports were in the form of proposals for funding, describing the work that could be carried out. But these reports were after the fact; the experiments had already taken place. Von Foerster later told me that "over and over" in only one semester, students learned to see four-dimensional objects according to his strict definitions. Although relatively obscure, especially when compared to Noll's widely discussed films, Von Foerster's work gave considerable academic gravitas to claims of higher-dimensional vision that were also being made in the counterculture at that time.

Thomas Banchoff is a tireless advocate for the use of computers to visualize the fourth dimension. His early work with computer scientist Charles Strauss in the late 1970s resulted in many improvements over Noll's pioneering work. Strauss built an array, or parallel, processor that could perform many computations simultaneously, and as a result, it could compute a complete new hypercube in less than one-thirtieth of a second, meaning that the computer screen could refresh at the rate of a normal television with a new, rotated image each time. There was an exquisite responsiveness to Banchoff's computer; the hypercube quivered at the slightest touch. Critical junctures—for example, when cells rotated out of lines—could be repeated, back and forth, until these odd events began to seem normal and the viewer developed an intuitive "feel" for four-dimensional rotation. Thus, Banchoff and Strauss succeeded in producing the first real-time computer-interactive display of higher-dimensional figures. Indeed, Banchoff correctly surmised that real-time was more important than stereo. Even one-eyed people see space fairly well, having learned depth perception by turning the head, moving through space, or watching objects move in space.

Banchoff also introduced body-centered rotations. As mentioned, Noll's and T. P. Hall's mathe-matics describes the six possible rotations in four-dimensional space when axes are taken two at a time to select a plane in which the rotation occurs. These rotations have come to be called world rotations: both the four-dimensional object and the viewer are in the same coordinate world. But how would one describe the intentional roll maneuver of a fighter jet or the end-over-end pitch or pinwheel yaw of an out-of-control airplane? These rotations are easy to define if the axes are those of the pilot (a coordinate system attached to the body of the plane), but they are complicated to define from the coordinate system on the ground. They also *look* very different from world rotations. In four-dimensions, body-centered rotations are bizarre, and the full surprise and magic of four-dimensional figures is revealed only by using both kinds of rotations. The programming of body-centered rotations is more complicated: a summary of all rotations must be kept, and either the inverse of this matrix must be computed or several running summaries of rotations must be kept separate and consulted before each image is computed and drawn. But all twelve rotations (six body-centered and six world) are essential to understanding.

Banchoff and Strauss's film *The Hypercube: Projections and Slicings* (with cells color-coded for clarity) was widely distributed and most influential. Often admired for the astounding transformations found in hypercubes rotating in four dimensions and then projected into three, the slicing part of the film is often overlooked. But no clearer distinction between these two different lower-dimensional manifestations of the hypercube has been made or could be imagined. The terms *slicing* and *projection* were used almost interchangeably in earlier popular literature, and even today the importance of this distinction is often missed. The Banchoff and Strauss movie, still in circulation twenty-five years after it was made, although looking technically outmoded, is still the best way to understand the difference between the projection and slicing models of higher-dimensional space.[1]

Banchoff and his many students were all born at the right time. During the 1980s, as this higher-dimensional visualization project was becoming part of the research effort and curriculum of the mathematics department at Brown University, where Banchoff was chair for many years, two important developments in computer equipment became widely available: the digital color screen and the personal computer. First, the digital color screen allowed for surfaces, not just lines, to be depicted mathematically by computers. The computer could fill these surfaces with transparent color, allowing the overlap of surfaces to be clear. One result was the investigation of hyperspheres and related surfaces in four-dimensional space. Second, the creation of personal computers with computing power equal to or greater than a room-size mainframe greatly accelerated developments.

The four-dimensional sphere is defined as all the points at a given four-dimensional distance from a point, just as the ordinary sphere in three-space is defined as all the points an equal three-dimensional distance from a point. Banchoff points out that the vertices of a hypercube are points of this hypersphere and that one could make a faceted subdivision of the hypercube, inflating the hypercube to approach the surface of the hypersphere. Each facet could be filled with a different color, eventually modeling the surface to appear completely smooth. In central perspective projection the hypersphere appears to be a solid collection of nested torii, just as in central perspective projection the hypercube appears to be a cube with a cube. The surface of any torus hides a great deal of structure, as does the surface of the hypercube. By foliating the surface of selected torii (with Hopf circles) the "inner" surfaces are visible. The influential film *The Hypersphere: Foliation and Projection* (1985) by Thomas Banchoff, David Laidlaw, Huseyin Kocak, and David Margolis shows that by rotating the foliations in four-dimensional space the positions of the torii can be reversed and the surface can be rotated inside out. New images and animations by Banchoff and

Davide Cervone continue to investigate the hypersphere (see fig. 7.9). According to Banchoff, "The collection of Hopf circles on the hypersphere is one of the most intriguing higher-dimensional images. More complicated data sets produce orbits of greater complexity, leading to knotted curves and curves that do not close up after a certain amount of time. It is by comparing such complex systems to the collection of Hopf circles that researchers can begin to visualize more subtle relationships" (1990, 137).

In the hundreds of introductory lectures that Banchoff has given over the years, he usually begins with a discussion of the comic book references to the fourth dimension that he saw as a kid. Indeed, during his early university years, the fourth dimension was still considered kid's stuff, while "real math" included differential geometry or complex analysis. It is Banchoff's legacy, after decades of concentrated, good-humored effort, that real math now includes the computer study and visualization of higher-dimensional polyhedra and surfaces.

The effort to master the geometry of four spatial dimensions is international. Koji Miyazaki (see pl. 1) notes that Japanese mathematician Dairoku Kikuchi wrote an essay called "Introduction to Flatland" that discussed the properties of the four-dimensional cube just four years after Abbott's *Flatland* (1884) was published in England. Manning's *The Fourth Dimension Simply Explained* (1910) was translated into Japanese in 1922. That same year Einstein, a recent recipient of the Nobel Prize, visited Japan, and his visit created interest in the fourth dimension on the part of Japanese scientists, mathematicians, and novelists alike. During the following decade, other important texts on four-dimensional geometry were translated into Japanese.

Although Brill models were brought to Japan in the 1920s, no one pursued the technical drawing of four-dimensional figures in Japan until 1970, when Miyazaki presented the first paper on

the subject to the Japan Society for Graphic Science. The paper was illustrated with drawings of four-dimensional figures that Miyazaki made by hand. The presentation caused a sensation; it won Miyazaki a prize and a series of successively prestigious academic appointments, through which he could collaborate with many computer scientists, mathematicians, physicists, and artists. (His academic appointments have had various titles, from professor of descriptive geometry and graphic science to professor of environmental design.) Miyazaki has produced nine books and over seventy papers, and his students, including the physicist Satoshi Yamaguchi, have produced scores more. For many years, Miyazaki was a mathematical newspaper columnist, as well as the editor of the international journal *Hyperspace,* which had articles in English as well as Japanese.

Like Noll's work just a few years prior, Miyazaki's four-dimensional studies became a research problem that stimulated the development of computer graphic algorithms, and thus computer graphics in general. Originally trained as an architect, Miyazaki has long studied the possibilities of applying four-dimensional geometry to structures. Coxeter credits him with the first quasicrystal tessellations, which were studied as dome structures. Through his many efforts, the computer investigation of higher-dimensional form has a strong following in Japan, and the powers of visualization thus engendered have produced strong work in the geometry and topology of four dimensions.

I have written elsewhere of the profound impact that seeing Banchoff's real-time computer display of the hypercube had on me in the summer of 1979. I was already using multiple perspectives in paintings to place the viewer in several positions at once, as in *1979–8* (pl. 5), as a depiction of hyperspace, but my fascination with and understanding of four-dimensional geometry greatly increased with my experience of Banchoff's computer. The next spring, with the en-

couragement and participation of Herbert Tesser, who was then chair of the computer science department at Pratt Institute, I undertook the study of computer programming for the sole purpose of replicating Banchoff's computer. Tesser's grant of a mainframe computer from the National Science Foundation stipulated that the computer be made available to a larger community than just Pratt, and Tesser was happy to have artists work in his computer lab. In fifteen weeks flat, with no programming background, I had a rotating hypercube on the screen, with all twelve different rotations. The following year, aided by correspondence from Coxeter, I made the first tessellations of hypercubes rotating in four-dimensional space (fig. 10.1). Like my solitary hypercubes, these tessellations rotated in real time (with some jerkiness) and also relied on red and blue anaglyphic glasses to provide stereo viewing. By 1982, personal computers were advanced enough to perform certain tasks as quickly as the million-dollar Vax computers used by university departments so that I could continue to work on computer modeling of higher-dimensional space on my own. At that time, computers were open-chassis devices

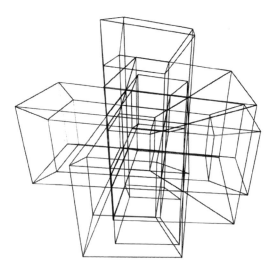

Fig. 10.1. Nine tessellated hypercubes, from my 1982 computer program *Hypers.*

that could be hot-rodded with custom graphics cards and faster crystal timers. Later, these early hardware-specific programs were converted to generic versions by Kurt Baumann; these versions were released as freeware with my first book, *Fourfield: Computers, Art, and the Fourth Dimension* (1992), and also posted on bulletin boards in the early 1990s. With the help and advice of physicist Paul Steinhardt, I also programmed the de Bruijn algorithm for generating quasicrystals, and demonstrations of the multiple symmetries of rotating quasicrystals were also made available to the public in 1992.

The next major development in technical drawing was the invention of the Cave by Tom Defanti, Dan Sandi, Maxine Brown, and Caroline Cruiz-Niera at the Electronic Visualization Laboratory at the University of Illinois at Chicago in 1992. The first Cave consisted of three walls and a floor. Coordinated computer images were projected on each of these surfaces: the walls were screens with back projection, via mirror, and the floor images were projected from above. Siggraph, the annual convention of computer scientists, enthusiasts, and industry representatives, first presented the Cave to the public in 1992, and long lines of people waited to see the amazing virtual reality created by immersion in a world of computer graphics. Wearing stereo glasses, I seemed to walk on the floor of an ocean and capture sharks that swam around me in full three-dimensional space. Even this first Cave tracked the viewer, presenting a new stereo image with every movement, although in contrast to today's Caves the motion was jerky and somewhat delayed. In Caves, there are at least two trackers, one following the body and the other noting which way the head is turned. Cave dwellers also carry a wand or controller, an input device, that is tracked in space and further tracked as to which direction it is pointing. All tracking can be accomplished by cables attached to the glasses and wand or by infrared broadcast. It is a challenge and a require-

ment that the tracking be precise and seemingly instantaneous. As was the case with Bell Labs, one of the first projects of the new technology was visualization of elusive mathematical objects.

The National Center for Supercomputing Applications (NCSA) at the University of Illinois at Urbana-Champaign built the second Cave. George Francis, a member of the mathematics department there, soon saw the potential for his work in topology. Francis's book *A Topological Picturebook* (1988) had already proved his commitment to, and abilities in, visualizing mathematical objects. Working with various teams at Chicago and Urbana-Champaign, Francis applied these immersive and interactive computer projection systems to the visualization of non-Euclidean and four-dimensional geometries. Also like Bell Labs, the teams included artists; Sandi had an art background, and Francis's first collaborator at NCSA was Donna Cox, a professor of art at the university who had drawn Francis into her "Renaissance team" even before the Cave was invented. So essential were artists to the creation and fruitful use of this tool that Francis says, "There were two times in the history of Western culture when art unquestionably preceded mathematics: the Renaissance, with perspective, and today, because computer graphics is bringing up issues in the foundation of geometry that would not come up otherwise" (interview with the author, 2004).

One object of Francis's study is a "3-D shadow of soap films in positively curved elliptic space," an object that he calls the *Snail*. It is a curved surface composed of straight lines, smooth (and minimal) like a soap bubble and twisted like a Möbius band; it is part of the three-sphere that is cast into three-dimensional space. Imagine the lower-dimensional analog: draw a circle on a globe of the earth, and trace on this circle lines of latitude, evenly spaced. To those on the earth these lines are straight, but viewed from a spaceship, the lines make curved bars like a hard-boiled egg in an egg slicer. If this process is repeated on the three-sphere, the result is the *Snail* (pl. 6).

The *Snail* is a specific projection of this circle-with-ruled-lines into a flat three-space, which results in its convoluted surface. The parallel lines that join the edges of the circle appear straight to one on the surface of the three-sphere but appear curved when viewed from outside. The circle in the middle of the *Snail* may seem to be just that to one traveling along its route, but there are views of it from the outside that show it to be a Möbius band. The Cave allows viewers of the *Snail* to take this trip, among many others, and gradually develop a sense of the fullness of this unusual mathematical object. The *Snail* program has a homotopy feature, so that the snail shape morphs into a surface whose edges form a corkscrew. All these objects are continuous deformations of the same object, and the challenge of the *Snail* program is to see how the surface can change from one to another without breaking or tearing.

Francis and his students and collaborators continue to work on a program called *ZYspace* that tessellates the three-sphere with a four-dimensional dodecahedron (the 120-cell). Through each point of the three-sphere passes a unique geodesic, a Hopf circle, which is a line of sight from that point inside the three-sphere in a particular direction. The lines twist about each other as they progress. In collaboration with Jeff Weeks, Francis will explore these lines of sight (pl. 7). Weeks believes our physical universe may be structured like a three-sphere, and so the dodecahedral grid of *ZYspace* could be used to test models of large-scale astronomical observations.

The true value of the Cave and, later, the more complete environment of the Cube (fig. 10.2), which has four walls and a floor of active images (one of which is at the Beckman Institute for Advanced Science and Technology at the University of Illinois at Urbana-Champaign), is that the viewer, in moving through space, has a view that changes with movement. This kinesthetic feedback is an even more powerful tool for reinforcing spatial consciousness than is an interactive joystick. The brain has evolved to make spatial maps

Fig. 10.2. The Cube at the Beckman Institute, University of Illinois at Urbana-Champaign. Drawing by Lance Chong, used by permission.

based on the body's movement and the turning of the head—and these are precisely what is instantaneously tracked in a Cave display. One walks by a convoluted mathematical object—or, better yet, one flies into the middle of it and walks around, turning from side to side like an overstimulated Peter Pan—and builds an intuitive understanding of the object that no amount of back-of-the-envelope sketch or meditation on the formulas can deliver. Like my wall pieces that undergo a four-dimensional rotation as one walks by, observers in a Cube display, walking in a three-dimensional box, could turn onto a four-dimensional path and enter a new three-dimensional box that is a cell of a four-dimensional figure, receiving the vista and visual clues appropriate to that direction in four-dimensional space. This project began with a four-dimensional maze walkabout, called 4Dmaze, by George Francis and Mike Pelsner. In this Cave application, the viewer is able to hike through, not just peer into, a four-dimensional space. Eventually, by many such trips, people will build a four-dimensional mental map, though how easy it is to do so remains debatable.

Has higher-dimensional visualization with these new technical drawing tools already produced a significant breakthrough in mathematics?

Francis cannot yet point to major mathematical proof discovered in the Cave, yet he is certain that the sessions, and those who program them, are building solid intuitions about higher-dimensional space. My recent paintings, such as *2002-5* (pl. 8), grow out of such solid intuitions; time spent on computer programs of four-dimensional geometry and topology allow for a comfort level with, and a taste for, the visual paradox that comes from projecting four-dimensional objects into three dimensions.

Work by Michael D'Zmura and his student Gregory Seyranian at the University of California at Irvine perhaps provides proof that intuitions of hyperspace are a human capability that can be actualized by virtual computer experience. In 2001, the authors reported on a study to test whether subjects could learn to navigate in four-dimensional space. They constructed a virtual house with some rooms connected in three-dimensional space and others connected by passages through the fourth dimension. Each room was distinct in color and detail, so that subjects would have a sense of place as they maneuvered through the rooms by mouse click, in the manner of a computer game. Six subjects were told to depart from the home room in search of a yellow box and then return to the home room by the most efficient route. When the four-dimensional passages were omitted from the trials, it was found that nearly all subjects could immediately return home by the most efficient route. When the four-dimensional passages were added to the trials and yellow boxes placed in rooms accessed only through one or more of these four-dimensional passages, subjects initially had trouble finding the box and returning home by the most direct route. With repeated trials, however, all subjects soon returned home by nearly optimal routes. The authors concluded that their subjects had learned to navigate in four-dimensional space.

A question remains as to whether subjects really form a four-dimensional map or whether they merely navigate by a turn-by-turn set of instructions. After all, ants successfully navigate: they go all over the yard and still get back to their nest. Ant-traversed surfaces sometimes fold up into a third dimension: ants also get inside houses, climbing up the walls, across the countertops, and into the kitchen cabinets. It is hard to believe that ants in the kitchen have a full three-dimensional map, yet they do return to their nest somehow. (No doubt, if they had some decent artists among them, ants making such trips would eventually build a three-dimensional map of the world in ant consciousness.)

Path integration is an intermediate skill between a route instruction set and a full mental map. Path integration means intuiting relative position: if you walk down one block and turn left one block, you can easily guess that making a forty-five-degree left turn faces you back toward the starting position, and also you can fairly accurately guess how far away that position is from where you are now. In the following years, D'Zmura and Seyranian made a new computer-generated environment to test whether subjects could learn four-dimensional path integration. This virtual house had rooms connected in four-dimensional space that all looked the same. Subjects wandered through the maze and after three or four turns were asked to face home and estimate that distance. This task was more difficult than returning home in the yellow-box test, but all subjects improved and gained skill with repeated trials. Most improved dramatically, suggesting that people can learn four-dimensional path integration.

Yet the Irvine authors did not say that their subjects formed a four-dimensional map of their four-dimensional house, because in the first experiment "subjects did not intuit the presence of shortcuts [and this] is an argument in favor of the position that these subjects used local, landmark-based representations for navigation rather than global or map-like representations" (Seyranian and D'Zmura, 30). A convincing proof of a four-

dimensional mental map would find subjects returning by shortcuts that passed through rooms they had not visited on their way to the yellow box. This test would also be convincing if there were a much more complicated four-dimensional house.

There are differences between the 4Dmaze at Urbana-Champaign and the virtual four-dimensional test rooms at Irvine. In the 4Dmaze, there are many more rooms and passageways. Perhaps for these reasons, players rarely function well or get out of the maze. No controlled studies have been done with the 4Dmaze, while at Irvine the authors are psychologists who tested four-dimensional spatial learning in a scientific way. At Urbana-Champaign, the maze spelunking is done in a Cave, whereas at Irvine subjects sat in front of a single computer screen. It would be interesting to bring the best of both installations together for a scientific test. But perhaps this is quibbling: following turn-by-turn instructions and developing skill at path integration are probably initial steps in forming a mental map. And it remains a remarkable fact that, with the aid of computers, individuals can come to grips with four-dimensional space.

Even computer-assisted touch can add to the comprehension of four dimensions. Andy Hanson at the University of Indiana, Bloomington, uses a haptic device to trace the surfaces of a four-dimensional object. To use the device, a subject holds a pen that is attached to computer-controlled gears. The subject can move the pen at will to touch a four-dimensional surface, but if the subject's pen starts to move off the surface the gears resist that motion. Four-dimensional surfaces and polytopes often self-intersect when projected from four to three dimensions; even if one had a mathematically accurate hard model, one could not continuously trace the surface without bumping into a wall that is an artifact of the projection. The advantage of the computer-assisted touching is that one can pass through these walls and hear a sound cue or a voice that says the probing is passing "under" a part of the surface in the fourth dimension. With the aid of this tool, one can build an intuition of the continuity of the four-dimensional surface.

The improvements to the technical illustration of the fourth dimension provided by computers enrich the visual culture in which art and mathematics are done. Geometries are given credence by visualization technologies, whether it is a Renaissance pen drawing, a seventeenth-century wooden model, or a twenty-first-century virtual environment. Seeing it before your eyes, walking through it for a kinesthetic experience, perhaps making a mental map of structures in four-dimensional space, even seeing by touch as a sightless person might—all lead individuals to a more efficient capability with higher-dimensional projections.

Conclusion:
Art, Math, and
Technical Drawing

Too long overlooked is the powerful role that projective geometry has had in the development of current thinking in mathematics and physics. A dominant subject during the nineteenth century, but now often lost from our view, projective geometry contains ideas that have a profound resonance today. And it could not be otherwise, as many of today's mathematical ideas originate with projective geometry.

In Klein's *Developments of Mathematics in the Nineteenth Century*, just after discussing the connection between projective and non-Euclidean geometry, a connection Klein professed over the objections of his colleagues, he returned to the fundamental importance of projective geometry to developing thought. Klein stated that Poncelet, the founder of projective geometry, "should be seen as one of the greatest representatives of the class of mathematicians who we have characterized as daring conquerors. His influence runs through the whole of the 19th Century and has become essential [to] our thought" (1926, 75). About Staudt's invention of the projective *throw*, which Klein understood to be an ordinal number (a placement number) rather than a metric (a measurement number), Klein says, "I had inferred the independence of projective geometry from all metrics . . . [whereas my colleagues] did not conceive of Staudt's purely projective definition of the throw as a pure number, but insisted that this

number is given only as the cross-ratio of four Euclidean distances." In other words, Klein saw the projective metric defined as one that is internal, without reference to any coordinate system at all. The basic concept of a background independent metric, defined without reference to an underlying grid, begins with projective geometry.

Also fundamental to modern thought is the dual nature of objects in projective geometry. In some sense a point and a line are the same object; projective points are lines in a higher dimension. In stating the axioms of projective geometry, one can substitute point for line, and the statements not only make sense but are equally true. These propositions were made long before the dual nature of matter—that a photon, or a neutron, is a bullet and a frothy wave—was accepted. As Penrose later proposed, light rays are much more like projective lines than lines in space because they have a dual nature, not only as particles and waves but also as both points and paths depending on how fast the observer is traveling. Projective geometry begins to challenge the either-or logic of the classical world and replace it with the either-and logic of the quantum world. Nonlocal, with multiple definitions and an inability to be placed in a Cartesian coordinate system—these are features of both projective and quantum reality.

Finally, the classical definition of time cannot withstand modern scrutiny: it runs at different

rates, it can be considered to flow backward on occasion, it holds multiple histories of the same events, it can have an end and a beginning, and it can be constructed on the fly out of parts of other systems. All these may well be features of time, and they are each incompatible with a calculus, or slicing, model of units stacked on one another filling a direction, like building an arrow by adding one wafer-thin section of the shaft on top of another. When applied to spacetime, the projective model holds futures and pasts in the same shape and shows the continuity between the two. The emphasis on the homotopy of the shapes of the future with the shapes of the past is something supported, if not started, by projective geometry. In books on the history of mathematics, diagrams usually show that projective geometry was a necessary prior mathematics to the development of non-Euclidean geometry in the nineteenth century, but the flowchart should also include topology as a consequence of projective geometry. It certainly was the inspiration for Klein's work in topology.

Spatial model is a weak and hackneyed term; spatial models are polyhedra of understanding. Our experience takes place in space, and space is defined by its constituent polyhedra. The effort and goal of scientific explanation is to find the polyhedron or geometric object that accurately describes and then predicts experience. One example given by Albert Einstein and Leopold Infeld in *The Evolution of Physics* (1938) is the drawing that describes a stone falling from a tower (like the tower of Pisa). Although the rock's path could be described by a straight line from its starting position on the tower to its final location on the ground, this geometric object fails to describe an important part of the event. Another line, on a different grid, might describe the distance the rock travels at each one-second interval of its fall; this line, which is a description of its gravitational acceleration, would be a curved line, and Einstein preferred this geometric object because it is a

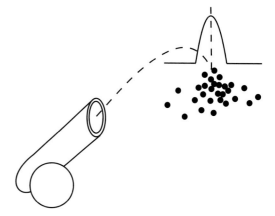

Fig. 11.1. A mathematical technique computes the ideal trajectory, but this ideal is not a true representation of what happened.

complete static model of the event. This model is not quite complete, however, as the new curved line sacrifices a commonsense description of the straight path of the object in order to clarify the nature of its change of speed. Indeed, any geometric model of events glosses over some details in order to exemplify others.

Another example, from Charles Ruhla's *The Physics of Chance* (1992), makes a corollary point. A cannon is adjusted to hit a target; with the same elevation and charge, repeated shots cluster around the target (fig. 11.1). Using the mathematical techniques of standard deviation, the ideal trajectory is calculated. This geometric object is deemed to be true and real, while the actual scatter of shots that do not exactly fit the geometric model is considered to be of lesser truth, to be in error, or even to be beyond the standard deviation and thus not worthy of consideration at all. Ruhla's example shows that there is a value system inherent in any geometric model. A later mathematics that acknowledges, codifies, and even endorses chaos and the "butterfly effect" (where small effects are repeated to have large consequences) has a different inherent value system. When applied to cannon trajectories, this new mathematics would consider the ideal trajec-

tory to be unreal and untrue while considering the scattered hits to be of value. In fact, from the point of view of this new physics, a fractal polygon with edges that dissolve into nothingness would be a better geometric model of the trajectory than a crisp one-dimensional line.

These two examples show spatial models to be only faulty approximations of physical events, models rooted in cultural preferences. Yet the effort to define a law of nature by way of a polyhedron of understanding is so much a part of the scientific approach, so much a part of the furniture, that the models themselves are taken to be real. Such confusion as to the true nature of spatial modeling allows unconscious assumptions to nestle into the upholstery as stowaways. A most pernicious hidden assumption is that the slicing model is an accurate, complete, and exclusive representation of four-dimensional reality, and that any other model used could be converted to it without losing its essential utility as a model of events. But some things that happen in space cannot be reduced to the slicing model, and the projection model is not merely an alternative but often a requirement.

"Mathematics is an exact science; wrong answers are 100 percent wrong." I heard this boring admonition repeatedly in high school when my disastrous math tests were returned to me. (I usually got the algorithm right but was hopeless at computation.) Now, finally, I agree. Observers in different states of motion—and that means just about everybody—are in different coordinate systems. True, relative to the speed of light, the difference in a coordinate system attached to someone walking compared to the coordinate system of someone standing is exceedingly, even immeasurably, small. But mathematics is an exact science, and there is a calculable difference. If the slicing model of spacetime works only for nonrelativistic observers, then it works for blessed few. The projective model of spacetime is the norm. We are living in a projection, not a slice. Alice cannot take the 1 p.m. slice out of her itinerary, give it

to Bob, and expect him to know exactly when she will be at his house. Because they have been in relative motion, their two clocks will not be in sync.

Solids exist because their atoms are in patterns and lattices. There has been a revolution in the mathematics that describes these patterns. They are, all of them, best understood as projections of more simple lattices in higher-dimensional space. Quasicrystal patterns, in particular, are logical and acceptable when viewed this way.

Light rays are more like projective lines than lines in space. A full picture of a light ray or other massless particle shows it to be naturally independent of coordinate systems, naturally twisted, and naturally suited to complex numbers. The enduring mystery of the arrow of time begins to yield to complex projective analysis. Projective lines seem more basic, more fundamental than a coordinate system of dimensionless points. The German physicist Bertfried Fauser, like physicists of every generation since Minkowski's, calls for a study of "projective relativity" (box 11.1).

The state space of quantum particles is a space described by projective geometry. This space consists of lines made from homogeneous coordinates, lines that have a slope but no arrowhead. For two entangled particles, when the receptors are set up to provide discrete results, these state-space lines form some of the polytopes of four-dimensional geometry. It is too odd to be a coincidence; there must be some, as yet unknown, relationship between the three-dimensional space of our experience and the higher-dimensional space of reality. This would be a subtle relationship outside of the modeling capabilities of the simple slicing metaphor.

Quantum foam proposes that there are many quantum routes from A to B. We may experience all of these routes as having been folded into one, but a close study of small events consistently proves that the same thing must have been in more than one place at the same time. By defining

Box 11.1 Later Projective Relativity

Beginning in 1921, Theodor Kaluza speculated that if space could have four dimensions (adding time made five) then electromagnetism and special relativity might be united in a single framework. Oscar Klein elaborated on the idea, and it became the Kaluza-Klein model. The idea intrigued many, and set a precedent for a spacetime model where not all dimensions were directly observable as directions or durations. In 1933, Oswald Veblen attempted to retain the five-dimensionality of Kaluza-Klein yet return the model to the dimensions of our direct experience by applying the principles of projective geometry, to make four homogeneous coordinates out of the original five. Einstein, Peter Bergmann, and Wolfgang Pauli repeatedly took up projective relativity only to abandon the idea as moribund.

Now projective relativity is being revived by physicist Bertfried Fauser, at the Max Planck Institute, and others in Germany. In 2000, Fauser reiterated that for quantum physics, projective geometry never really died: "Birkhoff and von Neumann showed that quantum mechanics is based on projective concepts. . . . Dirac told that projective reasonings led him to find his electron equation." The main problem of relating "the projective space to a metrical world continuum was done by [Pascual] Jordan," he continued, citing a 1955 paper. Finally, with words that are music to my ears, Fauser wrote that the fixed idea that "lines, planes, and spaces are made from continua of points is no more than a mathematical virus. The antidote to this kind of virus is projective geometry" that functions without Cartesian coordinates (3–5).

Fauser did not mention twistors, the other recent attempt to use projective geometry to unite relativity with quantum mechanics, which makes his approach all the more spontaneous. He admitted that he is only at the beginning, "a first small step in this new direction."

our experience to be projective, then turning our projective experience into a higher-dimensional projection, we can unfold the many histories and the nonlocalities of quantum events into a comprehensible model.

Consider this book a modest proposal to rid our thinking of the slicing model of four-dimensional figures and spacetime in favor of the projection model. In effect, the proposal is to see time whole, as geometry, and in this way to embrace higher-dimensional geometry as solid, factual polyhedra of understanding. According to our philosophical traditions that place value on the symmetrical origins of multiple, simultaneous information, there is, in truth, a *reality* to a higher-dimensional-geometry description of nature, and it is often accepted as such. Although it already is a working premise in physics that reality is higher-dimensional, it is also conceded that we experience higher-dimensional reality reduced to three dimensions of space and a residue, called time. Here is the opportunity to understand the nature of that reduction. The proposal means developing a distaste for the slicing model, for the arrogant and inhibiting claim that time is the fourth dimension, and especially for the ubiquitous notion that seeing something evolve in time is somehow an experience of four-dimensional reality. Applications of the slicing model to four-dimensional objects short-circuit understanding; our space may have a far different structure as in the "many-fold" proposal (box 11.2).

Though people at the end of the nineteenth century could imagine a higher-dimensional reality that impinged on the world of experience, it is more factual to imagine a higher-dimensional reality wholly applied to and inserted into the world of three dimensions. Such a concept comes to a culture when it can be supported by technical drawing and by the visual culture as a whole. Technical drawing of higher-dimensional figures is the foundation that stabilizes these concepts and makes these spatial models real.

Box 11.2 Projections and Branes

In his book *The Great Beyond* (2004), physicist Paul Halpern argues that the five-dimensional Kaluza-Klein model is a continuing tradition in modern physics, with adherents in every generation since its inception in 1921. Halpern shows that contemporary string-and-brane (membrane) models use Kaluza-Klein as a basis. The *manyfold* version of the brane models, by Nima Arkani-Hamed, Savas Dimopoulos, and Georgi Dvali, is implicitly a projection model—projection with a filter. Light must go through the four-dimensional fabric of spacetime, like the warp threads in a folded cloth, but gravity can be projected from fold to fold. Such a model can account for the unusual weakness of gravity; Halpern notes that even a small magnet can defeat the gravitational pull of the entire earth on a paper clip. In the manyfold model, gravity leaks out of spacetime in the fold of the cloth into the bulk around the cloth. Gravity can also skip from layer to layer of the cloth, like a silver pin through the pleats of a kilt. By passing through the bulk, gravity affects objects in the brane directly while light from this same gravitation source must pass through the long journey along the folded cloth; this would account for the dark matter in the universe that greatly outweighs the visible matter. Both the leaking out of and the leaking into the brane should be testable effects of gravity. The gravitational attraction of objects very close to one another should be different from the gravitational attraction at human scale. Unfortunately, clever experiments show no diminution of the gravitational force at distances as small as one-fifth of a millimeter. Also studies show no difference in the arrival times of light and gravitational effects from the same astronomical source.

What blocks the advancement of our understanding, or our acceptance of the already well-developed models of events in contemporary physics as real, is the bad habit of our attachment to the slicing model. This is essentially an emotional rather than a conceptual block. But culture offers emotional support. Technical drawing is the ground on which art and mathematics both stand. Like water finding its level, Mind is moving to a new equilibrium. Unwittingly, and hopefully more and more wittingly, Art moves with Mind and in turn offers comfort and courage to Mathematics.

Appendix

Poincaré's analysis for the Lorentz transformations of $x, y, z,$ and t to their new primed values is as follows:

$$\gamma = \frac{1}{\sqrt{1 - \left\{ \dfrac{v}{c} \right\}^2}}$$

$$x' = \gamma x + \left\{ \frac{i\gamma v}{c} \right\} t$$

$$y' = y$$

$$z' = z$$

$$t' = -\frac{i\gamma v}{c} x + \gamma t$$

Note that since

$$\gamma^2 + \left\{ \frac{i\gamma v}{c} \right\}^2 = 1,$$

these two terms can be considered the cosine and sine, respectively, of an angle. The Lorentz transformations then assume the formalism of a four-dimensional rotation about the origin.

Notes

Chapter 1. The Origins of Four-Dimensional Geometry

1 Although biographical details in an obituary in the *Vancouver Daily Province* do not agree with earlier information in the *Tabor College Monthly* and Clark University documents, it seems likely that the details of his life are as presented here.

2 Hall became a progressive thinker in Vancouver: "Why should it be necessary for a woman to sell her virtue in order to live? Only because the community, by an unjust system of industrial slavery, has denied to her, in many cases, any way of making a decent living . . . prostitution will continue . . . until every woman is given her right, the opportunity to earn a good living and to get all that she earns." *Urologic and Cutaneous Review,* November 1913, 599. Late in life, he also published science fiction in *Amazing Stories Quarterly* (oddly, the only thing that comes up in an Internet search for Hall).

3 Newcomb's argument against the airplane is cogent, detailed, but wrong. Newcomb failed to envisage lightweight hollow airplanes. Nor did he imagine the efficiency of the modern propeller or jet engine. In fairness to Newcomb, he did mention the helicopter as a promising idea and wondered why no one seemed to be pursuing it.

4 Historian of science Scott Walter found more than two thousand titles dealing with *n*-dimensional and non-Euclidean geometry in a 1911 bibliography.

Chapter 3. The Fourth Dimension in Painting

1 Adam's observation was made during a lecture I gave on this material to the graduate art history department at Oxford University, 2 March 2004.

2 Strictly speaking, figures 3.5, 3.6, and 3.8 could all be considered projections: figures 3.5 and 3.6 are both composites of parallel projections to a plane, while figure 3.8 is a nonperspective projection. To keep terminology clear, however, and especially to distinguish sources and conceptual approaches one from another, parallel projection to a plane—a technique that renders exploded or unfolded figures composed of three-dimensional cells—shall be referred to as the *slicing model*, while the term *projection model* shall refer to drawings and models of fully connected cells, which place all the cells in the same (three-dimensional) place at the same time.

Chapter 4. The Truth

1 In 1904, Lorentz cited new experiments by Rayleigh and Brace, and others by Trouton and Noble, all now obscure, which he concluded to confirm the Michelson-Morley results. Thus for Lorentz, the experimental evidence was accumulating. After Michelson gave up, Morely and his new collaborator Dayton C. Miller kept trying, well into the 1930s, but these experiments took place after the time being considered.

2 Minkowski's notebook is archived in the Jewish National and University Library, Israel (box 9, folder 7); photocopies are held at the Niels Bohr

Library at the American Institute of Physics, College Park, Maryland.

Chapter 6. Patterns, Crystals, and Projections

1 Known since antiquity, the *golden ratio* is an irrational number found in the ratio between the diagonals and the sides of a pentagon. There are two ways to arrange the ratio, yielding two numbers:

$$\frac{\sqrt{5} + 1}{2}$$

and

$$\frac{\sqrt{5} - 1}{2}$$

or 1.61803 . . . and 0.61803. . . . Both numbers are in the golden ratio to 1. A Fibonacci series starts with a long and short interval, and grows by replacing every long interval with a long and short interval and replacing every short interval with a long one.

2 Like Ammann, de Bruijn too had a difficult early life. During the Nazi occupation of Holland, he spent four years hidden in an attic. Initially uninterested in mathematics, he picked it up as a way to distract himself from his ordeal. Never really formally trained (and therefore a bit of an outsider like many in this book), de Bruijn nevertheless ended his career as a distinguished professor of mathematics at Eindhoven University of Technology, without ever even receiving his Ph.D. It was after his retirement from teaching that de Bruijn took up the quasicrystal studies that will be his greatest contribution. As of this writing, a happier, more vigorous eighty-six-year-old man would be hard to find.

3 Although it seems that the projection method skips directly to the desired dimension, it actually projects to each dimension along the way. For example, a four-dimensional pattern of hypercubes is projected first to the third dimension, then that three-dimensional object projects to the flat plane where the Penrose tiling is shown. The Penrose tiling of rhombs is a special case of the quasicrystal tiling of blocks; they are turned so that the third axis is completely foreshortened. Architect and mathematician Haresh Lalvani has studied the relationship between these levels in a projection; he has noticed that the angles in the unit cells of the flat patterns are the dihedral angles (the angles of the folds of the blocks) of the units of the next-higher-dimensional unit cells. For example, the

acute angles of the fat rhomb of the Penrose tiling are 72 and 108 degrees, and 36 and 144 degrees for the skinny rhomb. These are the angles at which the planes of the three-dimensional blocks meet. There are likely many insights to be gained in this area of study.

4 This is a relative matter, as no crystal, periodic or not, is perfect. Peter Stephens and Alan Goldman, among others, have suggested that in the case of quasicrystals, quite a few mistakes in the tessellation could be tolerated and still produce sharp, fivefold Bragg peaks, which would make quasicrystals more random, and thus less mysterious.

Chapter 7. Twistors and Projections

1 Inside the light cone would be Newtonian physics, on the surface of the light cone would be the physics of total relativity, and outside the light cone altogether would be the undefined physics of faster-than-light travel. But relativity is not all or nothing, and speeds less than that of light also contract space according to the known formulas of Lorentz. As spacetime paths approach the slope of the surface of the light cones, they become more and more like the projective lines of the surface; the interior too, to some degree, is a projective space.

2 When $v = c$, then

$$\sqrt{1 - \frac{v^2}{c^2}} = 0$$

and any length multiplied by this Lorentz factor also becomes zero.

3 If we use homogeneous coordinates that are ratios of a triplet of numbers—$(a, b, c) \sim (a/c, b/c)$—any set of numbers that satisfies the ratio can be considered to be the same point, as there is no way to distinguish between them. These points all lie on a line in higher-dimensional space (see fig. 5.5).

4 Deepening the connection to projective geometry is the possibility of transforming any four points on the Riemann sphere to any other four points by a projective transformation, as long as both sets have the same cross-ratio. (Here think of the Riemann sphere as a complex projective line.) The four points must be co-planar on the Riemann sphere, meaning that they must be collinear when projected on its corresponding plane. This means that Lorentz transformations, Möbius transformations, and projective transformations are mathematically equivalent in some cases.

Chapter 9. Category Theory, Higher-Dimensional Algebra, and the Dimension Ladder

1 These higher-dimensional weak categories are complicated and intricate. Subtle modifications have consequences that are hard to fully predict. It takes much work to prove that they are still self-consistent when variations are introduced. It has yet to be determined that the various candidates for weakening categories are all mathematically equivalent, so that a practitioner can choose with confidence one that suits the purpose at hand. Precisely which modification will be useful for which application is also hard to predict. Finally, that category-theory mathematics can be communicated to, and used by, those who have not devoted a full life of work to it is also a legitimate criterion for success.

Chapter 10. The Computer Revolution in Four-Dimensional Geometry

1 The film *The Hypercube: Projections and Slicings* is available on film, VHS, or DVD from T. Banchoff, 18 Colonial Road, Providence, R.I. 02906. The film *Hypersphere: Foliation and Projection* is also available from the same address.

Bibliography

Abbott, E. A. 1884. *Flatland: A Romance of Many Dimensions.* Reprint, New York: Barnes and Noble Books, 1963.

Aczel, A. 2001. *Entanglement: The Greatest Mystery in Physics.* New York: Four Walls Eight Windows.

Aravind, P. K. 1997. Borromean Entanglement of the GHZ State. In *Quantum Potentiality, Entanglement and Passion-at-a-Distance*, ed. R. S. Cohen, M. Horne, and J. Stachel. Dordrecht: Kluwer.

——. 1999. Impossible Colorings and Bell's Theorem. *Physics Letters* A262: 282.

——. 2000. How Reye's Configuration Helps in Proving the Bell-Kochen-Specker Theorem: A Curious Geometrical Tale. *Foundations of Physics Letters* 13: 499.

——. 2004. Quantum Mysteries Revisited Again. *American Journal of Physics* 72: 1303–7.

——. n.d. Home page, Worcester Polytechnic Institute. http://users.wpi.edu/~paravind/.

Arkani-Hamed, N., S. Dimopoulos, and G. Dvali. 2000. The Universe's Unseen Dimensions. *Scientific American*, August, 62–69.

Baez, J. 2004. Why *n*-Categories? What *n*-Categories Should Be Like. Space and State, Spacetime and Process. Slides and notes for lectures given at the Institute of Mathematics and Its Applications workshop on *n*-categories, June. Available on Baez's Web site, http://math.ucr.edu/home/baez/n_categories/index.html#why.

——. n.d. *John Baez's Stuff.* http://math.ucr.edu/home/baez/.

Banchoff, T. F. 1990. *Beyond the Third Dimension: Geometry, Computer Graphics, and Higher Dimensions.* New York: Scientific American Library.

——. n.d. Home page. http://www.geom.uiuc.edu/~banchoff/.

Banchoff, T., and J. Wermer. 1991. *Linear Algebra through Geometry.* New York: Springer-Verlag.

Bar-Natan, D. 2003. "Khovanov Homology." http://www.math.toronto.edu/~drorbn/papers/Categorification/NewHandout.pdf.

Bell, E. T. 1937. *Men of Mathematics.* New York: Simon and Schuster.

Bohm, D. 1957. *Causality and Chance in Modern Physics.* Princeton, N.J.: Van Nostrand.

Boyer, C. B. 1949. *The Concepts of the Calculus.* New York: Hafner.

Brisson, D. W., ed. 1978. *Hypergraphics: Visualizing Complex Relationships in Art, Science and Technology.* Boulder: Westview.

Brown, R., and T. Porter. 2001. The Intuitions of Higher Dimensional Algebra for the Study of Structured Space. Lecture given at the École Normale Supérieure, Paris, May 30. Available on Brown's Web site, http://www.bangor.ac.uk/~mas010/paris-cogn8.pdf.

——. 2003. Category Theory and Higher Dimensional Algebra: Potential Descriptive Tools in Neuroscience. Lecture given at the International Conference of Theoretical Neurobiology, Delhi, Feb. 24. Available on Brown's Web site, http://www.informatics.bangor.ac.uk/public/mathematics/research/ftp/cathom/03_05.pdf.

Carter, S., S. Kamada, and M. Saito. 2002. *Surfaces in 4–Space.* New York: Springer-Verlag.

Carter, S., L. Kauffman, and M. Saito. 1997. Diagrammatics, Singularities, and Their Algebraic Interpretations. *Matemática Contemporânea* 13: 21–115.

——. 1999. Structures and Diagrammatics of Four Dimensional Topological Lattice Field Theories. *Advances in Mathematics* 146: 39–100.

Carter, S., and M. Saito. 1991. *Knotted Surfaces and Their Diagrams.* Providence, R. I.: American Mathematical Society.

Cervone, D. n.d. Home page. http://www.math.union.edu/~dpvc/.

Cheng, E., and A. Lauda. 2004. *Higher-Dimensional Categories: An Illustrated Guide Book.* A draft version was prepared for the Institute of Mathematics and Its Applications workshop on *n*-categories and is available at http://www.dpmms.cam.ac.uk/~elgc2/guidebook/.

Collins, H., and T. Pinch. 1993. *The Golem: What You Should Know about Science.* Cambridge: Cambridge University Press.

Cooke, R., and V. Rickey. 1989. W. E. Story of Hopkins and Clark. In *A Century of Mathematics in America,*

Part 3, ed. P. Duren. Providence, R.I.: American Mathematical Society.

Corefield, D. 2003. *Towards a Philosophy of Real Mathematics*. Cambridge: Cambridge University Press.

Courant, R., and H. Robbins. 1941. *What Is Mathematics?* Oxford: Oxford University Press.

Coxeter, H. S. M. 1942. *Non-Euclidean Geometry*. Toronto: University of Toronto Press.

——. 1948. *Regular Polytopes*. Reprint, New York: Dover, 1972.

——. 1961. *Introduction to Geometry*. Reprint, New York: Wiley, 1980.

——. 1964. *Projective Geometry*. New York: Blaisdell.

Daix, P. 1995. *Dictionnaire Picasso*. Paris: Laffont.

DeBruijn, N. 1981. Algebraic Theory of Penrose's Non-Periodic Tiling of the Plane. *Koninklijke Nederlands Akademie van Wetenschappen Proceeding Series A*.

——. n.d. Home page. http://www.win.tue.nl/~wsdwnb/.

d'Espagnat, B. 1981. The Concepts of Influences and of Attributes as Seen in Connection with Bell's Theorem. *Foundations of Physics* 11: 205–34.

Dubois, J. M. 2000. Beyond the Usefulness of Quasicrystals. In *Quasicrystals: Preparation, Properties, and Applications*, ed. E. Belin-Ferré, P. Thiel, A. Tsai, and K. Urban. Warrendale, Pa.: Materials Research Society.

Durkheim, E. 1897. *Suicide, a Study in Sociology*. Trans. J. A. Spaulding and G. Simpson. New York: Free Press, 1966.

Einstein, A. 1905. On the Electrodynamics of Moving Bodies. Reprinted in *The Principle of Relativity*. New York: Dover, 1952.

——. 1952. *Relativity: The Special and General Theory*. Trans. R. W. Lawson. Includes an appendix on "Relativity and the Problem of Space." New York: Crown, 1961.

Einstein, A., and L. Infeld. 1938. *The Evolution of Physics*. New York: Simon and Schuster.

Einstein, A., B. Podolsky, and N. Rosen. 1935. Can Quantum-Mechanical Description of Physical Reality Be Considered Complete? *Physical Review* 47: 777.

Elser, V. 1986. The Diffraction Pattern of Projected Structures. *Acta Crystallographica Section A* 42: 34–36.

Elser, V., and N. Sloane. 1987. A Highly Symmetric Four-Dimensional Quasicrystal. *Journal of Physics A: Mathematical and General* 20: 6161–68.

European Cultural Heritage Online. n.d. "Notebooks of Einstein and Minkowski in the Jewish National and University Library." http://echo.mpiwg-berlin.mpg.de/content/relativityrevolution/jnul.

Fauser, B. 2000. Projective Relativity: Present Status and Outlook. Available on Citebase, http://citebase.eprints.org/cgi-bin/citations?id=oai:arXiv.org:gr-qc/0011015.

——. n.d. Home page. http://kaluza.physik.uni-konstanz.de/~fauser/P_BF.shtml.

Fishback, W. T. 1962. *Projective and Euclidean Geometry*. New York: Wiley.

Francis, G. K. 1988. *A Topological Picturebook*. New York: Springer-Verlag.

——. 2005. Metarealism in Geometrical Computer Graphics. In *Visual Mind II*, ed. M. Emmer. Cambridge, Mass.: MIT Press.

——. n.d. Home page. http://www.math.uiuc.edu/~gfrancis/.

Galison, P. L. 1979. Minkowski's Spacetime: From Visual Thinking to the Absolute World. *Historical Studies in the Physical Sciences* 10: 85–121.

Greenberg, M. J. 1973. *Euclidean and Non-Euclidean Geometries*. San Francisco: Freeman.

Greenberger, D. M., M. Horne, A. Shimony, and A. Zeilinger. 1990. Bell's Theorem Without Inequalities. *American Journal of Physics* 58: 1131–43.

Hall, G. S. 1893. *Third Annual Report of the President*. Worcester, Mass.: Clark University.

Hall, T. P. 1893. The Projection of Fourfold Figures upon a Three-Flat. *American Journal of Mathematics* 15: 179–89.

Halpern, P. 2004. *The Great Beyond*. Hoboken, N.J.: Wiley.

Hawking, S., and R. Penrose. 1996. *The Nature of Space and Time*. Princeton, N.J.: Princeton University Press.

Henderson, L. 1983. *The Fourth Dimension and Non-Euclidean Geometry in Modern Art*. Princeton, N.J.: Princeton University Press.

——. 2005. Modernism and Science. In *Modernism*, ed. V. Liska and A. Eysteinsson. Amsterdam: John Benjamins.

Huggett, S. A., ed. 1998. *The Geometric Universe: Science, Geometry, and the Work of Roger Penrose*. Oxford: Oxford University Press.

Hughston, L. P., and R. S. Ward., eds. 1979. *Advances in Twistor Theory*. San Francisco: Pitman Advanced Publishing Program.

Institute for Mathematics and Its Applications. n.d. *IMA 2004 Summer Program: n-Categories: Foundations and Applications*. http://www.ima.umn.edu/categories/.

Ivins, W. M. 1946. *Art and Geometry*. New York: Dover.

Janot, C. 1994. *Quasicrystals: A Primer*, 2nd ed. Oxford: Clarendon Press.

Jouffret, E. 1903. *Traité élémentaire de géométrie à quatre dimensions* (Elementary Treatise on the Geometry of Four Dimensions). Paris: Gauthier-Villars.

——. 1906. *Mélange de géométrie à quatre dimensions* (Various Topics in the Geometry of Four Dimensions). Paris: Gauthier-Villars.

Kauffman, L. n.d. Time, Imaginary Value, Paradox, Sign and Space. Available on Kauffman's Web site, http://www2.math.uic.edu/~kauffman/TimeParadox.pdf.

——. n.d. Home page. http://www2.math.uic.edu/~kauffman/.

Klein, F. 1908. *Elementary Mathematics from an Advanced Standpoint, Geometry*. Trans. E. R. Hedrick and C. A. Noble. New York: Dover, 1939.

——. 1926. *Developments of Mathematics in the Nineteenth Century*. Vol. 1, trans. M. Ackerman. Brookline, Mass.: Math Sci Press, 1979. Vol. 2, reprint (untranslated), New York: Chelsea, 1950.

Kwiat, P. G., and L. Hardy. 1999. The Mystery of the Quantum Cakes. *American Journal of Physics* 68: 33–36.

Longuet-Higgens, M. S. 2003. Nested Triacontahedral Shells. *Mathematical Intelligencer* 25: 25–43.

Lorentz, H. A. 1895. Michelson's Interference Experiment. Reprinted in *The Principle of Relativity*. New York: Dover, 1952.

Mallen, E. n.d. *On-Line Picasso Project*. http://www.tamu.edu/mocl/picasso/tour/thome.html

Manning, H. P. 1910. *The Fourth Dimension Simply Explained*. Reprint, New York: Dover, 1956.

——. 1914. *Geometry of Four Dimensions*. Reprint, New York: Dover, 1956.

Mermin, N. D. 1989. *Space and Time in Relativity*. Prospect Heights, Ill.: Waveland Press.

——. 1990. Quantum Mysteries Revisited. *American Journal of Physics* 58(8): 731–33.

——. 1994. Quantum Mysteries Refined. *American Journal of Physics* 62: 880–82.

Miller, A. I. 1981. *Albert Einstein's Special Theory of Relativity*. Reading, Pa.: Addison-Wesley.

——. 2001. *Einstein, Picasso*. New York: Basic Books.

Minifie, W. 1871. *A Text Book of Geometrical Drawing*. Reprint, New York: Van Nostrand, 1881.

Minkowski, H. 1907. Das Relativitätsprinzip (The Relativity Principle). *Jahresbericht der Deutschen Mathematiker-Vereinigung* 24: 372–82; also available in *Annalen der Physik* 47: 927–38.

——. 1908. Space and Time. Reprinted in *The Principle of Relativity*. New York: Dover, 1952.

Miyazaki, K. 1983. *An Adventure in Multidimensional Space: The Art and Geometry of Polygons, Polyhedra, and Polytopes*. New York: Wiley.

——. 1991. Design of Space Structures from Four-Dimensional Regular and Semi-Regular Polytopes. In *Spatial Structures at the Turn of the Millennium*, ed. T. Wester, S. J. Medwadowski, and I. Mogensen. Copenhagen: IASS.

Monge, G. 1803. *Geometría Descriptiva*. Reprint, Madrid: Colegio de Ingenieros des Caminos, Canales y Puertos, 1996.

Needham, T. 1997. *Visual Complex Analysis*. Oxford: Clarendon Press.

Nelson, D. R. 1986. Quasicrystals. *Scientific American* 255, no. 2: 43–51.

Newcomb, S. 1878. Note on a Class of Transformation Which Surfaces May Undergo in Space of More Than Three Dimensions. *American Journal of Mathematics* 1: 1–4.

——. 1898. The Philosophy of Hyperspace. *Science* 7: 1–7. Originally published in *Bulletin of the American Mathematical Society* 4 (February 1898): 187–95.

——. 1906. The Fairyland of Geometry. In *Side-lights on Astronomy and Kindred Fields of Popular Science*. New York: Harper.

Noll, M. 1967. A Computer Technique for Displaying N-Dimensional Hyperobjects. *Communications of the Association for Computing Machinery* 10, no. 8: 469–73. Reprinted in Brisson.

——. 1968. Computer Animation and the Fourth Dimension. *AFIPS Conference Proceedings*, vol. 33. Washington, D.C.: Thompson.

——. 1994. The Beginnings of Computer Art in the United States: A Memoir. *Leonardo* 27: 39–44.

Olivier, F. 1933. *Picasso and His Friends*. Trans. J. Miller. New York: Appleton-Century, 1965.

——. 1988. *Loving Picasso*. Trans. C. Baker. New York: Abrams, 2000.

Palau i Fabre, J. 1990. *Picasso Cubism (1907–1917)*. New York: Rizzoli.

Peat, D. E. 1988. *Superstrings and the Search for the Theory of Everything*. Chicago: Contemporary Books.

Penrose, R. 1978. The Geometry of the Universe. Reprinted in *Mathematics Today: Twelve Informal Essays*, ed. L. A. Steen. New York: Vintage Books, 1980.

——. 1979. Combinatorial Quantum Theory and Quantized Directions. In Hughston and Ward.

——. 1987. On the Origins of the Twistor Theory. In *Gravitation and Geometry*, ed. W. Rindler and A. Trautman. Naples: Bibliopolis. Also available at http://users.ox.ac.uk/~tweb/00001/index.shtml.

——. 1989. *The Emperor's New Mind*. Oxford: Oxford University Press.

——. 1994. *Shadows of the Mind: A Search for the Missing Science of Consciousness*. Oxford: Oxford University Press.

——. 2004. *The Road to Reality: A Complete Guide to the Laws of the Universe*. London: Jonathan Cape.

Penrose, R., and Rindler, W. 1984 (vol. 1), 1986 (vol. 2). *Spinors and Space-Time*. Cambridge: Cambridge University Press.

Poincaré, H. 1905. *Science and Hypothesis*. Trans. J. Larmor. New York: Dover, 1952.

——. 1913. *Last Thoughts*. Trans. J. W. Bolduc. New York: Dover, 1963.

Poncelet, J. V. 1822. *Traité des propriétés projectives des figures* (Treatise on the Projective Properties of Figures). Reprint, Paris: Gauthiers-Villars, 1865.

Robbin, T. 1989. Quasicrystal Architecture. *ISISS Budapest*. Reprinted in *Leonardo* 23, no. 1.

——. 1992. *Fourfield: Computers, Art, and the Fourth Dimension*. Boston: Little, Brown.

——. 1996. *Engineering a New Architecture*. New Haven: Yale University Press.

——. 1997. *An Architectural Body Having a Quasicrystal Structure*. U.S. Patent and Trademark Office, patent number 5,603,188.

——. 1997. Quasicrystal Architecture: The Space of Experience. In *Beyond the Cube*, ed. J. F. Gabriel. New York: Wiley.

——. 2005. Four-Dimensional Projection: Art and Reality. In *Visual Mind II*, ed. M. Emmer. Cambridge, Mass.: MIT Press.

Rosenfeld, D. 1991. *European Painting and Sculpture, ca. 1770–1937, in the Museum of Art, Rhode Island School of Design*. Providence, R.I.: The Museum.

Rucker, R. v. B. 1977. *Geometry, Relativity and the Fourth Dimension*. New York: Dover.

——. 1980. *Speculations on the Fourth Dimension: Selected Writings of Charles H. Hinton*. New York: Dover.

——. 1987. *Mind Tools*. Boston: Houghton Mifflin.

Ruhla, C. 1992. *The Physics of Chance, from Blaise Pascal to Niels Bohr.* Trans. G. Barton. Oxford: Oxford University Press.

Ryan, P. J. 1986. *Euclidean and Non-Euclidean Geometry: An Analytic Approach.* Cambridge: Cambridge University Press.

Schläfli, L. 1852. *Theorie de vielfachen Kontinuität.* Reprint, Zurich: Zurcher und Furrer, 1901. Translated in part by A. Cayley as "On the Multiple Integral . . . ," *Quarterly Journal of Pure and Applied Mathematics* 2 (1858): 269–301.

Schlegel, V. 1882. Quelque théorèmes géométrie à *n* dimensions (Some Theorems in *n*-Dimensional Geometry). *Bulletin de la Société Mathématique de France* 10: 172–203.

———. 1885. Ueber Projektionsmodelle der regelmässigen vier-dimensional Körper (On the Projection Models of the Regular Four-Dimensional Figures). Pamphlet distributed with the Shilling and Brill models.

School of Mathematics and Statistics, University of St. Andrews, Scotland. n.d. Math biographies. http://www-gap.dcs.st-and.ac.uk/~history/BiogIndex.html.

Schoute, P. H. 1902. *Mehrdimensionale Geometrie: Die Linearen Räume* (Higher-Dimensional Geometry: The Linear Space). Leipzig: G. J. Göschensche Verlagshandlung.

———. 1905. *Mehrdimensionale Geometrie: Die Polytope* (Higher-Dimensional Geometry: The Polytope). Leipzig: G. J. Göschensche Verlagshandlung.

Senechal, M. 1995. *Quasicrystals and Geometry.* Cambridge: Cambridge University Press.

———. 2004. The Mysterious Mr. Ammann. *Mathematical Intelligencer* 26: 10–21.

Senechal, M., and G. Fleck, eds. 1988. *Shaping Space.* Boston: Birkhäuser.

Seyranian, G., and M. D'Zmura. 2001. Search and Navigation in Environments with Four Spatial Dimensions. Available on the University of California at Irvine's 4D Virtual Environment Web site, http://www.vrlab.uci.edu/vrlab/movies/spaceship.html.

Smolin, L. 2001. *Three Roads to Quantum Gravity.* New York: Basic Books.

Sommerville, D. M. Y. 1929. *An Introduction to the Geometry of N Dimensions.* Reprint, New York: Dover, 1958.

Stein, G. 1933. *The Autobiography of Alice B. Toklas.* Reprint, London: Penguin Books, 1966.

Stephens, P. W., and A. I. Goldman. 1991. The Structure of Quasicrystals. *Scientific American* 264, no. 4: 44.

Stillwell, J. 1989. *Mathematics and Its History.* New York: Springer-Verlag.

Story, W. E. 1897. Hyperspace and Non-Euclidean Geometry. *Mathematical Review* 1.

Stringham, W. I. 1880. Regular Figures in *n*-Dimensional Space. *Journal of Mathematics* 3: 1–14.

———. 1885. On the Rotation of a Rigid System in Space of Four Dimensions. *Proceedings of the American Association for the Advancement of Science* (Philadelphia, September 1884, thirty-third meeting), 55–57.

Struik, D. J. 1984. *A Concise History of Mathematics.* New York: Dover.

Sylvester, J. J. 1869. A Plea for the Mathematician. *Nature* 1 (30 December): 238.

Thorne, W. M. 1888. *Junior Course: Mechanical Drawing.* Philadelphia: Williams, Brown and Earle.

van Gogh, V. *Van Gogh: A Self-Portrait, Letters Revealing His Life as a Painter,* ed. W. H. Auden. New York: Dutton, 1963.

Von Foerster, H. 1971. Reports of the Biological Computer Laboratory, Department of Electrical Engineering, University of Illinois, Urbana, nos. 712 and 722.

Walter, S. 1999. The Non-Euclidean Style of Minkowskian Relativity. In *The Symbolic Universe,* ed. J. Gray. Oxford: Clarendon Press.

Weeks, J. R. 1985. *The Shape of Space.* New York: Marcel Dekker.

———. 2004. The Poincaré Dodecahedral Space and the Mystery of the Missing Fluctuations. *Notices of the AMS* 51: 610–19.

Index

The letter *b* following a page number denotes a box, and the letter *f* following a page number denotes a figure. Color plates are referred to by plate number rather than page number.